ADVENTURE IN REPERTORY

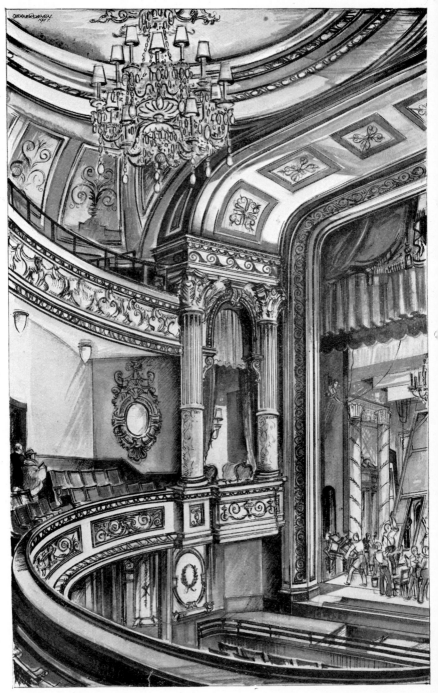

(*From a drawing by Osborne Robinson*)

INTERIOR OF THE NORTHAMPTON REPERTORY THEATRE

ADVENTURE IN REPERTORY

by

AUBREY DYAS

with a Foreword by

J. B. PRIESTLEY

**NORTHAMPTON REPERTORY
PLAYERS**

First Published in 1948

PRINTED BY JARROLD AND SONS, LTD.
THE EMPIRE PRESS, NORWICH

FOREWORD

A HISTORY of a Repertory Theatre in Northampton may seem no great matter, except to people living in that town and its neighbourhood; but I think this would be a mistaken view. Here, in my opinion, is a book of considerable interest and of some importance to all persons who are concerned with the theatre. The famous repertory theatres of great cities like Birmingham and Liverpool have had their historians, but this is, I believe, the first detailed history of a repertory venture in a town that is neither very large nor very rich—a fairly average sort of place. We set out on the adventure in the middle nineteen-twenties and are brought up to date. We are given some details of the management; we learn who were the players, what they played, and how their efforts were received.- All this is information of some value.

I realize that it may be impossible to give the public frank details of the financial background of the venture, but I much regret this omission. It is a pity we are not told what were the weekly receipts and how they compared with the outgoings. I should like to know something about the costs of production. The economic structure of the theatre is extremely important, and the tendency to neglect it is to be deplored. Even a few specimen budgets would have been very useful indeed.

There is much to learn from these chapters. Notice, for example, how many well-known players have appeared on this stage in Northampton—far more than most of us would have guessed. This confirms the opinion, which many of us have often put forward, that repertory, even modest weekly repertory, is a first-class training ground. Notice again, how few new plays have been performed in this playhouse although we gather that the policy of the management was generally to encourage first-time-on-any-stage productions. Is this because few playwrights capable of writing a sound, actable play have taken the opportunity of seeing their plays first performed by a provincial repertory company? (My advice to aspirants has always been that they should try the nearest Rep. before bombarding the West End managers with scripts.)

Notice again the interesting fluctuations of taste and policy—and perhaps courage—on the part of the management: with now a brave rush of experimental productions, and then a lamentable falling-back upon those inevitable light comedies that succeed in the West End not upon their merits but through the adroit contributions of one or two favourite stars. Oddly enough—and I write "oddly" because it is my view that audiences in general have better taste than they had before the war—the level of post-war programmes here seems lower than that of the late 'thirties. Does this mean that audiences in Northampton are an exception, or that higher costs have made the management more cautious, more ready to fall back on revivals and easy West End successes?

But I will stop asking questions and will make a final point. The existence during all these troubled years of a Repertory Theatre in Northampton must have made a great difference to many people's lives in that town, must have given them many a welcome and heartening glimpse of colour, wit, grace, humour, pathos of the sombre depths and glittering heights of this life. Innumerable men and women must have gone to this playhouse in a bleak and perhaps hopeless mood, and come out of it refreshed and heartened. The living theatre, with its direct impact, has a quality of appeal quite beyond the reach of films or radio. In the theatre we escape from the machine. In times like these, when the spirit sickens, we need the theatre urgently. Yet our official attitude towards the playhouse in this country is still dubious and grudging. It is not properly recognized that a Repertory Theatre in Northampton is a glorious amenity, a blossoming oasis in the desert of our austerity, a glimpse of real civilization. But let us fight on. And any book like this that helps us to fight on is therefore most heartily welcome.

<div style="text-align: right">J. B. PRIESTLEY</div>

PREFACE

Conscious as I am of the great compliment paid to me by the invitation of the directors to write a history of the Northampton Repertory Theatre, I feel there are others who might have accomplished it more ably. Let me hasten to explain that for nineteen years it has been my privilege to contribute a weekly note on the current and forthcoming plays to the programme. Apart from an intense interest in the theatre in general and the Repertory Theatre in particular, that instructive hobby is my sole qualification for carrying out what has proved a fascinating task. I sincerely trust that I have done ample justice to this story of a brave venture in repertory.

You will appreciate that to comment in detail on every production of the Repertory Theatre would extend this book to unreadable proportions and would prove tedious. Comment will, therefore, be confined to the more important and interesting productions. The selection of these is an invidious task, being dependent to a degree on personal taste. If, therefore, I have omitted certain plays which made a deep impression on you, I crave your indulgence. I hope that I have dealt with a sufficient number of productions in adequate detail to chart the theatre's course accurately.

A quick glance over the programme of plays presented during the past twenty-one years will call to mind a series of jewels that must be long treasured in the playgoer's memory, and if this book enables repertory playgoers to recapture but the faintest gleam which originally shone from those jewels, its purpose will have been achieved.

My indebtedness to others is considerable. I am indeed grateful to Mr. P. B. Baskcomb for reading the proofs, and through conversation, for giving me insight into many of the early events. I am also much indebted to Alderman W. J. Bassett-Lowke for his encouragement and help, particularly with the illustrations; to Mr. H. Musk Beattie for supplying certain important data, and to Mr. Osborne Robinson for designing the dust-cover and frontispiece, and for his advice regarding the illustrations. My best thanks are also due to

7

Mr. Bernard G. Holloway, the Editor of the *Northampton Independent*, for granting me access to his files; to Miss Rose Walding for giving me personal details concerning many of the former Repertory Players, to Miss Betty Reynolds, who for twenty years has acted as the efficient and genial secretary at the Repertory Theatre, for her invaluable assistance and Mr. John H. Archer of Messrs. Jarrold & Sons, Ltd., for his expert guidance and help.

CONTENTS

Chapter		Page
	FOREWORD	5
	PREFACE	7
	INTRODUCTION	13
I.	FOUNDATION STONES	15
II.	CURTAIN UP	22
III.	EARLY DAYS	27
IV.	A CHANGE AT THE HELM	34
V.	CRISIS	41
VI.	INTERLUDE AT BATH	50
VII.	WELCOME HOME	54
VIII.	THE FICKLE WIND	62
IX.	HEROIC WORK	71
X.	SMOOTHER SAILING	79
XI.	SUCCESSFUL YEARS	87
XII.	A NEW ORDER	97
XIII.	HIGH FESTIVALS	106
XIV.	CRITICAL YEARS	116
XV.	A VITAL CHANGE	124
XVI.	WAR YEARS	132
XVII.	FAVOURITES OLD AND NEW	140
XVIII.	THE WORK GOES ON	149
XIX.	PERSONALIA	157
XX.	HONOURS LIST	164
XXI.	THE CHALLENGE OF THE FUTURE	173
	APPENDIX I—THE DIRECTORS OF NORTHAMPTON REPERTORY PLAYERS LTD.	179
	APPENDIX II—LIST OF PLAYS AND PLAYERS	180
	INDEX	222

ILLUSTRATIONS

INTERIOR OF THE NORTHAMPTON REPERTORY THEATRE

Frontispiece

GROUP OF DIRECTORS *Facing page* 30

"R.U.R." 31

"ALICE IN WONDERLAND" 31

"A WOMAN OF NO IMPORTANCE" 40

"THE QUEEN WAS IN THE PARLOUR" 40

"THE WITCH" 41

"BY CANDLELIGHT" 41

"THE IMPORTANCE OF BEING EARNEST" 56

"THE OUTSIDER" 56

"MARY, MARY, QUITE CONTRARY" 57

"TWELFTH NIGHT" 57

"MARTINE" 72

"JACK AND THE BEANSTALK" 72

"CAESAR'S FRIEND" 73

"THE TAMING OF THE SHREW" 73

"MARRIAGE À LA MODE" 88

"SIR MARTIN MARR-ALL" 88

"THE INSECT PLAY" 89

"THE CIRCLE OF CHALK" 89

"TOBIAS AND THE ANGEL" 104

"ST. JOAN" 104

"THE FLASHING STREAM" 105

"A HUNDRED YEARS OLD" 105

"PRIVATE LIVES" 120

"ANDROCLES AND THE LION" 120

"BURNING GOLD" 121

"THE ROSE WITHOUT A THORN" 121

"WINTERSET" *Facing page* 128

"THE BANBURY NOSE" 128

"COMMAND PERFORMANCE" 129

"A MONTH IN THE COUNTRY" 129

"UP THE GARDEN PATH" 160

"THE MARQUISE" 160

"WITHOUT VISION" 161

"CINDERELLA" 161

INTRODUCTION

THE story of the Repertory movement in England is a thrilling saga of struggle and achievement. Paradoxical as it may sound, its first seeds were sown in Irish soil. A little band of Irish players who called themselves the Irish National Dramatic Company, achieved fame in a night when they gave two performances in London in May 1903. So profoundly impressed was Miss Annie Horniman that she made an offer to W. B. Yeats to provide and equip a small theatre in Dublin for their use. This fine gesture of generosity led to the foundation of the Abbey Theatre, Dublin, at a cost to Miss Horniman which has been estimated at about £13,000, and was responsible for producing a host of plays and players that have enriched the world's drama.

On 23 September 1907, Miss Horniman started repertory at the Gaiety Theatre, Manchester, which thus became the cradle of the English repertory movement. A woman of amazing personality, she was determined to attain a high standard of artistic excellence in plays and production. Many an unknown playwright received his first chance, and the now famous Manchester School of playwrights arose, with Stanley Houghton of *Hindle Wakes* fame, Allan Monkhouse, who wrote *The Conquering Hero*, and Harold Brighouse, author of *Hobson's Choice*, as its chief protagonists. A new school of actors was also inaugurated, led by Sybil Thorndike, Lewis Casson, Esme Percy, and Milton Rosmer, who were then unknown. The theatre in England had become resurgent.

Before the Manchester Repertory Theatre was forced to close its doors through insufficient support in 1917, the Repertory movement had made enormous strides, and, by way of acknowledgement of her invaluable pioneer work, Miss Horniman had become known as the "Queen of Repertory". How well merited was that title is shown by the encouragement and practical help she gave to the founders of the Liverpool Repertory Company, which, with loud acclamations, began performing at the Playhouse in 1911. Although during the early years, the spectre of bankruptcy stared the directors in

the face, they spent money, they took risks, and they persevered. Ultimately, the Company won success and did magnificent work until 1940, when German bombs wrought damage to the Playhouse. "The Liverpool Repertory Theatre," declared St. John Ervine, "has enriched English acting to a quite extraordinary extent, and I believe it is true that more of the West End actors and actresses learned their job in Williamson Square than in any other part of the country."

In the spacious days of 1907, a band of youthful enthusiasts for the drama, known as "The Pilgrim Players", began producing plays in their own dining-rooms in Birmingham. Their leader was a young man named Barry Vincent Jackson, who, in 1912, built for them the first repertory theatre to be erected in England, and, in so doing, lighted a flame which has proved unquenchable. Not even public apathy or bigotry or financial losses could dim its beacon light. Despite a commendable quality of plays and standard of production, and the introduction to the world of many sterling plays, including *Back to Methuselah*, *Bird in Hand*, *Abraham Lincoln*, and *The Farmer's Wife*, the theatre was neglected by the citizens of Birmingham, and, until 1924, Barry Jackson bore the financial burden alone, annually footing the bill.

Thanks to the initiative, courage, and zeal of the pioneers, the Repertory movement has flourished. To-day between thirty and forty repertory theatres are at work. Apart from providing invaluable schools for playwrights and players, and being well-springs of new plays, they have saved the life of the theatre in the Provinces, when it looked as if it would succumb under the death-blow dealt by the cinema. As William Armstrong has said, "Repertory is no longer a term of derision or pity. It stands now for a recognized and significant branch of the theatrical activity in this country. In the recent history of the theatre, indeed, nothing is more remarkable than the progress and success of the Repertory movement." Let us then gratefully salute, in particular, those great hearts of the theatre, Miss A. E. F. Horniman, C. H., and Sir Barry Jackson for their vision, their courage, their single-mindedness, their tenacity, and their boundless energy and hard work, without which Repertory might not have endured, and would assuredly never have triumphed.

CHAPTER I

FOUNDATION STONES

"The baby figure of the giant mass of things to come at large."

SHAKESPEARE.

Drama lay in the doldrums in Northampton in the fateful year of 1926. A similar plight affected the majority of other towns and cities in England at that time. The theatre was at a low ebb, enfeebled, stale, and moribund. Third-rate touring companies and tawdry stock companies were the chief purveyors of dramatic entertainment. Cheap plays were thrown on and badly acted. Small wonder that they often played to ruinous business. An apt example is provided by the season given at the Opera House, Northampton, from January to April 1926, by an old-style touring-stock company. Playing twice nightly they put on two pieces a week for three nights each. Happily, the so-called plays in their repertoire have now been banished to the limbo of the past. The wonder is not that they are dead but that they were ever born. They were tuppenny paper tales adapted for the stage, cheap, crude, and, at the most, vulgarly diverting. The titles of the pieces billed during that season clearly indicate their class, *Her Life of Pleasure*, *The White Slaves of London*, and *The Plaything of an Hour*. In the main, they comprised three varieties: harrowing melodramas, like *The Face at the Window*; hackneyed sentimental stuff such as *When the Angelus is Ringing*, and *Back Home in Tennessee*; and trite pieces with suggestive titles like *Soiled*, *The Unwanted Child*, *Not Fit to Marry*, *Shame*, and *Should a Wife Refuse?*

This dramatic fare provoked an outspoken leading article in the local press bearing the heading, "Is Northampton's Dramatic Taste Declining?" After the writer had decried the type of plays being given at the Opera House, he wrote, "One cannot but deplore a departure from a standard conducive to the best possible tone in all phases of Northampton life. . . . A theatre is a business proposition. Thus, we are forced to the sorry conclusion that Northampton's dramatic taste is definitely declining. . . . Slowly but surely Northampton is being 'black

15

listed' by leading producers. If the process is allowed to con-
tinue, we may find ourselves unenviably isolated from the best
in provincial dramatic art. What is the remedy? It lies not
with the theatre but the public themselves." As we shall soon
discover, that final sentence proved prophetic. What could not
be foreseen was that immense changes were afoot. The nation
was on the verge of a revolution in its playgoing. In that very
year of 1926, indeed within a few months, the film was to find
its voice and the advent of the talkies was to kill the old-time
touring system past all resurrection.

When the stock company departed from the town the
dramatic barometer rose steeply. On 5 April 1926, Mr. N.
Carter-Slaughter's Elephant Theatre Repertory Company
started a season at the Opera House. It was a second string to
his company running a highly successful season at the Elephant
and Castle Theatre, London. Although the productions were
rough and ready and often lacked finish, the company was
reasonably well balanced, consisting of both experienced
artistes and promising young players, while the type of play
given was a distinct improvement, comprising established
favourites like *David Garrick*, *A Tale of Two Cities*, *Caste*, and
Nell Gwynne, and more recent popular successes such as *The
Sign on the Door*, *Hobson's Choice*, *Daddy Longlegs*, *Bulldog Drum-
mond*, and *The Flag Lieutenant*. At first the audiences were small,
but the play-going public gradually rallied to support the
wholesome and entertaining plays given. Interest was aroused.
Folk began to talk. The theatre in Northampton had sprung
to life again.

In a lengthy article entitled, "The Re-Birth of the Drama
—England's Opportunity to Recover her Dramatic Prestige",
published in the *Northampton Independent* on the 24 April 1926,
it was stated: "In the provinces repertory theatres are springing
up like mushrooms in a night, but unlike the mushroom, have
proved that they have arisen to endure." After having des-
cribed the success of the repertory theatres at Bath, Bristol,
and Birmingham, the article concluded, "The public's wel-
come of returning drama is proved by the Elephant Company's
ever-growing audiences."

On 1 May 1926, another article appeared in the same journal
headed, "Can Northampton establish its own Repertory

Theatre? A call to local playgoers." It told of the establishment and administration of the Bristol Little Theatre formed through the initiative of the Bristol Rotary Club and of the Bath Players, who had a scheme, outlined by Mr. Dennis Eadie, the noted actor, for the Theatre Royal, Bath, to become a repertory theatre, and finished with these words, "It now only remains to be proved whether Northampton is capable of following the admirable lead of other cities. . . . It is up to the Northampton theatre-going public to build a dramatic edifice worthy of the town and its large majority of intelligent citizens." A series of letters from readers was subsequently published, showing that there were, in fact, a large number of "intelligent citizens" eager to give the foundation of a repertory theatre their whole-hearted support. The idea, which was symptomatic of the times, continued to attract wide attention. In clubs, in cafés, and wherever lovers of the drama met, it became the topic of keen discussion. The Rotary Club gave the idea its unanimous approval. Thus, many became passively interested, but five enthusiasts became actively so. They were Mr. Bernard G. Holloway, Editor of the *Northampton Independent*, Mr. P. B. Baskcomb, Mr. Francis Graves, Editor of the *Northampton Echo*, Mr. C. Graham Cameron, a member of the Elephant Theatre Company, and Mr. O'Brien Donaghey. Most appropriately, the first informal chat between them took place in the foyer of the Opera House itself. This discussion had far-reaching results. The pioneers formulated their ideals and a definite plan of action was evolved.

The Mayor of Northampton (Councillor J. G. Cowling, J.P.) was approached and promptly agreed to call a public meeting to discuss the possibility of launching a repertory theatre in the town. Here is an extract from the *Northampton Independent* of 19 June 1926: "What all who were present hoped would be local dramatic history was made in the Mayor's parlour this afternoon, when a preliminary meeting of influential ladies and gentlemen of town and county was convened by the Mayor to discuss the possibilities of the establishment of a Repertory Theatre and Playgoers' Association for Northampton."

This meeting was held on 18 June 1926, at the Guildhall, and here is the Agenda:

1. His Worship the Mayor.
2. Mr. P. Baskcomb, B.A., of the Northampton Town and County School, will briefly outline the proposed scheme and submit the following resolution:
 "That this meeting, having heard the proposals for the formation of a Repertory Theatre for Northampton, has resolved to support the scheme and to assist in whatever way possible to carry out the proposals set forth."
3. Discussion and submission of above resolution.
4. Resolution being carried, it is moved that:
 "Two Committees be appointed; the first one of business men to discuss and draft a scheme for a Company to be floated in the town and county with the object of renting the Opera House and engaging a Repertory Company; the second to draft the constitution of a Playgoers' Club."

After introductory remarks by the Mayor, Mr. Baskcomb gave a brief and lucid résumé of the proposals made and concluded his speech by saying, "All repertory theatres have had to fight for their existence, and I have no doubt that the Northampton Repertory Theatre will have to fight—and fight very hard. Nothing good has ever been done without patience, perseverance, and optimism. At no very distant date, Northampton may achieve the distinction of possessing one of the finest repertory theatres in England." Both these statements have proved prophetic.

The first resolution was carried with unanimity and following an interesting discussion, the two committees were appointed: the first committee comprised Councillor Harvey Reeves (Chairman), Mr. Baskcomb (Deputy Chairman), Mr. Donaghey and Mr. Holloway (Joint Secretaries), Councillor H. W. Dover, Mr. Reginald Brown, Mr. W. J. Bassett-Lowke, Mr. H. Musk Beattie, the Rev. J. B. Dollar, and a representative of the Northampton Rotary Club; and the Second Committee consisted of Mr. Compton James, Miss Wallace, Mrs. Frank Panther, the Rev. J. E. Evans, the Rev. J. B. Dollar, the Rev. J. F. Winter, and the Rev. J. Trevor Lewis, R.D. Meeting followed meeting, some being held in the most unconventional places, and ultimately the First Committee devised a concrete scheme.

If a repertory theatre were established, where would it be housed? That was the pressing problem that faced these pioneers. The Opera House was the obvious choice. Its

atmosphere and tradition were ideal, and, with a seating capacity of about 850 it was the right size. But the place was due to be demolished. Could they save it from destruction? If so, could satisfactory terms for renting it be arranged? The Committee's initial inquiries were sympathetically received by Lieut.-General Sir John Brown, K.C.B. and Mr. W. Pepper Cross, O.B.E., the directors of the Northampton Theatre Syndicate, owners of the theatre.

A charming, well proportioned theatre, the Opera House and Theatre Royal, as it was originally known, opened on 5 May 1884, with a production of *Twelfth Night*, by the Compton Comedy Company, headed by that famous Victorian actor, Edward Compton and his wife, Virginia Bateman, the parents of Fay Compton and Compton Mackenzie, the novelist. At that performance, the audience was treated to a somewhat prolix discourse by the General Manager, Mr. Isaac Tarry, in the course of which he declared: "We intend to cater not for a class but for all classes. There shall be Shakespeare for those who admire him—and who does not? There shall be melodrama for lovers of the sensational. There shall be opera for those who love it. There shall be tragedy for those who choose to weep and comedy for those who love to laugh." Now, really, you could not say fairer than that, could you? Half a century of history is encompassed by that theatre which became a centre of entertainment for Northampton people before the plans were made for the first jubilee of Queen Victoria, and in days when Mr. Gladstone was the outstanding figure in British politics, when General Gordon was an idol of the British public, when the voices of Charles Bradlaugh and Henry Labouchere, the borough's two M.P.s, were heard in the House of Commons and when Northampton was less than half its present size. During the forty-three years prior to its conversion into a repertory theatre, most of the favourite plays of those decades had been acted at the Opera House by touring companies as well as opera and musical comedies of every quality. The plays performed ranged from the classics to pot-boilers, from *Hamlet* to *Jim the Penman*, from *The Rivals* to *It's Never Too Late to Mend*. Renowned artistes, some of whom are now but names, walked its boards, were illuminated in its footlights, and made their contribution to its

history. Among them were Sir Henry Irving, Ellen Terry, Edward Compton, and Virginia Bateman, Sir Charles Wyndham, Mary Moore, Osmund Tearle, Kitty Loftus, Wilson Barrett, Genevieve Ward, Laurence Irving, Fred Terry, and Julia Neilson, Sir Frank Benson, "Little Tich", Sir John Martin Harvey, Frank Curzon, Sir Seymour Hicks, and Charlie Chaplin. On one visit of the Carl Rosa Opera Company, the orchestra was conducted by Sir Henry Wood.

Although the scheme to establish a repertory theatre received the official blessing of the Mayor, it will be observed that there was no suggestion that it should be a civic theatre. Such a proposition would probably have been regarded as revolutionary. In the English official mind, the theatre is not considered among the civic assets of the community. Museums, art galleries, and public libraries are permissible burdens for the ratepayers, but not the living theatre. In this respect, of course, Northampton does not differ from any other English town or city.

Eventually, a company known as "Northampton Repertory Players Limited" was formed with a capital of £2,000, divided into 2,000 ordinary shares of £1 each. The raising of the necessary capital proved a difficult and anxious business. The sums invested by a number of interested people provided a substantial amount towards the total figure required but left a balance to be subscribed. At last, a final meeting was held in Mr. Graves's room at the *Northampton Echo* offices. Those attending wore anxious expressions. The whole inception of the movement hung in the balance. The amount required was still some £250 short, and desperate telephone calls were made to all sorts of possible subscribers. Slowly—very slowly—after repeated failures, more hopeful suggestions were advanced, and after alternations of hope and despondency, the amount was collected, and the way was at last clear.

The object of the new Company was to present the best dramatic entertainment produced by a company of professional artistes under the direction of an experienced producer. Through the medium of the organization known as the Playgoers' Association, audiences were to be closely linked with the theatre. The Board of Directors of the Company consisted of Sir James Crockett, J.P. (Chairman), Mr. W. H. Horton

(Deputy Chairman), Mrs. Helen Panther, Mr. (now Alderman) W. J. Bassett-Lowke, Mr. Francis Graves, and Mr. H. Musk Beattie (Secretary), and one seat was reserved for a representative of the Playgoers' Association. One autumn evening in 1926 saw the culmination of the protracted and difficult negotiations for the Opera House and final arrangements were concluded for the Company to be granted a lease. As the representatives of the Repertory Company left the office of the Opera House with the terms of settlement in their pockets and with hearts filled with optimism, one of the representatives of the owners of the theatre called out as a parting shot, "I'll give you four months!"

Mr. C. Graham Cameron of the Elephant Company was appointed the General Manager, and the four most popular artistes in that company, Bluebell Glaid, C. T. Doe, J. Drew Carran, and C. Harcourt Brooke, were offered engagements by the new Company. The directors felt that their continued appearance in Northampton would act as a bridge between the old Company and the new, and thus ensure that regular supporters of the Elephant Company would transfer their allegiance to the Northampton Repertory Players. The directors also decided that the company must play twice nightly if they were to become established on a sound financial basis. And so the whole organization was complete. Nothing remained to be done but to produce the first play and prepare for the opening night. Even at that early stage, the cynics, the pessimists, and the know-alls wagged their heads and predicted that the new venture was doomed to fail.

CURTAIN UP

"The actors are come hither."

SHAKESPEARE

The year 1927 might be a century ago for all the manifold changes wrought in the last two decades. Just think of it: petrol was 1s. 1½d. per gallon, sheets 12s. 6d. a pair, port 3s. 6d. a bottle, and coal 45s. a ton. Although nearing their sudden demise, silent films were in vogue, and the most favoured stars of the silver screen were Rudolph Valentino, Pola Negri, Harold Lloyd, Mary Miles Minter, Gloria Swanson, Dorothy Gish, Milton Sills, Clara Bow, John Gilbert, Isobel Elsom, and Buster Keeton. Industry and home affairs were settling down after the national upheaval of the General Strike the previous year, but a serious coal shortage prevailed. In the world of cricket, a young Gloucestershire batsman, Walter Hammond, equalled W. G. Grace's record of scoring a thousand and twenty runs during the month of May. The West End successes of the year included, *Rookery Nook, The Ghost Train, And So to Bed, Interference, The Constant Nymph, Yellow Sands, The Letter, Marigold, On Approval, The Vagabond King,* and *The Desert Song.* At the height of his popularity, H.R.H. the Prince of Wales, in the midst of a strenuous life, hunted frequently with the Pytchley. Although involved in a hunting accident early in the year, he paid his second formal visit to Northampton within six months. Other notable visitors to the town included Dame Clara Butt, the Earl of Birkenhead, Max Miller, Miss Megan Lloyd George, Ramsay MacDonald, St. John Ervine, Pachmann, Mrs. Patrick Campbell, General Booth, a Labour M.P. known as Oswald Mosley, and Gracie Fields in an Archie Pitt revue. That was the year in which the Northampton Repertory Theatre made its bow.

By the New Year, intensive preparations for the great adventure ahead had already begun. These were by no means commonplace. On arrival, the first members of the Northampton Repertory Players naturally made their way to the Opera

House only to find it was occupied for pantomime and not available for the rehearsals of *His House in Order*. Imagine their surprise when they were directed to a well-known hostelry near the theatre. Some of them, who had felt certain doubts and misgivings about this new company, speedily revised their opinions. "This sounds promising," they thought to themselves, licking their lips in pleasant anticipation. No wonder the rehearsals went with spirit from the start!

Search had been made for a capable and experienced producer. The Secretary of the Bristol Players, Mr. A. E. Stanley Hill, anxious to help the venture in repertory in Northampton, had recommended Mr. Max Jerome, who had rendered valuable assistance in carving out the initial fortunes of the Bristol Repertory Theatre Company, and in laying the foundations of the high standard of dramatic art offered by the Little Theatre, Bristol. When Mr. W. Bridges Adams resigned, Mr. Jerome became general manager of the Liverpool Repertory Theatre. He was indeed proud of the fact that during his régime the Playhouse was for the first time not only an artistic but a financial success. He had also been a member of Sir Frank Benson's company, stage-manager and producer for Robert Courtneidge, and producer for the Stockton-on-Tees Repertory Company. With such varied experience, Mr. Jerome promised to be a dependable pilot of the new company.

The final stage of the formation of the Northampton Playgoers' Association was reached just two days before the first performance of the Northampton Repertory Players. At an enthusiastic meeting held at the Town Hall, the project was outlined by Mr. P. B. Baskcomb in a wise and witty speech. "The Association will form a powerful connecting link between the Repertory Company and its public," declared Mr. Baskcomb, who extolled the advantages of a repertory theatre in the town. After a discussion, the constitution was adopted and the association established. Mr. Baskcomb, who is the brother of those two well-known West End actors, Mr. Lawrence Baskcomb and the late Mr. A. W. Baskcomb, became the chairman of the association and its representative on the Board of Directors of the Repertory Theatre. His wide knowledge of the drama and his shrewd judgment have been highly prized down the years. The Northampton Playgoers'

Association steadily grew in strength and became a dynamic force providing a strong body of support to the theatre in its early days. In the words of Christopher Hassall, it was:

> "A bridge across the footlights boldly thrown
> For two-way traffic between the stage and town."

Conscious that the opening play should be a strong play with a broad appeal, the directors selected Sir Arthur Pinero's *His House in Order*. In choosing a play by a seasoned playwright such as Pinero, who, St. John Ervine says, raised the English theatre out of the gutter, they acted wisely. His plays are always well written, technically excellent, and "good theatre". *His House in Order*, with its enthralling story of Filmer Jesson and his two wives, is no exception.

Soon after his arrival in the town, Max Jerome was introduced to the eleven players who comprised Northampton's first Repertory Company. They consisted of five artistes, Bluebell Glaid, C. T. Doe, J. Drew Carran, C. Harcourt-Brooke, and C. Graham Cameron, who had been members of the Elephant Company, and six newcomers, Margot Lister, Arthur Hambling, Mildred Trevor, Maurice Neville, Enid Gwynne, and Clifton James. Harcourt-Brooke and Mildred Trevor were appointed stage-manager and assistant stage-manager respectively. From their previous work and experience, Mr. Jerome had every ground for confidence that he had under his command a well-balanced "eleven" of professional players. Having cast the play, Mr. Jerome started to put the artistes through their paces with characteristic enthusiasm. In the bright and bibulous surroundings, the play soon began to take shape and swiftly the night of the first performance approached.

No brassy fanfare greeted the opening of the Northampton Repertory Theatre on Monday, 10 January 1927, but it aroused tremendous interest. A host of felicitations were received by the company, including a gracious and encouraging message from Sir Barry Jackson. "I congratulate Northampton upon its enterprise," he wrote, "and I wish the venture every success." Well before six-thirty, the time appointed for the first performance of the evening to commence, the Opera House was well filled. One person who has a particularly vivid

recollection of that night is Mrs. May Button, the ever-cheerful and courteous manageress of the box office. That was her "first night" too with the Repertory Theatre—the first of some 63,000 nights during which she did yeoman service for the theatre.

A ripple of excitement ran through the audience when the Mayor of Northampton (Councillor James Peach, J.P.) and the Mayoress, together with members of the Corporation and other prominent and influential citizens arrived, while the orchestra was giving a spirited rendering of Roncovelli's "La Fiesta". The lights dimmed. The hubbub of chatter ceased. The audience, which now packed the theatre to the doors, sat back expectantly. The curtain rose. Interest focused on the stage. The atmosphere seemed charged with tense expectancy. Everyone's critical faculties were keyed up. It was apparent that most of the actors were not a little affected by the ordeal of such a special first night. After those old friends of the Elephant Company had each received cordial ovations, the players became more at ease and *His House in Order* got into its stride. Arthur Hambling as Hilary Jesson, and Bluebell Glaid as Nina, showed their sterling qualities, and finished performances were contributed by Margot Lister as Geraldine Ridgeley, C. T. Doe as Sir Daniel, and Clifton James as Pryce Ridgeley.

As you watched the progress of the play, it became apparent that, although *His House in Order* was a good choice from the point of view of popular appeal and dramatic effectiveness, it was far from an easy play for a new company to perform. Its close interplay of character upon character demanded meticulous timing and team-work wellnigh impossible to achieve in the comparatively short period of rehearsal. The fact that more than two-thirds of the company were called upon to impersonate characters twenty and thirty years older than themselves was a further handicap. Thus, a large proportion of the audience were unable to appreciate to the full the admirable character-studies of such comparatively young artistes as Margot Lister, and Mildred Trevor as the aged Lady Ridgeley. Nevertheless, everyone saw enough to become convinced of the unquestionable talent of the producer and players in this highly creditable first production.

At the final fall of the curtain, the theatre rang with rapturous applause, followed by scenes of enthusiasm. Mr. Graham Cameron, the general manager, who had so manfully sustained the burden of the play in portraying Filmer Jesson, stepped forward. The clapping stopped. In a happily phrased speech, he remarked that Northampton playgoers were watching the efforts of the Northampton Repertory Players very carefully, critically, and some, compassionately, but all with very good spirit. In conclusion, he presented Max Jerome, the producer, who, smiling modestly, acknowledged the enthusiastic appreciation of the audience for his intial production.

And so the first performance of the Northampton Repertory Players concluded with a flourish of excitement. The exciting adventure of repertory in Northampton had begun.

EARLY DAYS

"The stage but echoes back the public voice;
The drama's laws, the drama's patrons give,
For we that live to please, must please to live."

SAMUEL JOHNSON

SCOFFERS and "dismal Desmonds" became more vocal. They burst forth in prophecy affirming that Northampton's bold enterprise in repertory would fail within a few months. They told how similar theatres at Manchester, Bristol, Southend, and elsewhere had been forced either to seek further financial support or to close down. "If that happens in large towns and cities," they croaked, "what chance of success has a repertory theatre in Northampton, a town with a population of barely 100,000?" Happily, they proved wrong.

After their flying start, the Northampton Repertory Players forged gaily ahead, even despite the visitation of a serious influenza epidemic to the town. Their second production was *The Truth About Blayds*, A. A. Milne's gentle comedy of the problem created by the great secret entrusted by a nonagenarian poet to his younger daughter. With faultless make-up and bearing, Arthur Hambling gave a fine and sensitive portrayal of the part of Oliver Blayds, the lovable old poet, and, as Isobel, his younger daughter, Margot Lister revealed her ability as a dramatic actress. These two players won instant approval from the public and lent strength to the company in those early days. They had each learnt their art in the hard school of experience: Mr. Hambling in America, Canada and the provinces as well as the West End with Sir Charles Hawtrey, Cyril Maude and Sybil Thorndike and Miss Lister in repertory at Plymouth, Southend, and Bristol. Both of them expressed their surprise and gratification at the hospitable welcome accorded them by Northampton audiences.

"Miss Clemence Dane is the most distinguished woman dramatist in the history of the theatre," wrote St. John Ervine of the author of *A Bill of Divorcement*, the Repertory Players'

third offering. All who witnessed the smooth production of that powerfully effective play readily endorsed that opinion. Forceful performances were given by Max Jerome as Hilary Fairfield, the husband who unexpectedly returns home after fifteen years in a mental home, Margot Lister as his wife, and Bluebell Glaid as his daughter.

Within a month, Mr. St. John Ervine delivered an address at the Northampton Public Library on the occasion of its jubilee celebrations. Mr. Ervine, who has always been a champion of the Repertory movement, was in excellent form. His witty and amusing lecture was punctuated with some trenchant outbursts about the state of health of the theatre. He declared that the theatre had become "a sort of annexe to a dressmaker's shop" and that the theatre as we know it "is on its last legs." In the light of the vitality of the English Theatre in general and the gallant achievements of the Northampton Repertory Theatre in particular during the past decade, these unequivocal pronouncements clearly prove that even distinguished dramatic critics are far from infallible!

An important function of a repertory theatre consists of producing new plays. When the Repertory Theatre had been running only seven weeks, *Experiment*, a comedy by Robert and Mabel Gilbert, was performed for the first time on any stage. A brave step for a theatre so young! The authors visited the town to supervise several rehearsals and attended the première when a crowded house, excited at being present at a real first night, was all agog with anticipation. The play opened strongly enough and then began to slacken, like a runner who over-exerts himself on the first lap. The company battled manfully to keep the play afloat, but failed to breast the tide of weak construction. Indeed, the story had to be seen to be disbelieved. Ending tamely it proved to be just—an experiment. Happier fare followed the next week with another Pinero play, *Sweet Lavender*, which found C. T. Doe as Dick Phenyl, and Bluebell Glaid as Lavender, in fine fettle.

The Passing of the Third Floor Back was an appropriate choice for Holy Week with its picture of a typical London boarding-house where a new spirit steals into the house when a stranger takes a room on the third floor back, and through him, the mixed bag of worldly guests become transformed. Curiously

enough, that modern morality play, in which Sir Johnston Forbes-Robertson scored his greatest success, was written by a humorist, Jerome K. Jerome, author of that irresistibly funny novel, *Three Men in a Boat*. In his reminiscences, *My Life and Times*, Mr. Jerome relates how the idea for the play came to him through seeing a shadowy, dark-cloaked figure in a London street one foggy night. The figure merely passed him. Jerome did not see his face, only his back and slightly stooping shoulders as he disappeared down a side-street peering up at the numbers of the houses as he went—just a passer-by, a stranger, or whomever you like to think. . . . J. Drew Carran, who usually played debonair parts, proved his versatility by giving a sincere and convincing performance as the Stranger and one of the finest individual performances of the season. By a coincidence, the following week, whilst on a motoring holiday, Mr. Jerome stayed at Northampton and visited the Repertory Theatre with his wife and daughter. During his stay, however, he was suddenly taken ill, and this famous novelist and playwright died in the Northampton General Hospital on 14 June 1927, at the age of seventy-seven.

Although still in his twenties, Mr. Drew Carran had gained useful experience in London playing with Leon Quartermain, Ivor Novello, and other well-known actors. A quick study, he possessed a good appearance, a pleasing voice and a restrained manner. His popularity with the public was not surprising. C. T. Doe, another firm favourite, had run away from home to join a circus when a youngster, had toured twice round the world and been a member of Wilson-Barrett's Company. Without doubt, he was the most consistent performer and became the backbone of the company in those early days. In contrast, Bluebell Glaid had acted but a few parts when she first came to the town with the Elephant Company. By hard work and earnest study, she developed into an engaging actress. Uniformly finished performances were given by this trio of players in *The School for Scandal*, the first classic play acted by the company. C. T. Doe's Sir Peter Teazle, Bluebell Glaid's Lady Teazle and Drew Carran's Charles Surface were admirably supported by Margot Lister's Lady Sneerwell and Stanley Vine's Joseph Surface. They combined to make Sheridan's witty dialogue sparkle throughout and amply

merited the enthusiasm with which this incomparable comedy of manners was received. A local commercial artist, Charles Maynard, designed and painted pleasing settings and from that time acted as the first scenic artist to the Company. His appointment represented a significant step in the right direction artistically. Previously the Company had used stock-sets which were usually dull and often shabby. This production synchronized with the anniversary of two important productions of *The School for Scandal*: the original at Drury Lane one hundred and fifty years before, on 8 May 1877, and the first of the play at the Opera House by Edward Compton's Company on 7 May 1884.

The succeeding nine plays did not strike a very high level, and the first season ended with Reginald Berkeley's comedy of 1914–18 war, *French Leave*, the final performance being given on Saturday, 23 July, 1927. Looking back over that first lap of the adventure during which twenty-eight plays had been produced and some 170,000 people had witnessed them, the directors had every reason for satisfaction. The critics and pessimists had been confounded, for the ship had not only been launched, but, sailing through unknown waters, had successfully completed her maiden voyage.

The second season opened with Pinero's *The Second Mrs. Tanqueray*, that tensely dramatic play about Aubrey Tanqueray's second marriage to Paula Ray in spite of his friends' warning that she is a woman of easy virtue. Two notable newcomers played the leading roles: Ailsa Grahame, who had done a considerable amount of work on the West End stage, gave emotional force to Paula and Noel Morris, fresh from playing leading parts at the Bristol Little Theatre, made a favourable impression as Tanqueray. They were strongly aided by C. T. Doe, J. Drew Carran, Clifton James, and James Hayter. It is somewhat surprising to note that at that time only two male members of the company were Englishmen. They were Noel Morris, and Alfred Richards the hard-working stage-manager. Max Jerome was a Scotsman, Drew Carran an Irishman, and Graham Cameron a South African. Both C. T. Doe and Clifton James were born in Australia, and James Hayter came from India. Almost an example of Imperial preference!

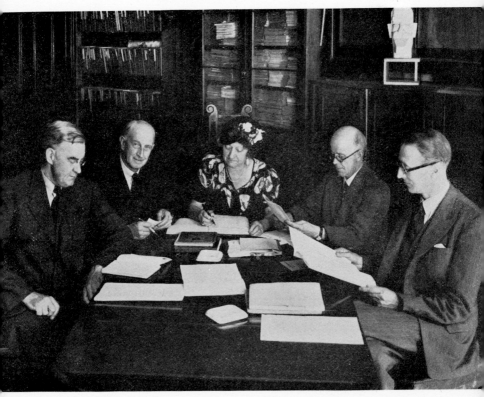

(*Photograph by Henry Cooper and Son*)

DIRECTORS' MEETING AT THE REPERTORY THEATRE

Reading from left to right: P. B. Baskcomb, B.A., W. J. Bassett-Lowke, M.I.Loco.E., F.R.S.A., Mrs. H. Panther, M.B.E., J.P. (Chairman), H. Musk Beattie (Secretary), W. H. Fox, F.S.A.A.

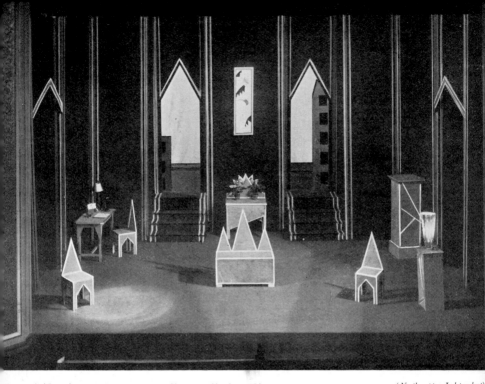

(*Above*) SETTING FROM "R.U.R." (1928)

(*Northampton Independent*)

(*Below*) "ALICE IN WONDERLAND" (1928)
Curigwen Lewis as "Alice"

(*Northampton Independent*)

Although Clifton James had been gassed and sustained a smashed right hand in the first Great War, he was the most exuberant member of the company. During a varied theatrical career, he had played in Mrs. Patrick Campbell's Company, and at the Southend Repertory Theatre as well as being a theatrical agent. His forte was comedy, as his acting in twenty-five parts during the first season had demonstrated. James Hayter, after graduating from the Royal Academy of Dramatic Art, had toured in *The Merchant of Venice*, the youngest professional actor to play the Jew. This breezy, carefree young actor proved himself an admirable light comedian and no mean character-actor. Among a series of comedies and thrillers, Frederick Lonsdale's *The Fake*, with Clifton James in fine form, and Israel Zangwill's *We Moderns*, stood out prominently. The latter play caused something of a storm in a teacup: many playgoers considered the play too highbrow for their patience and interest, while others felt that, since it portrayed the outspoken young people of the nineteen-twenties, it was morally below them. With the simplicities of *Peg O' My Heart* the next week, the public found themselves on more familiar ground and packed the Repertory Theatre.

Max Jerome's work as producer was terminated in October 1927. His successor, Rupert Harvey, was engaged for a period of three months, expressly to reorganize production, and during that time, the directors sought a suitable permanent producer. Northampton owed a considerable debt to the Bristol Little Theatre in those early days, as has already been seen and that indebtedness was increased with the advent of Mr. Harvey straight from Bristol, where he had won high praise both as an actor and producer. The standard of plays improved at once. Shakespeare, Shaw, and Barrie made their debut in the repertoire. His initial production of Alfred Sutro's powerful play *The Choice*, marked an improvement in production as well, and this standard was well maintained in his subsequent work. Barrie's two inimitable one-act plays, *The Old Lady Shows Her Medals* and *The Will*, bore the imprint of intelligent and sympathetic direction. Excellent work by producer and players combined to make Shaw's *Arms and the Man* a highly creditable production in which Bluebell Glaid's Raina, C. T. Doe's Captain Bluntschli, and Arthur Hambling's

Every repertory theatre has wrestled with the self-same problem: How to appeal to the public and at the same time maintain a worthy standard of plays? All repertory theatres, The Abbey Theatre, Dublin (which, incidentally, Mr. St. John Ervine once directed), and the Liverpool Playhouse included, have found the same solution. Their repertoires have been mainly composed of plays with a popular appeal, and occasionally they have produced a masterpiece or made an experiment. But for the money made by the popular plays, they would never have dared to face the almost certain financial loss involved in the production of a masterpiece or an experimental play. Henceforward, that became the policy of the Northampton Repertory Theatre, and the directors strove to observe the precept, with which few will quarrel, that when crook plays or farces were given they must be good of their kind.

From the outset, there had been no dint of suggestions from playgoers of plays they would like to see performed. Some of them were most helpful to the management, others quite impractical. The plays suggested were by no means stereotyped as is shown by a humorous note in the magazine-programme about this time under the heading "Letters to the Editor". It read, "We should like to be able to produce *Ben Hur*, but we regret that the theatre has not grown big enough for it yet. Perhaps it will one day." It is a sobering thought that in wellnigh a thousand productions given in the course of twenty-one years, the Northampton Repertory Players still have not staged this mammoth spectacle! Maybe they are short of an odd chariot or so!

Determined to raise the level of the Repertory Theatre to that of the best repertory theatre in the country, the directors sought a producer of distinction and appointed Herbert M. Prentice, who came from a similar position at the Cambridge Festival Theatre. Mr. Prentice deserted the routine of commerce for the vagaries of the theatre where his heart had been since the days of his youth. He played a leading part in founding the Sheffield Repertory Theatre, where he laboured arduously as producer for seven years. Then, that wealthy young man with a passion for the theatre, Terence Gray, conceived the desire of buying a theatre to run on his own lines, and, hearing glowing accounts of the achievements of

Although Clifton James had been gassed and sustained a smashed right hand in the first Great War, he was the most exuberant member of the company. During a varied theatrical career, he had played in Mrs. Patrick Campbell's Company, and at the Southend Repertory Theatre as well as being a theatrical agent. His forte was comedy, as his acting in twenty-five parts during the first season had demonstrated. James Hayter, after graduating from the Royal Academy of Dramatic Art, had toured in *The Merchant of Venice*, the youngest professional actor to play the Jew. This breezy, carefree young actor proved himself an admirable light comedian and no mean character-actor. Among a series of comedies and thrillers, Frederick Lonsdale's *The Fake*, with Clifton James in fine form, and Israel Zangwill's *We Moderns*, stood out prominently. The latter play caused something of a storm in a teacup: many playgoers considered the play too highbrow for their patience and interest, while others felt that, since it portrayed the outspoken young people of the nineteen-twenties, it was morally below them. With the simplicities of *Peg O' My Heart* the next week, the public found themselves on more familiar ground and packed the Repertory Theatre.

Max Jerome's work as producer was terminated in October 1927. His successor, Rupert Harvey, was engaged for a period of three months, expressly to reorganize production, and during that time, the directors sought a suitable permanent producer. Northampton owed a considerable debt to the Bristol Little Theatre in those early days, as has already been seen and that indebtedness was increased with the advent of Mr. Harvey straight from Bristol, where he had won high praise both as an actor and producer. The standard of plays improved at once. Shakespeare, Shaw, and Barrie made their debut in the repertoire. His initial production of Alfred Sutro's powerful play *The Choice*, marked an improvement in production as well, and this standard was well maintained in his subsequent work. Barrie's two inimitable one-act plays, *The Old Lady Shows Her Medals* and *The Will*, bore the imprint of intelligent and sympathetic direction. Excellent work by producer and players combined to make Shaw's *Arms and the Man* a highly creditable production in which Bluebell Glaid's Raina, C. T. Doe's Captain Bluntschli, and Arthur Hambling's

Nicola were deservedly praised. When the performance of
this play was first broached, Bernard Shaw wrote an amusing
letter to his friend, Alderman W. J. Bassett-Lowke, in which he
said, "The Northampton Repertory people evidently have
not admitted my works to their reading circle. They actually
ask where they can get the play. Something in the turn of the
question suggested a profound inner bewilderment as to who
the devil I might be." In a new play *On the Night of the 22nd*,
of which Noel Morris was part-author, Milne's *The Dover Road*,
and G. K. Chesterton's delicious fantasy, *Magic*, Rupert
Harvey revealed his skill as an actor. He revelled in the part
of the Stranger in the last-mentioned play, and gave such a
sensitively timed portrayal that it still remains vivid in one's
memory.

The perennial enchantment of *A Midsummer Night's Dream*
proved delightful Christmas fare, appealing equally to the
young and not-so-young. Starting on Christmas Eve, once-
nightly performances were given for two weeks. The Company
strove whole-heartedly to make it an outstanding production.
Colourful costumes and settings were specially designed by
Charles Maynard, and made in the theatre itself. An aug-
mented orchestra under the direction of Mr. R. Richardson-
Jones, F.R.C.O., played aptly selected music by Mendelssohn
and Grieg. The haunting beauty and wealth of comic invention
with which the play is invested were admirably depicted by
Ailsa Grahame as Oberon, Ivy Walenn as Titania, Noel
Morris as Theseus, Bluebell Glaid as Hermia, J. Drew Carran
as Demetrius, Rupert Harvey as Lysander, Margot Lister as
Helena, C. T. Doe as Bottom, and James Hayter as Puck.
How deftly Shakespeare weaves the three different threads of
the fairy pranks of Oberon, Titania, and the mischievous Puck,
the tangled loves of Helena, Hermia, Lysander, and Demetrius
and the rustic revels of Bottom and his fellow-craftsman into a
magical pattern! "The reading of this play," wrote Hazlitt,
"is like wandering in a grove by moonlight." Or in the words
of G. K. Chesterton, "It is the most exuberantly English thing
that ever happened." The audiences were unstinting in their
appreciation of this ambitious production of Shakespeare's
lovely fantasy which rang down the curtain on the first year
of the Repertory Players.

Milestones, the tour-de-force of Arnold Bennett and Edward Knoblock, followed. A costume play, with pleasing pictorial values, that has a serious theme showing the gradual unfolding of the lives of John Rhead and his wife, Gertrude and family, and how through three generations the same prejudices, the same problems and the same emotions recur. Always popular, this human story has humour and pathos, much strength and not a little fragance, all of which were faithfully portrayed by Noel Morris as John Rhead, Bluebell Glaid as Gertrude, and Margot Lister as old Mrs. Rhead. *Milestones*, Rupert Harvey's swan song, provided a delightful play for the Northampton Repertory Theatre's first birthday and it was, in more than one sense, a milestone.

A CHANGE AT THE HELM

"A man must serve his time to every trade
Save censure—critics all are ready made."

BYRON

Shoals of letters arrived at the Northampton Repertory Theatre at the end of the first year. Patrons had felt impelled to write to the management, thus proving beyond any doubt the interest provoked by this new force in the dramatic life of the town. The views expressed in the correspondence were vastly and entertainingly varied. Some of the writers sounded the trumpet of praise, others beat the drum of criticism. The critical patrons chose an easy target. They assailed the choice of plays and their objections were nothing if not diverse. They alleged that (1) the management catered for a minority and not for the majority: (2) there were too many popular plays and not enough "far removed from the common rut"; (3) there should be more "straightforward" plays; (4) there were too few melodramas; and (5) the plays presented ought to be "works of a simpler type which could be followed easily by *all* members of the audience". No better evidence could be found to support the axiom that what the public wants is an insoluble riddle.

A redoubtable critic also entered the arena when the captious St. John Ervine gave the Repertory Theatre national notice. Writing in the *Observer*, he remarked, "At Northampton an effort is being made to lift the local repertory theatre up to the level of high-class repertory theatres—not, indeed, before the effort was needed. On the only occasion on which I was present at a performance in that theatre, I saw a play which would have given the owner of the Elephant and Castle a pain in his tummy; a melodrama of the crudest and silliest sort. Northampton will have to do a lot better than that before its repertory theatre can expect to receive any respect. I do not demand the frequent or exclusive performance of gloomy plays. In all my advocacy of the repertory theatre I have insisted that it shall be a catholic theatre; the theatre, not of a clique, but of

the community. My ambition is to see in every city in these islands at least one theatre in which the average intelligent citizen may be certain of seeing a pretty good play whenever he goes to it. I would not exclude crook plays from my repertory theatre if I had charge of one but I would insist that the crook play done in it should be good of its kind. I would not exclude farce, but I would insist that it must be good of its kind. Nothing, in my experience, is so damning to repertory theatres as the narrow-minded belief that only plays by Sophocles, Shakespeare, and Shaw must be performed in them. But equally damning is the timorous belief that experiments must never be made."

Much of the criticism was, indeed, justified. The quality of the plays during the first ten months was far from high. Entertainment value alone had clearly dictated their selection. Too many were trivial and third-rate pieces: several, such as *The Eye of Siva*, and *The Barton Mystery*, suffered from superficiality and inconsequence, and others from banality, as, for example, *Bought and Paid For*, and *The Education of Elizabeth*. Admittedly, therefore, the directors were not always wise in their choice of plays, but this was undoubtedly due to their over-anxiety to walk before they ran. "The public is a body that cannot be forced," says Dawson Turner. "Some extraordinary genius may have succeeded in guiding it, but they are few, and the greatest part of those who have made the experiment have failed." Or as Sir John Millais once wrote, when his work was brilliantly original but also unsuccessful, "A doctor sugars the pill and I must do the same. You can't thrust pictures down people's throats." It is equally true, as the previously mentioned correspondents showed, you can't thrust plays down people's throats. Apart from the downright bad plays, the general choice of plays was sound, and the policy of giving popular fare was not mistaken, for support had to be wooed and won. No one in his senses would expect an audience accustomed to the simplicities of *A Pair of Spectacles*, and *Bulldog Drummond* to switch over to the subtleties of *Hedda Gabler* or *The Adding Machine* in a matter of a few weeks. Anyhow, the policy pursued not only kept the Repertory Theatre open, but increased the size of the audiences, and so laid foundation stones for future development.

Every repertory theatre has wrestled with the self-same problem: How to appeal to the public and at the same time maintain a worthy standard of plays? All repertory theatres, The Abbey Theatre, Dublin (which, incidentally, Mr. St. John Ervine once directed), and the Liverpool Playhouse included, have found the same solution. Their repertoires have been mainly composed of plays with a popular appeal, and occasionally they have produced a masterpiece or made an experiment. But for the money made by the popular plays, they would never have dared to face the almost certain financial loss involved in the production of a masterpiece or an experimental play. Henceforward, that became the policy of the Northampton Repertory Theatre, and the directors strove to observe the precept, with which few will quarrel, that when crook plays or farces were given they must be good of their kind.

From the outset, there had been no dint of suggestions from playgoers of plays they would like to see performed. Some of them were most helpful to the management, others quite impractical. The plays suggested were by no means stereotyped as is shown by a humorous note in the magazine-programme about this time under the heading "Letters to the Editor". It read, "We should like to be able to produce *Ben Hur*, but we regret that the theatre has not grown big enough for it yet. Perhaps it will one day." It is a sobering thought that in wellnigh a thousand productions given in the course of twenty-one years, the Northampton Repertory Players still have not staged this mammoth spectacle! Maybe they are short of an odd chariot or so!

Determined to raise the level of the Repertory Theatre to that of the best repertory theatre in the country, the directors sought a producer of distinction and appointed Herbert M. Prentice, who came from a similar position at the Cambridge Festival Theatre. Mr. Prentice deserted the routine of commerce for the vagaries of the theatre where his heart had been since the days of his youth. He played a leading part in founding the Sheffield Repertory Theatre, where he laboured arduously as producer for seven years. Then, that wealthy young man with a passion for the theatre, Terence Gray, conceived the desire of buying a theatre to run on his own lines, and, hearing glowing accounts of the achievements of

Mr. Prentice at Sheffield, Mr. Gray engaged him as pro-
ducer. The theatre acquired at Cambridge was one of the
finest examples of the Regency period and appropriately
renamed "The Festival". With Mr. Gray, an artist of ideas,
Mr. Prentice as producer, and Harold Ridge, a lighting-expert
in charge of a huge cyclorama and elaborate lighting system,
they formed a well-manned team to launch a repertory theatre.
Having recruited a company of young and capable actors, the
"Festival" opened at the end of 1926 with Aeschylus' *Oresteia.*
Thus began a series of arresting plays ranging from Greek
tragedy through Restoration drama and Victorian melo-
drama on to modern expressionistic work. Mr. Prentice built
up an impressive reputation through these productions which
were notable not only for the acting—always on a high level—
but also for imaginative lighting and striking stage designs.
Much of the designing was the work of Mr. Prentice, who, as a
designer of costumes and settings had exhibited at the Inter-
national Theatre Exhibition in London in 1922 and many
other important exhibitions.

A repertory theatre needs to be conducted with the utmost
vigilance and foresight, and the fate of the Cambridge Festival
Theatre illustrates what happens when these qualities are
lacking. You see, Terence Gray was a brilliant dilettante in
whose productions special emphasis was placed upon the
staging. Invariably, the settings had amazing beauty of colour
and line but were characterized by eccentricity and marred
by quaint conceits. Time and again this stressing of inessentials
tended to obscure the meaning of the play itself. "The meaning
doesn't matter," Gray would say. "A theatre is purely aesthetic
art." But gorgeous trappings do not make a play. After all,
although we have the facilities for elaborate mounting and
subtle lighting to-day, such as were unknown to Shakespeare,
"the play's the thing" still. Not surprisingly the public tired of
Gray's concentration on pictorial qualities of a production to
the detriment of the play itself; doubtless they found the
mechanical delights of the cinema more vital and satisfying,
and in 1933 the Cambridge Festival Theatre was forced to
close its doors.

Every repertory theatre must have its ideals and Mr.
Prentice was an avowed idealist. In a stimulating address to

the Playgoers' Association, he said, "My one religion is beauty, and the theatre should be the home of a drama that has for its mission the cult of the beautiful and the love of beauty. I would have people go to the theatre not only to be amused but to be inspired, to learn, and, above all to derive lasting satisfaction."

In John Drinkwater's *Mary Stuart*, his second production, Mr. Prentice established himself as a producer of real talent. Special interest attached to this finely written historical play by reason of the local associations with the ill-fated Queen. She was imprisoned at Sywell Hall and executed at Fothering-hay Castle. No Queen in English history has stirred the imagination of writers more than Mary Queen of Scots, and Mr. Drinkwater wove the tangled threads of her ill-starred life into a pattern of beauty and dramatic power. Margot Lister invested the Queen with dignity and depth of feeling, and her performance was well matched by Noel Morris's Darnley, and Rupert Harvey's Bothwell. The production came swiftly and smoothly to the stage. The following week saw a sound, workmanlike rendering of Sardou's famous play, *Diplomacy*, the English version of a strong French play of the nineteenth century. Nothing of particular significance was evident as attaching to it. Few people realized at that time that it would stand out as one of signal importance in years to come. It does so, however, because it was the first production for which the settings were designed and painted by Osborne Robinson, a young local artist, who had been appointed scenic designer to the Repertory Company. From the outset, Mr. Robinson threw himself into his arduous work with all the zeal and enthusiasm of youth. No one could then foresee the extent of the debt which the Repertory Theatre would owe him in the future. The work of a scenic artist of a theatre conducted on repertory lines, giving a fresh play each week, is indeed prodigious; but, without complaint, with his enthusiasm undimmed and at considerable personal sacrifice, he has toiled assiduously for the development of that vital department of the Repertory Theatre which is still under his charge. Harmonious collaboration between Herbert Prentice and Osborne Robinson resulted in enormous advances in the decor and mounting of the plays presented by the Company.

The progress in the raising of the standard of the Repertory

Theatre's work did not end there. The quality of the plays also rose with the audiences' growing dramatic taste and the Repertory Theatre started to become, what St. John Ervine calls, "a catholic theatre". After *Mary Stuart*, and *Diplomacy*, for instance, came *Hindle Wakes*, Stanley Houghton's racy comedy of youthful revolt in Lancashire; Cicely Hamilton's *The Old Adam*, wittily propounding that man is a pugnacious animal who will always fight; *The Skin Game*, John Galsworthy's finely poised study of the classes in conflict; and Edward Percy's striking dialect comedy, *If Four Walls Told*. Altogether a well contrasted and worth-while group of plays!

The Old Adam raised Cain in the town all through one little word! A character used a certain sanguinary adjective and Northampton was even more rudely shocked in the year 1928 than London had been when Bernard Shaw used the same word in *Pygmalion* a quarter of a century earlier. Letters of protest appeared in the local newspapers and similar letters were sent to the management. One horrified playgoer wrote, "I attended with my little sister aged nine, and she blushed." As St. John Ervine commented, writing of the incident in *Time and Tide* "We do not know how many West End comedies now showing would be welcomed by Northampton; we do not know what they think of the average revue morals; but we do wonder what kind of upbringing led a little sister aged nine to blush at a Shakespearean word."

A few weeks later the Repertory Players ran into trouble again. They put on Charles McEvoy's *The Likes of Her*, an attempt to depict life in the East End slums, with its mixture of humour and pathos, squalor and courage, cruelty and tenderness. The faithful characterization and Cockney dialogue were life-like and realistically interpreted by Margery Weston as Florrie Small, Noel Morris as Alfred Cope, Clifton James as Jim Sears, and C. T. Doe as Sam Bilson. Vivienne Bennett, an actress of great intelligence fresh from successes at the Cambridge Festival Theatre and the Abbey Theatre, Dublin, gave a vivid piece of acting in the part of Sally Winch. In spite of the efficiency of the production and acting, the public strongly disapproved of this realistic domestic play, apparently because of its slum atmosphere. Northampton audiences have always shown a marked predilection for well-dressed plays dealing

with high society life. A play set in the surroundings of low life starts off with a big handicap.

Outward Bound, that triumphant success in the West End in 1923, was an apposite choice for Holy Week. Sutton Vane's strongly characterized fantasy, set on a ship sailing in that mysterious unknown—the Hereafter—gave the artistry of Herbert Prentice and Osborne Robinson full scope. The setting, a luxury liner with a difference, subtly conceived and lighted, struck the right, uncanny atmosphere. Noel Morris's Scrubby, the barman, Vivienne Bennett's Mrs. Midget, the charwoman and James Hayter's clergyman were stage-worthy cameos. With a convincing performance as Prior, Godfrey Kenton, formerly of the Shakespeare Festival Company and Lena Ashwell Players, made his debut with the Company. A month later, in C. B. Fernald's *The Mask and the Face*, a witty, satirical comedy in which a wife confounds her husband by attending her own funeral, the Company met its demands incredibly well. Vivienne Bennett, Noel Morris, Datsie Alexander, Godfrey Kenton, and James Hayter were seen to much advantage.

So far as both plays and productions were concerned, *She Stoops to Conquer* during Whit-week, was the most elaborate of the season. Oliver Goldsmith's classic comedy of how Marlow and Hastings came to Hardcastle's house mistaking it for an inn, and how Miss Hardcastle stoops to conquer her backward suitor, drew crowded houses. Joan Ingram came back to play Miss Hardcastle, Noel Morris's Marlow, and Godfrey Kenton's Hastings had the right romantic touch. C. T. Doe as Mr. Hardcastle, and Alfred Richards as Sir Charles Marlow deftly represented the old generation. James Hayter was a mischievous and droll Tony Lumpkin. Mr. Justice Acton, His Majesty's Judge at the Northamptonshire Summer Assizes, and Lady Acton attended one performance. Sir Edward Acton, who for some years was President of the Manchester Playgoers' Association, confessed his delight with the Repertory Theatre and the production, saying that he had seldom seen *She Stoops to Conquer* so well acted. A certain fashionable lady once overheard Lord Darling, the famous judge, remark of her, "What a beautiful woman!" and, regarding Mr. Justice Acton, we echo her retort, "What a good judge!"

(*Above*) "A WOMAN OF NO IMPORTANCE" (1929) (*Vernon Ashford*)

(*Below*) "THE QUEEN WAS IN THE PARLOUR" (1929) (*Vernon Ashford*)

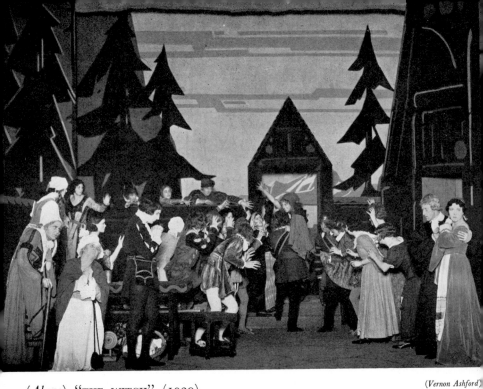

(*Above*) "THE WITCH" (1930)

(*Vernon Ashford*)

(*Below*) "BY CANDLELIGHT" (1931)

(*Vernon Ashford*)

CRISIS

"The man who writes a play gives hostages to fortune.
There is always something can go wrong. The weather
may be too hot or too cold, too wet or too frosty.
There may be a strike, an epidemic, or a financial slump."

IVOR BROWN

IN his delightful and instructive book, *About Conducting*, Sir Henry Wood enumerated the chief requirements of a good professional conductor of an orchestra. He said, "He must have a good physique, a good temper, and a strong sense of discipline." Surely that is equally true of a good professional producer! He guides and controls the moods and tempo of the whole play. Herbert Prentice possessed these vital attributes and the effect of his hand at the helm quickly became apparent. On his advent, the Northampton Repertory Theatre was rather like "a sturdy ragamuffin", as W. B. Yeats described the Abbey Theatre, Dublin, in its early days. But under the direction of Mr. Prentice, it soon began to discard some of its immaturities. Not only did the acting improve but the productions acquired a sense of balance and finish by the use of ingenious lighting and admirably designed settings. But, to effect such improvements, changes in method and personnel had to be made. And once again the Repertory Theatre ran into trouble with the public. That is one instance where "good temper" was essential to a producer.

As is customary with repertory audiences, they held certain actors and actresses in esteem and affection which was clearly seen by the applause that greeted each familiar figure as he or she stepped on to the stage each week. At the mere breath of a suggestion that one of these popular members was leaving, patrons expressed astonishment and grave concern. Complaints were made almost every time there was a change in the personnel of the Company. From time to time, rumours were rife in the town that one or other firm favourite was departing, and a buzz of dissatisfied speculation followed. On most occasions,

the rumours were without foundation. Changes, however, did occur and popular players left. When this happened, folk grumbled and blamed the directors or the producer, or both. An appropriate slogan in such circumstances would have been, "The Management is never right!" Expressions of dissatisfaction flared up on the departure of J. Drew Carran and C. Graham Cameron, the General Manager, and the *Northampton Independent* remarked, "Recent weeks have seen additional changes in the personnel of the Repertory Players, which have given rise to a feeling of uneasiness on the part of a section of playgoers that all is not well 'behind scenes'."

Looking back now, it is easy to see that there was no real ground for concern. Such incidents were merely teething troubles. Players were bound to make exits and entrances from and to the Company as they were from and to the stage. Their departures arose through several causes; some left of their own accord, having obtained a better or an easier engagement. For instance, Arthur Hambling went into the London production of *Marigold*, and Margot Lister joined Matheson Lang's company. Others passed on in the natural order of things, because the directors constantly strove to strengthen the Company. If, instead of indulging in easy criticism or dashing off an indignant letter to the local press, certain patrons had exercised a little patience and awaited developments, they would have seen that the departing artist was more often than not succeeded by an equally good or better actor. Several players, on the other hand, retired through ill-health, including Bluebell Glaid and Ailsa Grahame. This fact evoked no surprise to anyone who knew the intense pressure of work at the Repertory Theatre.

Imagine what the Repertory Players' work entailed, acting this week's play, rehearsing next week's play and learning a part for the week after—all during one week. Starting on a Tuesday, they would rehearse the next week's play from 10.30 a.m. to 2 p.m., with a dress rehearsal of longer duration on the following Monday. Home then for a meal and back at the theatre between 5.30 and 6 p.m. to dress and make up and thereafter act in this week's play twice each night of the week, rarely leaving the theatre before 11.15 p.m. Sometime during those arduous days and nights, learning their parts for the play

to be rehearsed next, and finding time somehow to deal with the perpetual problem of what clothes to wear in that part! It will readily be realized that all that work demanded the maximum of physical and mental endurance. When James Bridie says, "Actors talk and live nothing but theatre. They might be monks in a Trappist monastery for all the world means to them", he is right, but, in twice-nightly repertory, is it surprising?

One of Henry Arthur Jones's greatest successes, *Mrs. Dane's Defence*, proved a wholly satisfying choice. Mrs. Dane and Lionel Carteret, adopted son of a famous judge, are madly in love. When by mischance local gossips ferret out an unsavoury story about her past, the judge insists that before he can consent to Lionel's marriage, Mrs. Dane must clear her name. The scene in which the Judge cross-examines Mrs. Dane to divine the secret she strives to conceal has sustained tension and vivid dramatic interest. Joan Ingram and Godfrey Kenton gave good account of themselves as Mrs. Dane and Lionel respectively, and Mr. Justice Carteret was superbly played by T. G. Saville, a sensitive and intelligent young actor, direct from the Cambridge Festival Theatre where he spoke the opening lines in the initial production of *The Oresteia*, and had played lead after lead for over two years.

That the repertory system permits of no understudies causes those responsible for running a repertory theatre much heart-burning. If sickness attacks an actor, swift and sometimes desperate steps have to be taken. The producer prayerfully murmurs, "The play must go on", and keeps his fingers crossed while he tries to whistle "On with the Motley!" As the third season drew to a close, during the run of Sudermann's highly dramatic *Magda*, Joan Ingram effectively rendered the name-part, but on the Saturday night was unable to appear through injuries sustained in a riding accident. At the shortest notice and without rehearsal, Vivienne Bennett gallantly stepped into the breach and gave a remarkably fine performance. The next week, when C. K. Munro's comedy of a boarding-house, *At Mrs. Beams* was performed, Miss Bennett again deputized for Joan Ingram, and with only a few hours' study played the part without a prompt.

R.U.R., Karel Capek's dramatic criticism of the machine age,

wound up the third season. The irresistible march of Rossum's Universal Robots symbolizing the threat to civilization if mechanization went unchecked, proved to be an original and devastating satire. In this atomic age, we see all too clearly how it is a tragic piece of prophecy, and, incidentally, this play added the word "robot" to our language. Uniformly well acted by the entire company, the outstanding features were Vivienne Bennett's poignant study of Helena, Herbert Prentice's skilful production, and Osborne Robinson's striking sets. This expressionistic play with its Frankenstein theme in a new guise had a mixed reception. Some playgoers found the unusual treatment difficult to assimilate, while others rejoiced in a fresh experience in the theatre. A bold venture and a rewarding experiment!

Believe it or not, we had a real summer in 1928. A hot spell of weather, however, is the bane of a repertory theatre no less than any other theatre. When we enjoy that rarity, a glorious summer, we are prone to indulge in the pastimes of the open air and the pleasures of the open road. Then, although it is 90 degrees in the shade, theatre-managers may be seen shivering with anxiety! Still tender in years, still very much on probation with the public, the Repertory Theatre found this summer a testing-time. To make matters worse, the country was gripped by a trade depression which materially affected the staple trade of the town. Nevertheless, many hundreds of loyal supporters never faltered in their allegiance. One vital advantage was present. The Company remained unchanged. The players had not only become welded into a strong team but had endeared themselves to playgoers, as was evident when, after a well earned vacation, they returned and regaled the town with *In the Next Room*, a thriller, for August Bank Holiday.

The Romantic Young Lady, Martinez-Sierra's charming comedy, reflecting the gaiety and colour of Spain, which followed, was attractively presented with Osborne Robinson again excelling. It introduced a clever young actress, Curigwen Lewis, who, as Rosario, caught the sunny quality of the play with delightful effect. A month later, a new play, *The White Lady*, by Ena Hay Howe, was launched. Although set in Cremona in Italy, and telling of the conflict between a young

prince and his crafty brother, it turned out to be an unconvincing piece with a melodramatic flavour. Noel Morris as the Prince, T. G. Saville, as the brother, and Joan Ingram, as the White Lady, coaxed the characters into life and served the play far better than the playwright had served them in a play suggesting promise rather than fulfilment. The Repertory Players dipped into the French drama the next week and grappled with Jules Romain's *Dr. Knock*, and found the public somewhat frigid towards a satirical comedy of a quack doctor who builds up a practice by sheer audacity.

Eugene O'Neill's *Anna Christie* became the most discussed play of the season. With his simple and direct method and his unerring instinct for dramatic dialogue and situation, O'Neill is strong meat. Many found the brutal realism of his tale of the stubborn faith of an old Swedish captain of a coal barge in his daughter, Anna, who, unknown to him, has drunk of life's dregs in a house of ill-fame, unpalatable. But some playgoers hailed the astringent vigour of O'Neill's thesis that human beings are mere puppets in the hands of an over-ruling destiny. C. T. Doe brought power and integrity of feeling to the part of the father, and Elma Carswell strove hard to portray the wayward, passionate Anna. Mr. Robinson's settings provided the authentic atmosphere of "the lonely sea, the flung spray, and the blown spume, and the sea-gulls crying", and Mr. Prentice's vigorous production ensured that the emotional sweep of the play never wavered.

The Christmas season brought *Alice* as an honoured guest to Northampton for a fortnight. All on a summer's day in 1862, a young Oxford don, the Rev. C. L. Dodgson, sat under the shade of a hayrick in a cool, green meadow, and began to tell a story to three little girls grouped around him. During the long afternoon, the eyes of the children shone with laughter and excitement as they listened enthralled to *Alice's Adventures Underground*. As he wove that web of delicious nonsense, Dodgson little thought that later, when he published the story under the pen-name of Lewis Carroll, his small audience of three would grow to millions in the years to come. Herbert M. Prentice dramatized *Alice in Wonderland* and *Alice Through the Looking Glass* in a skilful and eminently faithful adaptation. Not a line of these nursery classics was tampered with and the

spirit of Lewis Carroll animated the play throughout. Children of seven to seventy revelled in Alice's quaint and humorous escapades, which, from the moment she went down the rabbit hole, grew "curiouser and curiouser", concluding with her encounter with the Red and White Queens.

Curigwen Lewis, as Alice, scored a personal triumph. She might, for all the world, have stepped out of the pages of Lewis Carroll or out of one of Sir John Tenniel's drawings. Indeed, she *was* Alice. In voice, manner, and appearance, she lived up to the demands of hundreds of youthful experts. James Hayter's sprightly White Rabbit, Noel Morris's dignified King of Hearts, C. T. Doe's rotund Cook, and T. G. Saville's three well contrasted performances as the Mock Turtle, the Walrus, and Humpty-Dumpty, were all delightful and faithful studies. Tenniel's famous illustrations came to life in a production as lavish as a pantomime, for which full credit must be given to the artistry and unflagging enthusiasm of the adaptor-producer and Osborne Robinson, both of whom toiled for weeks from frosty morn to foggy eve. The author of *Alice in Wonderland* once sent a copy of the book to Queen Victoria's youngest daughter and Her Majesty was so delighted with it that she ordered all the author's other works. Imagine her surprise when a large parcel arrived containing a set of learned treatises including *The Algebraic Formulae for Responsions* and *The Condensation of Determinants*, for Lewis Carroll was mathematical lecturer of Christ Church College, Oxford!

The Northampton Repertory Theatre concluded its second year with its vitality undiminished and *Ambrose Applejohn's Adventure*, the second birthday play, was an auspicious start to what proved an inauspicious year. In Walter Hackett's rollicking comedy concerning a bachelor's dream of his stirring adventures aboard a pirate's ship, T. G. Saville and Curigwen Lewis extracted the maximum amount of fun from the parts of Ambrose and Poppy Faire respectively. The ensuing three months saw a spell of fine work but with a distinct falling off in support.

Tons of Money found Noel Morris in his element in this screamingly funny Aldwych farce. *The Ship*, in which St. John Ervine exchanged the role of critic for that of playwright, was a powerful play, deftly constructed and possessing several

touches of real beauty. It provided excellent opportunities for forthright acting which were firmly seized by C. T. Doe, Noel Morris, T. G. Saville, and, especially, Marion Prentice, the producer's wife, who combined sympathy and strength as the dear old grandmother.

In *The Era* about this time was an article which referred to the Repertory Theatre in the following terms: "The footwear capital, with an incomparably smaller population than that of Birmingham, Manchester, Bristol, Liverpool, Hull and other big centres which maintain a Little Theatre, has proved already that what it lacks in size, it makes up in public spirit, and a vigorous dramatic movement has sprung up in and about the transformed Opera House."

Perdita Comes to Town aroused considerable interest because it was T. G. Saville's play in every respect. He was the author and the producer and played the leading role. Clever, subtle, and original, this farce had been inspired by those tricks of the mind that we have all experienced when we feel that something which is about to happen has occurred before. Perdita (Curigwen Lewis) worked as a typist in the office of a wealthy manufacturer, Daniel Otway (C. T. Doe), but owing to constant companionship with a maiden aunt, Perdita was years behind the times and even dressed in a Victorian riding habit. Through their acquaintance at the office, her employer's son, David (T. G. Saville) absorbed her antique peculiarities, and she absorbed his advanced characteristics. A startling change over in fashions resulted, he acquired a masculine style of an earlier age, whilst she became transformed into a modern young woman. Conjuring with a novel idea, Mr. Saville produced a richly farcical rabbit from an intellectual top-hat, which raised unbridled mirth. Galsworthy's dramatic comment on life and justice, *The Silver Box*, and Lonsdale's suave and amusing comedy, *On Approval*, were splendidly acted and produced, but poorly attended.

In a repertory theatre, the margin between financial success and failure can be surprisingly small so that two or three unsuccessful productions may mean a loss of several hundred pounds. Due in a measure to the severe winter weather, illness, and bad trade, the size of the audiences at the Repertory Theatre declined from the middle of January. By the month

of March 1929, therefore, the directors were faced with a crisis. On the 25th of that month, the important announcement was made that, after occupying the stage for twenty-seven months, the directors were reluctantly compelled, through lack of public support, to close down. This announcement was published during Holy Week, and the Repertory Players were presenting John Masefield's *Good Friday*. Attendances during that week touched the lowest ebb. When the writer witnessed one performance, there were twenty-one other people in the Stalls!

Ranking among the greatest religious plays in our language, *Good Friday* depicts, with simplicity, vividness, and poignancy, the trial and crucifixion of Christ. The Poet Laureate garnishes the dramatic events preceding the first Easter with beauty of thought and language. He illumines the incidents recorded in the Gospel with the flash of poetry, and the last lines reveal the quest of his poet's soul:

> "Wisdom that lives in the pure skies,
> The untouched star, the spirit's eyes,
> O Beauty, touch me, make me wise."

To the great credit of Mr. Prentice, *Good Friday* received the delicate treatment a play of such texture demanded and to the great credit of the Company, it was sincerely and reverently performed by T. G. Saville as Pilate, Noel Morris as Longinus, Alfred Richards as Herod, and C. T. Doe as the Chief Citizen, and a particularly moving study of the Blind Madman was given by James Hayter.

Fortune in the theatre is capricious and ironical. Lennox Robinson so truly says, "Theatres are tricky, uncertain things, and will suddenly bite you when you least expect." How regrettable it seemed that after such a successful start and when the Repertory Theatre was bidding fair to become one of the finest in the country, disaster nearly overtook it! However, a bold and courageous move was made by the directors. They decided to close the theatre only temporarily and not to disband the Company. Their courage drew an immediate response. At great personal sacrifice, Mr. Prentice agreed to remain and also act as manager until the time was ripe for the Repertory Players to return.

The *Daily Telegraph* published a letter about the Repertory Theatre on 28 March 1929, which stated:

"There are not so many good repertory theatres in England that we can afford to lose the least of them, and the Northampton Repertory Theatre is by no means the least important. It is unpleasing to hear that in a fortnight the theatre will be given over to touring companies. I was in Northampton last week and heard the news. In the case of Birmingham, when Sir Barry Jackson decided that he was tired of losing money and closed his theatre, there was a strong move to guarantee him an audience if he relented; and the more public-spirited citizens of Northampton will, I believe, set going a similar agitation in favour of their theatre. Last Saturday, two crowded houses rocked with laughter over Mr. Londsdale's *On Approval*. On Sunday I saw the dress rehearsal of Masefield's *Good Friday*, and found it well acted and extremely well staged. And for the last week, they are doing *Sweeney Todd*. Here is variety enough to please every taste. Surely Northampton would prefer that such good entertainment should be continued?"

With that note of interrogation pressing upon the minds of all true playgoers, the curtain fell upon the first phase of this adventure.

INTERLUDE AT BATH

"All the loveliness of Bath, set in her crescent of hills."

CECIL ROBERTS

W<small>HEN</small> the clouds gathered and the Northampton Repertory
Theatre had to close, the directors displayed no panic. In
their wisdom, cherishing the hope that the break would be a
temporary one, they did not disband the Company. When,
therefore, Sir Arthur Carlton, the proprietor of the Theatre
Royal, Bath, invited them to run a repertory season there, they
were in a position to accept. Indeed, the project was welcome,
if only to keep the players employed. Thus, at the end of
April 1929, Herbert Prentice, Osborne Robinson, and a full
company "went west" in a geographical sense only, of course!
The planning and preparations involved an immense amount
of work. Choice of plays, scripts, scenery, properties, packing,
transport . . . all these and more, demanded attention. Every-
thing was ready, at last, and the Repertory Players set out on
their journey to the famous Spa. Bath, with its Pump Rooms
and retired gentlefolk and invalids taking the cure! Bath,
with its history written in stone, its Roman baths, its magni-
ficent Georgian houses and it shades of Beau Nash in an elegant
age of brocade and sedan chairs! Bath—the home of Bath
buns, Bath chairs, Bath chaps and Bath Olivers! Or, in the
picturesque description of H. V. Morton, "Bath is the dear
old Lady of Somerset: grey-haired, mittened, smelling faintly
of lavender: one of those old ladies who have outlived a much
discussed past and are now as obviously respectable as only
old ladies with crowded pasts can be."

Work in repertory is so all-engrossing that one town is much
the same as another to a player, or, for that matter, to a pro-
ducer or scenic artist. After all, the inside of one theatre is
not very different from that of another, and, with rehearsals
and performances, most of their working-hours are spent there.
Nevertheless, members of the Company soon became aware that
Bath was historic, beautiful, and relaxing. The ghosts of the

great actors and actresses of the past moved across the stage and through the corridors and dressing-rooms of that charming old theatre, the Theatre Royal. On that very stage, Mrs. Siddons made her swift and sudden rise to fame, and, graduating to Drury Lane as the leading lady of David Garrick, reigned for thirty years as the unrivalled Tragedy Queen of the British stage.

Carrying out an excellent and ambitious scheme devised by Dennis Eadie, Bath had, only a few years before, launched its own repertory theatre, but through lack of sufficient support, it had gone the way of many such enterprises in towns and cities with larger populations than Bath's 68,000. The visit of the Northampton Repertory Players was, therefore, all the more welcome. Their season, which opened on 6 May 1929, was a memorable occasion. The Mayor of Bath and the Corporation, making one of their rare appearances at the theatre, honoured the Company by attending. With a crowded audience, they witnessed Barrie's sparkling comedy, *Alice-Sit-By-the-Fire*, which was enthusiastically received. Molly Francis brought charm and artlessness to the part of Alice, originally written for and played by Ellen Terry, and Curigwen Lewis gave an appealing performance as her daughter, Amy, who seeks to save her misguided mother from an entanglement with a rather pleasant scoundrel.

In a brief speech at the close of the performance, Mr. Prentice thanked Sir Arthur Carlton for giving the Company the privilege of appearing on a stage with such traditions, the Mayor and Corporation for giving the repertory season such a fine send-off, and the audience for the warmth and encouragement of their reception. The Mayor (Councillor Aubrey Bateman, J.P.) responded. "We have spent a really wonderful evening," he remarked, "and another link has been added to the long chain of memories in this historic theatre and city. The management have reverted to the practice which obtained in the days of Mrs. Siddons, who first achieved success in the Bath Theatre. Those were days when the stock companies acted in a succession of plays. I gladly welcome the new development in theatre in our city. The repertory movement is gaining strength all over the country. In the larger towns, such as Bristol, Birmingham, Liverpool, and Sheffield, and the

university cities of Oxford and Cambridge, there are now established repertory theatres which do nothing but present the higher forms of drama. . . . The present Company, after more than two years without a break at the Repertory Theatre, Northampton, have come here lock, stock, and barrel, to give some of the most interesting plays by the greatest dramatic authors. The ordinary companies visiting places of amusement in the city are capable of looking after themselves, but I regard the repertory movement as of outstanding importance, because it produces plays of real educational value, and gives the recreation that the strenuous and perplexing times in which we live demand." Rising from his seat in the dress circle, Mr. F. E. Weatherly, K.C., the well-known Counsel and song-writer, renowned for "Friend O' Mine," "Parted," and a score of other popular ballads added his tribute to the Company in the course of a witty speech.

During the ensuing weeks, the Repertory Players presented a varied selection of worth while plays including *The Lie*, *The Builder of Bridges*, *The Fake*, *Her Temporary Husband*, *If Four Walls Told*, *The Mask and the Face*, and *On Approval*. They all attracted large audiences, who were not slow to show their genuine appreciation of the capable production of Mr. Prentice, the delightful settings of Mr. Robinson, and the fine acting of the Players. Curigwen Lewis and James Hayter speedily became firm favourites with the patrons of the Theatre Royal and received highly appreciative notices. Of Miss Lewis, a local dramatic critic wrote, "In *The Lie*, she enhances the reputation she has quickly made in Bath as a clever little actress," and the following week: "Curigwen Lewis is a charming little heroine, fresh as an April breeze!"

The conclusion of the season was marked by the production of Sidney Howard's *The Silver Cord*, that tautly constructed play depicting an abnormally selfish and almost ruthless mother, who schemes and fights to keep the love of her two sons for herself alone. The *Bath and Wilts Chronicle and Herald* observed: "The Northampton Repertory Company produced their final and crowning success before a very large and enthusiastic audience. It deserves far higher praise than all the others. Such exquisite acting has not been known in Bath for years, and it far surpassed the acting of the average London

Play. Mr. Prentice is to be warmly congratulated on a truly great performance, which, it is hoped, will be the stepping-stone from which the theatre in Bath will rise once more to the heights of fame it once enjoyed." After praising the performances of Marion Prentice as Mrs. Phelps, and Curigwen Lewis, Molly Francis, James Hayter, and Maurice Farquharson, the notice concluded, "It was a tremendous success. The applause at the final fall of the curtain was whole-hearted and prolonged. It will be with great reluctance that we shall allow these actors to depart for other realms of success."

And to think that St. John Ervine once wrote, "There is a pathetic belief that Bath, for example, is a city where good plays ought to be easily and frequently seen, because it is largely inhabited by well-educated people, yet I do not know of any city which supports good plays so poorly as Bath." The experience of the Repertory Players there only goes to show that, as has been hinted before, dramatic critics, unlike the pre-war customer, are not always right!

WELCOME HOME

"Perseverance, dear my lord,
Keeps honour bright: to have done is to hang
Quite out of fashion, like a rusty nail,
In monumental mockery."

SHAKESPEARE

No sooner had the Northampton Repertory Players ceased to perform in the town than there was an outcry for drama. As the weeks went by, the protests grew louder and louder. Widespread regret was expressed that the town had been so neglectful of the fine work of the Company and had allowed it to depart elsewhere. You see, absence makes the playgoers ponder. They bitterly complained of suffering from dramatic starvation. Would the directors give them another chance? Would they bring the Company back from Bath and try again? Questions such as these were asked persistently. So numerous were the lamentations and pleas that it was clear Northampton had awakened to the fact of what it had lost. It realized the Repertory Theatre was not only a microcosm of the English drama but gave the town theatrical individuality. When it was evident that the town had learnt its lesson, the Company returned, after an absence of nearly four months. One of those who did his utmost to assist the Company was the Chairman, Sir James Crockett. In view of the prominent part he played in the inauguration of the Company, and, subsequently, his useful work for the Repertory Theatre, general regret was felt when Sir James was compelled to resign in June 1931, owing to ill health. He was succeeded as Chairman of the Board by Mr. W. H. Horton.

Starting on 5 August 1929, they played *The Green Goddess* to a packed theatre and to an audience obviously determined that the Repertory movement in Northampton should not fail. At that first performance, the feeling of eager anticipation and the exuberance of the audience were reminders of another first performance over two-and-a-half years before, when the

adventure had begun. Now, a new chapter was opening, a new chapter of the same story, the same adventure. When the curtain rose, a hum of excitement greeted the colourful melodrama set in the Far East and telling how the aeroplane carrying Dr. Treherne, Major Crespin and his wife, Lucilla, crashes in Rukli, the land of the Green Goddess, at a time when the Rajah of Rukli seeks revenge upon the English. Written by William Archer, the distinguished dramatic critic and translator of Ibsen's plays, *The Green Goddess* provided a spectacular part on stage and screen for George Arliss, who, incidentally, began his stage career in 1887 at the Elephant and Castle Theatre. The series of swiftly moving scenes were slickly directed by Herbert Prentice. Godfrey Kenton gave a subtle and forceful study of the Rajah, and three newcomers, Olive Milbourne, Noel Howlett, and Bertram Heyhoe lent strong support as Lucilla, Crespin, and Treherne respectively.

Monckton Hoffe's sentimental play, *The Faithful Heart*, the next production, saw the return of those three talented and popular players, Vivienne Bennett, Curigwen Lewis, and T. G. Saville. It proved one of the most appealing plays of the season with Mr. Saville, as a soldier-sailor, and Miss Lewis as his "tuppenny ha'penny" little daughter, interpreting their parts with understanding and charm.

In the language of the cricket field, the directors sought to allow the Repertory Players to "play themselves in". The utmost care and vigilance was applied to the selection of plays, popular successes being given preference and anything of an experimental nature being excluded at this juncture. Inevitably, therefore, the accent was on comedy. One of the biggest successes of the season was that rollicking, boisterous farce, *Lord Richard in the Pantry*, which showed T. G. Saville playing Cyril Maude's part of Lord Richard with a sureness of touch and a wealth of comic invention reminiscent of that polished actor, Sir Charles Hawtrey. *A Woman of No Importance* yielded Osborne Robinson a fine opportunity to display his prowess. He seized it with both hands and caught the right period with striking and ornate sets. Oscar Wilde's scintillating and epigrammatic comedy that shocked the "Naughty Nineties" revealed Godfrey Kenton as Gerald Arbuthnot, Olive Milbourne as Mrs. Arbuthnot, T. G. Saville as Lord Illingworth,

Vivienne Bennett as Mrs. Allonby, Noel Howlett as Sir John Pontefract, and Curigwen Lewis as Hester Worthing in buoyant mood. Much conviviality was provided by Frederick Lonsdale's two comedies, *The High Road*, and *Aren't We All?*, both of which were admirably acted.

In September, Mr. Saville left the Company to play the part of Captain Stanhope in *Journey's End*, in the Paris production of R. C. Sherriff's impressive play of the 1914–18 Great War at the English Theatre, Rue du Rocher, where it ran for over 200 performances. It came as no surprise to Mr. Saville's admirers in Northampton that his performance received the highest praise from the critics and audience alike.

Not all the plays hit the target. A few were frankly disappointing. The chief of these was undoubtedly Harold Chapin's *The New Morality*. However excellent it might be as a literary trifle, as an evening's entertainment for Northampton folk it was almost a fiasco, and Olive Milbourne and Noel Howlett worked hard with little reward. *Mixed Doubles* made an earnest attempt to be amusing but got lost in a maze of complications. *Mr. Wu* stood exposed as a poor, novelette type of play-writing, although handsome mounting, combined with two fine performances by Olive Milbourne and Godfrey Kenton went far to redeem the production.

The most notable all-round production was *The Queen Was in the Parlour*, the first play by the precocious, versatile, twenty-nine-year-old Noel Coward to be performed by the Repertory Players. "I want to be ordinary and happy," cries Nadya, but since she is a Noel Coward heroine, the poor girl has no chance of being either. She is, after all, a Princess of the Kingdom of Krayia, a close neighbour of Anthony Hope's Ruritania. She marries Sabien, a handsome commoner, and, on their wedding day they learn Nadya has become Queen of her Kingdom and must return to her royal duty. Declining to develop a satire on the rigours of kingship or a vindication of the divine right of lovers, Mr. Coward mixes the ritual of Ruritania with the morals of Mayfair and produces a bitter-sweet conversation-piece in the modern idiom. Vivienne Bennett brought poise and sophistication to the part of Nadya, and Godfrey Kenton expertly portrayed the mercurial Sabien. They both gave polished performances of a high order. A special revival of

(*Above*) "THE IMPORTANCE OF BEING EARNEST" (1931)

(*Below*) "THE OUTSIDER" (1931)

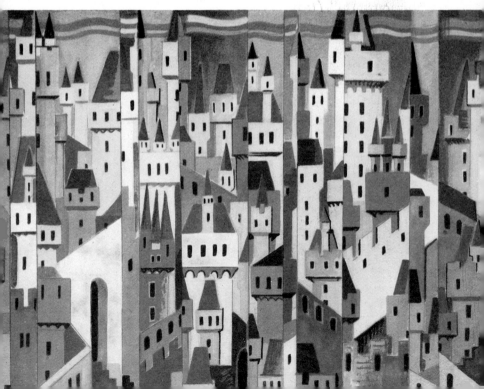

(*Above*) "MARY, MARY, QUITE CONTRARY" (1931)

(*E. C. Tippleston*)

(*Below*) "TWELFTH NIGHT" (1933)
"A City in Illyria"

(*From a drawing by Osborne Robinson*)

this production was given on 25 October 1929, on the occasion of the Annual Conference of the British Drama League being held in Northampton.

The delegates, who came from all parts of the country and included the Rt. Hon. Earl of Lytton, K.G., Prof. Gilbert Murray, O.M., and Mr. Geoffrey Whitworth, were unanimous in their praise of the acting, the astute production of Herbert Prentice, and the beautiful settings of Osborne Robinson, who once again excelled himself. Indeed, this performance was a triumph for all concerned and served to demonstrate to the visitors the high standard of work accomplished by this youthful Repertory Theatre.

A slick and well staged revival of that exciting hardy annual, *Raffles*, filled the theatre for the Christmas season. In the appropriate mood of the festive season, the adults forgot their years, and, joining in spirit with the young folk, enjoyed the improbable escapades of that audacious but lovable cricketer-cracksman, A. J. Raffles, played with verve and nonchalance by Godfrey Kenton. James Hayter made an engaging job of his friend, the loyal Bunny, and Elizabeth Arnold and Betty Nelson provided the necessary feminine appeal. With this production, the Repertory Players closed a season in which all the ground lost during the first months of the year had been regained. Now once again, receiving liberal and keen support, the Repertory Theatre was firmly established in public favour and enabled to face the New Year with confidence.

On the third anniversary night, a packed house, including the Mayor and Mayoress of Northampton and the Corporation, witnessed *The Prisoner of Zenda*, Anthony Hope's Ruritanian romance with obvious enjoyment. Noel Howlett distinguished himself in the dual roles of Rudolf the Fifth, King of Ruritania, and his English cousin, Lord Rudolf Rassendyll, and Betty Nelson made a decorative Princess Flavia. Osborne Robinson contrived four colourful and suitably elaborate settings. Anything can happen in a repertory theatre, not excluding riots, fire, flood, and black-out. A fortnight later, during one of the performances of *Betty at Bay*, for which Curigwen Lewis specially returned to play the lead, the theatre was suddenly plunged into darkness. Players were stranded in dressing

rooms and corridors. Stagehands groped in the wings. Actors
and audience were blotted out from each other. Directors
stumbled from the blackness of the office into the equal black-
ness of the theatre to find Douglas Allen, the assistant stage
manager, struggling to arrange some form of improvised
lighting. Inquiry elicited from the Northampton Electric
Light and Power Company that one of the street-mains had
fused. The audience, who took the incident in good humour,
waited patiently until, eventually, with the aid of candles and
gas, the play proceeded. What a pity the play was not *By
Candlelight*!

Few plays better illustrate how the slenderest plot can be
woven into a diverting play by brilliant craftsmanship than
Noel Coward's *Hay Fever*. This witty and satirical comedy
about the retired actress, Judith Bliss and her Bohemian
family, who flirt, fight, fall in love, and quarrel with each other's
guests in a week-end house-party, was as always, deliciously
amusing. As Judith Bliss, acted by Dame Marie Tempest
in the original production of 1927, Olive Milbourne was
superb and Bertram Heyhoe as David, her author-husband,
Vivienne Bennett as Sorel, her daughter, and Godfrey Kenton
as Simon, her son, made full contributions to the delirium.
Time and again, Noel Coward's plays were condemned as
degenerate—or worse, but one critic declared that *Hay Fever*
is a comedy to which not even a non-smoking, prohibitionist
Rural District Councillor could take exception! Far from
complaining, playgoers accorded the play an enthusiastic
reception and quite a number of them visited it as many as
three times. Indeed, numerous requests were received for
more of the author's plays. The production of *Hay Fever* was
the beginning of the Coward vogue in Northampton, as was
proved by the productions of *Easy Virtue* and *The Marquise*,
during the same season.

Another leading British dramatist who sprang into favour
with Repertory audiences at this time was Sir James Barrie.
So far the directors had fought shy of his plays, conscious that
a section of the public disapproved of plays of sentiment and
fantasy. Since, however, in all the other repertory theatres
in the country, Barrie's plays were the management's trump
card, the Repertory Players took the plunge with *Mary Rose*,

and playgoers fittingly responded to its imaginative quality. Beautifully staged by Osborne Robinson, the production captured the poignant beauty and wistful charm of the sweetly sad ghost story of Mary Rose, and The Island-That-Likes-To-Be-Visited. In the title role, Vivienne Bennett gave an exquisite performance and Godfrey Kenton's Simon, Noel Howlett's Cameron, Bertram Heyhoe's Mr. Morland, Olive Milbourne's Mrs. Morland, and James Hayter's Rev. George Amy were all excellent character studies. It was a memorable and enchanting production. *Dear Brutus* proved a stiffer task two months later. The adventures of the oddly assorted guests of that mysterious little gentleman, Mr. Lob, in the Magic Wood where they each get that longed for "second chance", revealed Barrie's superb craftsmanship. James Hayter, a truly Puck-ish Lob, gave an altogether delightful performance, and Vivienne Bennett's Margaret, Dearth's dream-daughter, was a delicate study.

Much surprise was caused in February 1930, by an announcement that the Northampton Playgoers' Association had decided to cease its activities. Many of its members had given assistance to the Repertory movement in its early days, both in raising some of the capital when the Northampton Repertory Players Limited was formed and in stimulating interest in the productions and work of the theatre. Since the majority of the towns and cities that boast a flourishing repertory theatre also possess an active and keen Playgoers' Association, the winding up of the Association in Northampton was deeply regretted.

First as a pioneer and subsequently as one of the original directors, Alderman W. J. Bassett-Lowke proved a vigorous champion of the repertory movement, his boundless energy combined with his wide knowledge of the British and Continental theatre, gained through extensive travel, made his contribution to the Repertory Theatre of unusual value. Time and again, he introduced fresh ideas and notabilities. In April, 1930, Bernard Shaw visited Mr. and Mrs. Bassett-Lowke. At that time, consent to produce Mr. Shaw's plays was not easily obtained. In characteristic fashion, Mr. Bassett-Lowke seized the opportunity and got permission for the Northampton Repertory Players to perform *Fanny's First Play*. Given on the occasion of Northampton's Festival Week, this production was

preceded by the Hubert and Arthur scene from Shakespeare's *King John*, fittingly set in Northampton Castle, and faithfully played by Godfrey Kenton as Hubert, and Vivienne Bennett as Arthur. Taking the hallowed respectability of the middle classes as an Aunt Sally for his merciless irony and flashing wit, Shaw strikes this typical English convention a shattering blow in *Fanny's First Play*. William Aldous and Olive Milbourne as Mr. and Mrs. Knox, and Bertram Heyhoe and Diana Carroll as Mr. and Mrs. Gilbey, the two families of highly respectable shopkeepers concerned, gave entirely satisfying performances.

Among the numerous comedies which won particular approval during the year were Lonsdale's *Spring Cleaning*, with its denunciation of the ultra-modern and supposedly smart set, Somerset Maugham's high comedy, *The Circle*, showing that even matrimonial history may repeat itself and the Quintero's amiable portrait of a centenarian, *A Hundred Years Old*. Incidentally, during the run of the last-mentioned play, Sir Barry Jackson attended one of the performances and afterwards praised the performance and interpretation of this Spanish comedy, which he preferred to the West End production. A revival of Sheridan's perennial classic, *The School for Scandal* was the Christmas offering and during a fortnight's run broke all records. But specially cordial praise was accorded the presentation of J. B. Fagan's *And So To Bed*. The persuasive charm, humour, and vivacity of this tale of the amorous Samuel Pepys, the famous diarist, and his embarrassing encounter with his sardonic monarch, Charles II, were irresistible. In the hands of James Hayter, Pepys was the most delightful and susceptible of men. Noel Howlett brought Charles II to life, and Vivienne Bennett, looking devastatingly attractive, dealt playfully with Mistress Knight. Max Adrian, Bertram Heyhoe, Olive Milbourne, and Michael Barry proved thoroughly competent supporting players. The production was such a dramatic and artistic success that, in response to public demand, the normal run of one week had to be extended for a second week, making twenty-four performances in all.

The Witch, John Masefield's adaptation from the Norwegian of Weirs-Jenssen will be remembered as one of Herbert Prentice's best productions. The play depicted the fanatical

Lutherans in their hunting down and burning of witches against the background of the moving and vividly dramatic story of Anna Pedersdotter, a young girl married to an old priest whose son conceives a passion for her. A strong and sinister portrayal was given by Marion Prentice as the Witch, which was undoubtedly her most effective piece of acting with the Company. As Anna's husband, Bertram Heyhoe made an earnest priest. Vivienne Bennett, as Anna, and Godfrey Kenton as Martin, the priest's son, played with a fine dramatic sense and a poignancy to wring the heart. Mr. Prentice's staging was excellent, particularly his handling of the crowd scenes. He caught all the excitement and pathos of the play, stressed the action and, with the aid of Osborne Robinson's atmospheric settings, created some fine visual patterns. Artistically and dramatically, the production was a triumph.

CHAPTER VIII

THE FICKLE WIND

*"The gods are just, and of our pleasant vices
Make instruments to plague us."*

SHAKESPEARE

THE experiences of the Northampton Repertory Players in
the production of one hundred and seventy-seven plays during
the first four years had been a great adventure fraught with
surprises and uncertainty. They had appeared in plays of
amazing diversity with parts requiring startling versatility
from the individual players. There had been words of welcome
and cries of "Farewell". There had been moments of heart-
break and occasions of triumph. There had been an enormous
amount of hard work, much speedy endeavour and improvisa-
tion, and a great deal of development. It had been adventure
—adventure all the way.

Tokens of the Repertory Theatre's success were to be found
in the numerous tributes paid to its work by both playgoers
and the Press. It was indeed more favoured than most repertory
theatres in the recognition received from the national Press. On
25 November 1930, the *Daily Mail* devoted a full column to the
Repertory Theatre's history and achievements, which con-
cluded, "A remarkable feature of the success of the Northamp-
ton Repertory Company is that they have no slack season.
The members play all the year round and they have stimulated
the theatre-going habit to such an extent that they have now
many patrons and parties of friends who occupy the same seats
regularly every week all the year round. They have thus made
their theatre not only a place of popular entertainment but a
recognized rendezvous for social reunions of visitors from over
a wide area." From time to time, complimentary references
to the work of the Repertory Theatre have been published in
The Times, the *Manchester Guardian*, *Vogue*, and *Drama*, among
many other newspapers and periodicals.

The original lease of the former Opera House was for a term
of four years, and early in January 1931, that lease was

renewed for a further five years. "This does not, of course, necessarily mean," remarked the editor of the magazine programme, "that the Repertory Company will continue for five more years, but it does mean that so long as there is a public for repertory that demand will be satisfied. The past year has given the directors good grounds for believing that the movement has firmly established itself in Northampton, and that the theatre-going public is increasing. . . . The difficulties under which a repertory company works have become appreciated. The public understands that no play can please everyone; they know that many plays we should all like to see cannot be given because they demand a large cast, and others because they cannot be played twice nightly. . . . The Company starts on the five years' lease with good hope."

They Knew What They Wanted, that richly humorous American comedy by Sidney Howard, was the first of the fifth year. Set in the lovely vine-clad valleys of California, it is the story of Tony, an Italian wine-grower, whom Prohibition had made rich, and his search for a beautiful and plump wife. One day, in 'Frisco, he sees Amy, a waitress, and knows she is his ideal. He gets his friend to write her a letter proposing marriage. When, eventually, Amy arrives, she is shocked to find Tony, a quaint old man of sixty. As Father McKee, the priest, remarks, "Maybe it won't turn out so bad, after all. There's always this about life: no man don't never get everything he sets out to get, but half the time he don't never find out he ain't got it." In the part of Amy, created by Tallulah Bankhead, Vivienne Bennett gave a finely etched character-study and Bertram Heyhoe's Tony was a human and lovable figure, whilst the whole Company acquitted themselves creditably aided by the colourful settings of Osborne Robinson.

Northampton was the first repertory theatre to be permitted to present *By Candlelight*, London's longest run of 1929, so superbly acted by Yvonne Arnaud, Ronald Squire, and the late Leslie Faber. This sparkling, witty comedy coaxes the familiar theme of the valet who impersonates his master into new and glowing life, and is brimful of gay inconsequences. The staging easily surpassed the West End production, for whereas in London the heavy curtains and furniture had an air of Victorian stuffiness, the Repertory Theatre presented a

room with doors emblazoned with Austrian eagles and with pillars, a handsome chandelier, modern gilt furniture, and decorated walls, truly suggestive of a once ducal palace. Needless to say, the decor bore the authentic stamp of Osborne Robinson's artistry. The acting had the same high quality. Noel Howlett's Bastien, the valet turned baron, was a deft and polished performance and Michael Barry was the embodiment of suavity as the baron who posed as his own valet. Vivienne Bennett made a captivating Elizabeth, the maid masquerading as a countess. The production aroused so much interest and it was so strongly supported that the run was extended to a second week.

In March, *Three Blind Mice*, a new play by R. J. McGregor and Ralph Hutton, served up the situation of a Somerset farmer who marries a French actress, but, as the treatment was far from original, the play never stepped out of the rut of commonplace farcical comedy. Three memorable productions followed: Shaw's brilliant comedy, *Candida*, particularly notable for Olive Milbourne's piquant portrayal of the title-role, and Max Adrian's temperamental and passionate Marchbanks; *Rope*, Patrick Hamilton's sinister thriller of the "perfect crime", with Noel Howlett, Michael Barry and Max Adrian giving forceful performances; and *The Importance of Being Earnest*, Wilde's classic farce which scintillated in the hands of Noel Howlett (John Worthing), Max Adrian (Algy), Vivienne Bennett (Gwendoline), Curigwen Lewis (Cecily), and Olive Milbourne (Lady Bracknell).

The finest flowering of the British drama in this century has occurred in the Irish School of playwrights in which J. M. Synge holds the supreme place by his genius to create beauty in dramatic form. His plays blended poetry and realism, and he put into the mouths of his Irish peasantry some of the most beautifully phrased, rhythmical dialogue heard on the stage. Who will forget the lilting music of *The Playboy of the Western World*, the first play representing this school performed by the Repertory Players? "One is charmed by the inevitableness of the words," wrote George Moore, "and the ease with which phrase is linked to phrase. Mr. Synge has discovered a great literature in barbarous idiom as gold is discovered in quartz, and to do such a thing is a great literary achievement." When

Synge's masterpiece, that joyous comedy, was first produced at the Abbey Theatre in 1907, it caused a riot at each performance, and night after night indignant Dubliners threatened to burn down the theatre. No dissentient voices were heard at Northampton when audiences were exposed to the delightfully absurd tale of Christy Mahon, a callow youth, who is believed to have killed his father and is magnified into a hero by the Irish villagers. The production, in which Max Adrian conveyed the true spirit of comedy in a superb performance as the grandiloquent Christy, and Vivienne Bennett played Pegeen with an unerring touch, was vigorous, boisterous, and amusing.

The last five plays of the season were all new tunes played on the old triangle, variations in a minor key on the theme, A is married to B, but loves C. *The First Mrs. Fraser*, *The Constant Wife*, *Meet the Wife*, *The Unfair Sex*, and *Love at Second Sight*; their titles alone indicate how closely they were concerned with love-entanglements and that "sauce piquante" to the dish of life—Woman. Take the eternal triangle theme, if you will, set it in a bygone leisured age, people it with lords and lackeys, dress them in elegant Georgian costumes, flavour it with wit and recount it in lovely, haunting language and what a transformation you have! This has no relation whatever to stuff like *The Unfair Sex*, and *Meet the Wife*. "It just cannot be the same theme," you murmur as, fascinated, you watch Ashley Dukes's comedy, *The Man With a Load of Mischief*, with its dialogue of "delicately polished and jewelled prose," as Dr. Allardyce Nicoll calls it. Many years since, beside the Bath Road, stood a tavern bearing the quaint sign "The Man With the Load of Mischief". Thither one night came a lady of the court and her maid, but recently rescued from the perils of a runaway coach by the timely intervention of a nobleman and his servant. At the inn, the travellers halt, thinking to remain there until their horses are fit again to take the road, but there is magic in the midnight air and love awaits on tip-toe. . . . Making a most welcome return, T. G. Saville gave a skilful and telling interpretation of the part of the would-be intellectual libertine of a nobleman and Avis Brunner was the attractively amorous maid. Although Noel Howlett, as the servant with a mind above his station, and Marion Prentice, as the Lady, played diligently, their characterizations lacked depth and

3

subtlety, and on their lips the exquisite dialogue lost much of its sheen. However, the production was given a warm reception, and so another season made a promising start. Patrons noted with pleasure that in the interim the theatre had been improved. An elaborate new lighting system had been installed. New carpets gleamed in foyer and corridors.

Dorothy Brandon's *The Outsider* was the second play in 1931 to run for two weeks. The provocative subject of the osteopath versus the orthodox specialists of Harley Street found strong favour with the public. They flocked to watch Ragatzy, the bone-setter, regarded by the medical profession as a quack and charlatan, perform a miraculous cure of Lalage, the crippled daughter of Dr. Sturdee, when all the doctors have failed. Olive Milbourne, who had improved immensely as the weeks went by, revealed her undoubted capacity for fine emotional acting in the part of Lalage, and Bertram Heyhoe made the most of the good acting stuff in Ragatzy. T. G. Saville, Noel Howlett, and Philip Yorke were a formidable trio of specialists. Miss Brandon, the authoress, attended one performance, and in a speech from the stage congratulated the producer and company on a vivid production, describing their work as "brilliant". With this production, the Repertory Theatre touched a peak on the road of its success. It follows that, after scaling a summit, the road descends again, and that is what happened. But, unaccountably as it seemed then, the road began to descend sharply towards that valley, rarely ever out of sight of a repertory theatre, the valley where the spectres of failure and bankruptcy lurk. The growing popularity of that new form of entertainment, the talkies, and trade depression were doubtless in some measure responsible for the decline in the size of audiences at the Repertory Theatre, but that was not the whole story.

Although, as has been said, you cannot thrust plays down people's throats, you can raise public taste, provided you tread warily and are content to progress gradually. Congratulations are due to the directors and the producer that they had accomplished the raising of the standard of plays in this manner. But no one was more conscious that the selecting of plays was fraught with pitfalls and risks. They realized that what is one man's meat is another man's poison, or, in the words of Denis

Johnston, "What is poetry to one man is a wilderness of words to another," and they knew only too well that a regular patron, who sees a play he does not enjoy or dislikes, may, as a result stay away from the theatre for several weeks afterwards. You find the same attitude in sport, where because he saw his team lose last week, a supporter (so-called) deliberately stays away this week, thus depriving himself of the pleasure of seeing his team win. That attitude always was, and possibly always will be, a sore problem to those at the helm.

During September, October, and November, 1931, public support waned, which was at least partially due to theatregoers resenting the theatrical fare offered them. It was not too highbrow: it was not too low-brow; but apparently it missed the mark. Hardly one of twelve plays performed during that period gave the normal amount of satisfaction. In all fairness, however, it must be said that no less than four of these plays did not deserve to succeed. Bernard Shaw furnished the Repertory Players with their best play of this batch of a dozen in *Mrs. Warren's Profession*. Notwithstanding that Margot Lister, formerly a great favourite, returned to give an excellent portrayal of Mrs. Warren, that genial, attractive old blackguard, and a new artiste, Mary MacDonald, appeared as Vivie, assisted by Max Adrian, Noel Howlett, and Donald Gordon, the production received scant appreciation. Complaints were heard that a play should not mention houses of ill fame or deal with the oldest profession in the world. "Of course," added some critics explaining it all, "Bernard Shaw's like that. Never knows his place and nothing's sacred to him. He's always peculiar." Perhaps Shaw's ridicule of our selfish morality and smug hypocrisy was a cap that fitted certain heads; that is, if ostriches ever get their heads out of the sand to wear caps! Even Noel Coward no longer proved a trump card, but it was not so surprising as his two plays, *I'll Leave It To You*, and *Home Chat*, were both artificial trifles of immature vintage, Clemence Dane's *Granite*, mirrowing love, murder, and retribution on the desolate wave-battered granite of Lundy Island, powerfully acted by Mary MacDonald, T. G. Saville, and Noel Howlett, proved too grim a tragedy for popular taste. On the other hand, "Too Life-like" was the criticism levelled at *To See Ourselves*, E. M. Delafield's amusing study of

a strangely contrasted couple's upheaval from their matrimonial rut. Of the remainder, neither Clifford Bax's *Up Stream*, nor Allan Monkhouse's *Paul Felice*, were worthy representations of playwrights of proved merit, and the less said about *He Walked in Her Sleep*, and its successor, *Kimono*, the better!

The fickle wind of public favour had veered away from the Repertory Theatre by the end of November 1931. Audiences had become so small and select that each production was losing money. Another crisis loomed in view when a further calamity occurred. For a year, Mr. Prentice had been bravely combining the offices of producer and general manager, sometimes working sixteen hours a day. As was inevitable, his health became impaired and his doctor ordered him away for a complete rest. The outlook of the Repertory Theatre just then was as black as the weather itself. But how often the hour of crisis produces the right man! In their dilemma, the directors found the man to save the situation within the Company itself. T. G. Saville stepped gamely into the breach and acted as producer. An immediate change of policy was made and a programme of popular plays selected. The ship must be saved at all costs, and as acting-captain, T. G. Saville surrendered himself whole-heartedly to steering a course clear of the rocks of disaster.

A sound start was provided by Somerset Maugham's entertaining farce, *Home and Beauty*, in which Sheila Millar, a charming young actress from the Bristol Little Theatre, scored a success as Victoria. Mr. Saville played Frederick, her husband, who had stood war and victory like a hero, but to stand peace and Victoria, or home and beauty, he had to achieve even greater feats of heroism! With *A Damsel in Distress*, a light-hearted, almost light-headed affair, and *The Ghost Train*, that little masterpiece of laughter and fears, the fortunes of the Repertory Theatre began to rise again, and with *Nothing But the Truth*, at Christmas, the crowds returned. As Bob Bennett, the man who made a bet that he would speak nothing but the truth for twenty-four hours, T. G. Saville shouldered the burden of this rollicking farce which rocked the rafters. His richly comic performance was remarkable for its speed and perfect timing. Margot Lister, Sheila Millar, Olive Milbourne, Joan Douglas, Max Adrian, Bertram Heyhoe and

Donald Gordon assisted in the fun. *The Silent House*, about a strange old house complete with a Chinese Room, eerie secrets and hidden treasure, exposed audiences to a full-blooded melodrama acted for all it was worth by Max Adrian and Bertram Heyhoe in two sinister character-studies as Dr. Chan-Fu and Ho-Fang, by Sheila Millar as T'Mala, and by Mr. Saville, suave and forceful, as Captain Winsford, the Franklin Dyall part. With Mr. Saville's last production, *Baa-Baa Black Sheep*, a piece of Ian Hay—P. G. Wodehouse nonsense, the Repertory Players entered upon their sixth year, and in it, Mrs. Popple, a small part, was entrusted to a newcomer named Lois Obee. Staunchly supported by the whole Company and staff, not least by Osborne Robinson, T. G. Saville had rendered splendid service to the Repertory Theatre. Thanks to him and his loyal team, the crisis had been averted. He fully merited the grateful acknowledgements of the directors and playgoers, for, during his short spell as producer, he had worked with characteristic fervour and zeal, playing a leading part in all the plays save one, and his power of comic invention and sense of impish fun were stamped on each production.

Renewed in health, Mr. Prentice returned. The leading roles of Deborah Kane in *Interference*, and Daisy, the Eurasian, in Maugham's *East of Suez*, Mr. Prentice's first two productions after his recovery, were played by Lois Obee. It was apparent from the first that Miss Obee, now, of course, famous as Sonia Dresdel, had acting ability, personality, and that inexplicable magnetic quality which makes an outstanding actress. The high promise of her early work was amply fulfilled by her vivid emotional performances as Paula in *The Second Mrs. Tanqueray*, and Elinor Shale in *The Lie*. In the course of those first six months, the directors took no chances, contenting themselves with offering a popular diet of comedies, thrillers, and revivals. Of the comedies, those of most consequence were *Bird in Hand*, John Drinkwater's merry study of rustic life; John van Druten's *After All*, with its amusing and natural presentation of the problem of the older and younger generations, and *Michael and Mary*, A. A. Milne's sentimental comedy success of 1930. An assorted bag of thrillers included *The Man Who Changed His Name*, the first play by the prolific Edgar Wallace given by the Repertory Players. Among the revivals were *And So to Bed*,

again an emphatic success, with Donald Gordon excelling as a roguish philandering Pepys; *Hay Fever*, *The Passing of the Third Floor Back*, Noel Howlett appearing as the Stranger, and *Ambrose Applejohn's Adventure*, in which T. G. Saville repeated his humorous and robust performance, and then, to the deep regret of all playgoers, bade the Company "Farewell".

Changes were in the air, for in June came the announcement that Herbert Prentice was leaving, having accepted the offer by Sir Barry Jackson to produce at the Birmingham Repertory Theatre. During four and a half industrious years at Northampton, Mr. Prentice had raised the whole standard of the work of the Repertory Theatre so that there was no finer repertory theatre in the country working under the arduous conditions imposed by a twice-nightly system and a weekly change of play. He had, moreover, considerably enhanced his own reputation by accomplishing, what was considered by many as an impossible feat, the presentation of a finished production each Monday night after only five days rehearsal. After that the fortnight or three weeks' preparation afforded by the Birmingham Repertory Theatre would surely seem a positive luxury to him. With the revival of *On Approval*, on 11 July 1932, Mr. Prentice reached three past his double century in productions and at the same time brought to a close his distinguished and momentous régime at Northampton.

HEROIC WORK

"The playgoer is the deciding factor in the theatre, and the only chance of getting good plays is by getting good audiences. All the rest follows —good actors, good producers, and good playwrights."

<div align="right">W. A. DARLINGTON</div>

CAPTAIN of a ship, producer of plays—to be one or other of these is the ambition of all who love the sea or the drama. Both these roles demand similar qualities. Wide knowledge, breadth of vision, leadership, sensitivity, and patience, which, as Joseph Conrad declared, is a form of courage, are valuable, if not essential assets in both spheres. Robert Young, who was appointed as successor to Herbert Prentice, possessed these vital qualities and quickly realized that he would have to exercise them to the full. Although one of the hottest nights for years, on Tuesday, 12 July 1932, a packed audience demonstrated their appreciation for Mr. Prentice's work, and then, when he introduced the new producer, gave Mr. Young an enthusiastic welcome. In acknowledging his warm reception, Mr. Young said, "Though I have only seen three of your productions here, I realize the high standard that is demanded by the Northampton Repertory Theatre audiences. It is one which equals, and, in my estimation, often surpasses many plays in the West End."

Robert Young's life had been crammed with adventure. Born in Manchester, he was faced with stern parental opposition when he first expressed a desire to go on the stage, and, in consequence, he did not visit a theatre until he was nineteen years of age and living in Buenos Aires. Shortly after, he worked his passage as a muleteer to New Zealand, where he first acted. On the outbreak of war in 1914, he enlisted in the New Zealand Expeditionary Force, being one of ten white men attached to a Maori regiment, and serving in Gallipoli, where he sustained severe shellshock, and in France, where he was wounded. After the War, he studied for the stage and had extensive and varied experience acting with Sir Frank Benson's Company, with

the Stratford-on-Avon Festival Company, and in the West End;
stage-managing for Arthur Bourchier for three years, and pro-
ducing for Lena Ashwell at the Century Theatre. Thus, Mr.
Young came well equipped to carry on the worthy tradition
established by Mr. Prentice. Furthermore, for several years
previously, Mr. Young had been a Member of Parliament for
North Islington, and, therefore, Northampton achieved another
claim to fame as the first Repertory Theatre with a former
M.P. as its producer.

During his initial three plays, *Windows*, a Galsworthy
revival, *Blackmail*, the sensational melodrama, and *Counsel's
Opinion*, a current farcical comedy, Mr. Young took the measure
of both the Company and the audiences. In Sidney Howard's
powerful domestic play *The Silver Cord*, which had won such
success at Bath, he had a finely taken chance to show his
mettle. The Press and the public were unanimous in their
praise of his intelligent direction, and the fine acting of Lois
Obee, who made Mrs. Phelps a ruthless, dominating mother,
Noel Howlett and Donald Gordon as her two sons, David and
Robert, respectively, Sheila Millar as Hester, and Joan Kemp-
Welch as Christina. This production was acclaimed as "one
of the outstanding performances in the career of repertory at
Northampton". Variety in choice of plays was the strong suit
at this time when you consider that the four succeeding plays
were a thriller, *The Cat and the Canary*; a sentimental comedy,
Lavender Ladies; a strong drama, *The Painted Veil*, and a French
classic comedy, *The Imaginary Invalid*. Against striking and
colourful settings by Osborne Robinson, Lois Obee shone in
another highly emotional part as Kitty Fane, the beautiful,
selfish, erring wife in *The Painted Veil*, and was well supported
by Donald Gordon as her revengeful husband and Noel
Howlett as Townsend, her lover. *The Imaginary Invalid*, F.
Anstey's adaptation of Molière's *Le Malade Imaginaire*, that
famous masterpiece of humour, proved a worthy addition to
the Repertory Theatre's repertoire. Polidore Argan, around
whom this picturesque costume comedy centred, was a pill-
swallowing, medicine-drinking, doctor-supporting old rascal
who enjoyed bad health to the uttermost. The Company had
been reinforced by Oswald Dale Roberts, an accomplished
Shakespearean and West End actor, who contributed a cleverly

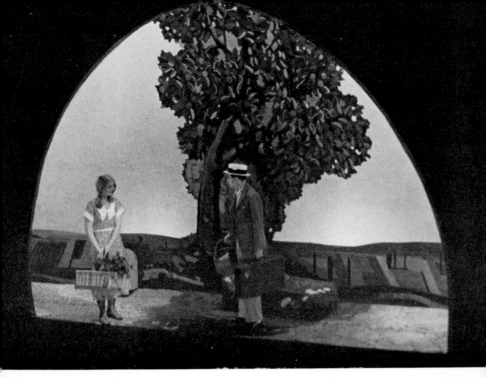

(*Above*) "MARTINE" (1933)
Sheila Millar as "Martine"

(*Below*) "JACK AND THE BEANSTALK" (1933)

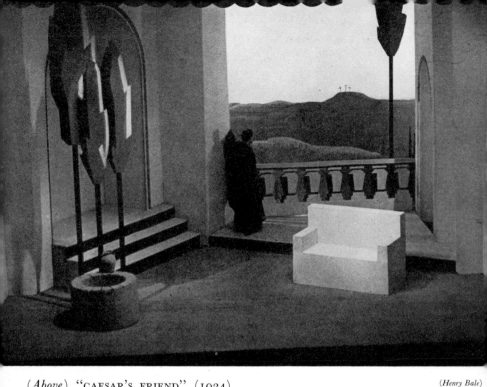

(*Above*) "CAESAR'S FRIEND" (1934) (*Henry Bale*)
Oswald Dale Roberts as "Pilate"

(*Below*) "THE TAMING OF THE SHREW" (1935) (*Henry Bale*)

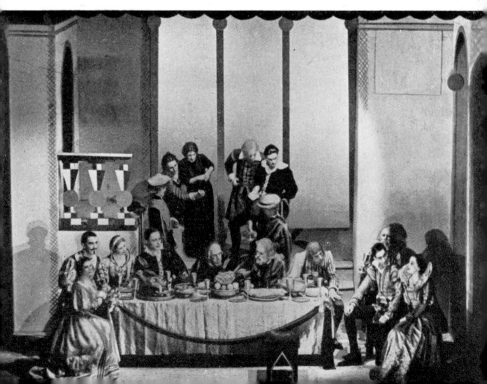

etched character-study of the old invalid, ably aided by Sheila
Millar, Lois Obee, Noel Howlett, Stringer Davis, and Peter
Rosser. Incidentally, Mr. Dale Roberts, who was educated at
Shrewsbury and Oxford, had a link with the town since his
maternal grandfather had been the Medical Superintendent
of St. Andrews Hospital, Northampton.

Le Malade Imaginaire was witnessed by Mr. S. P. B. Mais, the
well-known author, broadcaster, and critic, who, in the course
of a lecture in the town, spoke of the pleasure he had derived
from this very charming play. "The level of aesthetic entertain-
ment in Northampton," he said, "is much higher, and always
will be higher, than that in London. The general level of
entertainment in London is remarkably low. Are there half
a dozen plays in London worth the fare to the capital and the
trouble of the journey? I live about as far from London as you
do, and I say No! It seems to me that repertory is the only
chance of keeping the level of entertainment above emptiness
and vulgarity, so treasure your Repertory Theatre."

James Agate described Ronald Mackenzie's *Musical Chairs*
as the best first play of the last forty years. Although that may
be a high claim for a tragi-comedy about some unpleasant
people playing "General Post" with love, it did prove a
noteworthy vehicle for the Repertory Players to display their
talents. Noel Howlett's neurotic Joseph, Lois Obee's hard-
boiled Irene Baumer and Oswald Dale Roberts's amorous
Schindler were all realistic creations. The play had a bitter
tang which audiences found agreeable.

Repertory in Northampton was established through the
interest and energy of a handful of pioneers, as has been shown,
and among them Mr. W. H. Horton figured prominently.
When Sir James Crockett accepted the position of Chairman
of the Board of Directors, he did so on condition that Mr.
Horton acted as Deputy-Chairman and assumed the bulk of
the responsibility. During the ensuing six years, Mr. Horton gave
unstintingly of his time and energy in guiding the Repertory
Theatre through both calm and stormy seas. It was naturally
with deep regret that the directors, the Company, and play-
goers learnt, that, through pressure of business, Mr. Horton
felt compelled to resign from the Board. His successor was
Mrs. Helen Panther, M.B.E., J.P., another zealous pioneer,

who, on behalf of the directors, presented Mr. Horton with a solid silver salver in appreciation of his valued services.

Apart from a delightful revival of *Arms and the Man*, memorable for Stringer Davis's Bluntschli, the chocolate soldier, Sheila Millar's Raina, and Lois Obee's Louka, the most notable production of that season was *Easy Payments*, by Edward L. Stanway, a twenty-five-year-old Lancashire business man. Proving that money troubles, like silk stockings, run even in the best families this new play bristled with witty dialogue and showed how Pamela, Lord Lessington's daughter, fresh from college, took charge of her father's decaying estate and fought stubbornly to stave off bankruptcy. Sheila Millar as the capable Pamela, Noel Howlett as her impecunious father, and Lois Obee as her scheming stepmother, flashed three well contrasted characters to life, and, ably sustained by the rest of the Company, gave a sparkling rendering of a clever comedy.

After that riotous farce, *Tons of Money*, had evoked gales of laughter for the Christmas season came 1933, the year of Adolf Hitler's rise to power and a year of depression for the political and industrial world but a lively year for the Northampton Repertory Players, since variety is the spice of life. On the occasion of the Conference of the Repertory Theatres' Association being held at Northampton, the Repertory Players staged a specially elaborate production of Louis N. Parker's *The Cardinal*, which no other repertory theatre had so far attempted. Set in Rome in the sixteenth century, the play unveiled in beautiful prose the part played by Cardinal Giovanni de Medici in the vivid and exciting love-story of his brother, Giuliano, and the fair Filiberta, who is madly loved by Andrea Strozzi, a Florentine outlaw. Stringer Davis invested Andrea with fire and abandon; a strong portrayal of Guido Baglioni came from Noel Howlett, and to the difficult emotional part of Giuliano, Peter Rosser brought both force and feeling. Sheila Millar as Filiberta, Joan Kemp-Welch as Honoria, her companion, and Lois Obee as the Cardinal's mother, gave finished studies and presented an imposing appearance in gorgeous costumes. But the Cardinal, played by Oswald Dale Roberts with fine perception and dramatic power, was always an arresting figure and dominated the whole play. The settings by Osborne Robinson caught the period in their

ornate designs and glowed in a brilliant variety of colours, whilst the entire production proclaimed the sure and inspired direction of Robert Young, who received well merited congratulations from the delegates to the Conference. They expressed their astonishment that such a fine production could be achieved under a system which permitted only five rehearsals and involved performing twice nightly. Such enthusiasm was shown by the public that the play was continued for a further week. Glowing tributes also appeared in the national newspapers, for instance, the headline to a notice running to over half a column in the *Daily Mail* read, "A Repertory Triumph". "To-day I have paid a visit to Northampton's excellently run Repertory Theatre," wrote W. A. Darlington, the sagacious dramatic critic of the *Daily Telegraph*, "and have seen a performance of Louis N. Parker's *The Cardinal*, which, for directness of method and clearness of speaking, would give points to many more pretentious productions." After dealing with the method of work at the Repertory Theatre, Mr. Darlington remarked, "The work done by the producer and the company at the Northampton Theatre is nothing short of heroic," and then concluded, "The people of Northampton have a real live theatre in their midst. I hope they know their luck."

What vigour the Repertory Theatre had in those days! But three weeks after the rigours of *The Cardinal*, the Repertory Players showed commendable courage by the production of *Twelfth Night*. If producing a straightforward play in six days for performance twice nightly was no joke, what about a Shakespearean play? When you consider the cutting of the play, the costuming and planning necessary, in addition to innumerable staging difficulties, do you wonder that many repertory theatres shun Shakespeare? But in doing so they are not wholly fulfilling their function. They are like men who build an arch without a keystone, the edifice is incomplete, for are not the plays of Shakespeare the keystone and crowning glory of the world's drama? They are spared the toil, but miss the triumph, success may bring. Undaunted by the work involved or the difficulties encountered, Robert Young was determined that the master-playwright should take his place in the repertoire. That this determination was not ill founded was shown by the Repertory Players' performance of *Twelfth*

Night. They gave a finely spoken, spirited, and truly delightful rendering of that entrancing comedy, which John Masefield calls "the happiest and one of the loveliest of all Shakespeare's plays." With Noel Howlett's dignified Orsino, Sheila Millar's attractive Olivia, Lois Obee's engaging Viola, Donald Gordon's appealing Feste, Oswald Dale Roberts' jovial Sir Toby, and Robert Young's richly comic portrayal of Sir Andrew as an innocent, fatuous simpleton, the play swept along smoothly and gaily, and wrought its customary magic. Many folk acclaimed this first Shakespearean production by the Repertory Players as their finest in six years' work. Contrast came the three weeks following with *Pleasure Cruise*, a seaworthy light comedy; *The Improper Duchess*, Lois Obee persuasively assuming the Yvonne Arnaud part of the Duchess, and *Peg O' My Heart*, Sheila Millar making a vivacious heroine. Then, in that charming fantasy, *Berkeley Square*, Peter Rosser as Peter Standish, and Lois Obee as Kate Pettigrew, were both excellent. That same week, the Repertory Players made their first broadcast in the scene in Northampton Castle from Shakespeare's *King John*, featuring Oswald Dale Roberts (Hubert), Lois Obee (Arthur), and Donald Gordon (an Attendant), which won fresh laurels for the Company.

Those were brave days indeed! The next week, the Players returned to Shakespeare by playing *The Merchant of Venice* to large audiences. Much was demanded of the Company and they did not fail. Imagination was at work in Mr. Young's production and Mr. Robinson's settings, and the acting was uniformly sound from the clear-spoken Bassanio of Noel Howlett to the benign Launcelot Gobbo of Patrick Gover and faithful Nerissa of Sheila Millar. The Shylock of Oswald Dale Roberts was a powerful piece of acting. A proud, lonely man characterized by a deep sense of justice mixed up with the bitterness of resentment was his interpretation of the outraged Jew. His performance was well matched by the Portia of Lois Obee, who, whether presiding over the caskets at Belmont or resisting the Jew's claim for "his pound of flesh" in the Duke's Court, had poise and conviction. Such excellent support was accorded the production that its run was extended for a second week.

Trilby, du Maurier's picture of life among the artists;

Zangwell's *The Melting Pot*, with its gripping examination of
the Jewish problem; *The Play's the Thing*, Molnar's satirical
comedy, and *Badger's Green*, R. C. Sheriff's humorous and
authentic study of village life and the annual cricket match,
were among the most interesting plays during the remainder
of that season. But the most sensitive production came with
Martine by Jean-Jacques Bernard, who amply proved his
statement, "Drama is, before all else, the art of the unexpected."
By his use of indirect statement, he revealed the secret thoughts
and feelings of his characters in this play of fragile beauty,
which opens on a sun-drenched road in France when Martine,
a little peasant girl, rests in the cool shade of an apple-tree on
her way from marketing. Suddenly, as if the dream-prayer
of her young heart is answered, a young man approaches and
thereafter their tender love-idyll unfolds as exquisitely as the
petals of a rose. The play needed delicate handling which it
received from both producer and players.

During that season *Sacred and Profane Love* was enacted, and
on that production warm praise is bestowed by Mr. Cecil
Chisholm in his book, *Repertory*. "I remember," he writes, "a
performance of Arnold Bennett's *Sacred and Profane Love*,
produced by Robert Young at the Northampton Repertory.
In this piece of bravura, a typically romantic, yet hard-
headed Bennett heroine has to save a pianist of genius from
dope. In doing so she is called upon to run up almost the entire
scale from complete innocence to sophisticated cosmopolitan
cynicism; from the lightest of comedy to the darkest of tragic
suggestions; and she must keep one hand on a continuous
romantic undertone, while the other is executing all manner
of realistic trills and cadenzas. A young actress, Miss Lois
Obee, passed quite easily from the uncertainties of the pro-
vincial girl in love with a great artist, to self-assurance and poise
of the professional woman. She was alternately as youthfully
highfalutin and as mordantly cynical as Bennett himself
could have desired. Better still, she caught the romantic
undertones with beautiful fidelity. The old peer was beauti-
fully done by Oswald Dale Roberts, and a very young actor,
Peter Rosser, almost made one feel the exceptional sensibility
of Diaz, the music in the man."

A highly appreciative and enheartening article also from the

pen of Mr. Chisholm appeared in the *Sunday Referee* in June 1933. A few paragraphs are particularly worthy of note:

"London's hottest day was at its height when I left Euston. To exchange dingy London at 77 degrees in the shade for clean Northampton at about 76 degrees was encouraging, but what I found at Northampton was more rewarding still. For not even a heat wave can keep the local audience from their favourite theatre. The house was practically full.

"Almost 5 per cent of the local population visits the Repertory Theatre every week. On that basis Manchester could support half-a-dozen Repertories instead of so often failing to fill one. It would be interesting to discover whether any other town of under 100,000 inhabitants is doing so well for its Repertory.

"About seven years ago, after long debate and heavy spadework, the curtain was rung up in January 1927, on *His House in Order*. From that day to this the house has been in excellent order. During that time the Repertory Company has produced over 320 plays. Every year they seem to manage a Shaw play, two or three of Somerset Maugham's, a Galsworthy, sometimes a Molière as well as the best of the London crop, and a host of old favourites. Northampton gets almost everything that is worth doing from its company of fifteen. Here is an example of slender resources most efficiently used, for this is a fully equipped and staffed Repertory Theatre. Which shows what energy and brains can do."

SMOOTHER SAILING

"The theatre is a temple of the ascent of man."

"W<small>ILL</small> you seek, afar off?" cried Walt Whitman. The Northampton Repertory Theatre's answer during the autumn season of 1933 was, "We will". Theatre-going is invariably a voyage of discovery. Surely that is a vital part of its fascination! A repertory playgoer becomes a confirmed globe-trotter as that season in particular clearly showed. Among the places visited were France (*Other Men's Wives*), Italy (*See Naples and Die*), and (*Death Takes a Holiday*), the Austrian Tyrol (*Autumn Crocus*), New York (*The Thirteenth Chair*), and Portuguese West Africa (*The Green Pack*). There was equal diversity in the types of plays given, and the solid support forthcoming showed that the audiences emphatically approved of the varied menu offered them. Furthermore, the standard of plays that season was consistently high. Rarely in the whole existence of the Repertory Theatre has there been such an unbroken succession of absorbing and well contrasted plays as was presented during the months of September and October. It comprised in order of their appearance: *Young Woodley*, *You Never Can Tell*, *Dangerous Corner*, *Lean Harvest*, *Death Takes a Holiday*, *The Rivals*, *See Naples and Die*, and *Autumn Crocus*. There's richness and variety for you! There's a repertory theatre fulfilling its true purpose and laying the strongest emphasis on the finest work of our finest playwrights and being a microcosm of the theatre of the world. And the quality of the production, presentation, and acting matched the plays. To whom should go the chief credit for this spell of impressive work? Surely the astute St. John Ervine provides the solution to this interesting problem when he says, "Works of art are not produced by the marooned. The dramatist is peculiarly dependent upon his audience for the full life of his work. There is a sense in which we may say that the quality of the play depends upon the quality of the audience." Audiences at that period were large

and keenly receptive, and they had that "quality" which merited that fine list of plays and ensured their proper appreciation.

"Love, respect, friendship," said Chekhov, "do not unite a people as much as a common hatred of something." You then had a loyal audience who had been steadily built up over the years and had become enthusiastic repertory playgoers and they were united in a common hatred of the inartistic and tawdry, and united also in a common love of the more valuable, the more worth-while things in the Drama.

A number of changes had taken place at the close of the previous season. Lois Obee, Noel Howlett, Joan Kemp-Welch, and Stringer Davis had departed, and Richard Summers, who proved a friendly and enterprising business manager, had succeeded Peppino Santangelo. New faces appeared in the Company, including Dorothy Galbraith, Zillah Grey, Julian Clay and, as a student, Freda Jackson of Nottingham. Before they had been with the Players many weeks, they were expressing their pleasure at the large and obviously keen audiences attending the Repertory Theatre. They were, in fact, re-echoing the sentiments of almost all the members of the Company from the outset. Audiences at a repertory theatre differ from any other kind of theatre audience. Those who witness the performance of a touring company or a West End play have an air of detachment unknown to a repertory audience. Warmth, friendliness, and a marked responsiveness characterize a repertory audience who are usually bound to the players by a genuine bond of interest and affection.

Love's growing pains, the theme in John van Druten's *Young Woodley*, were effectively portrayed by Patrick Gover, as the schoolboy, and Sheila Millar, as his master's wife with whom he falls in love. The annual salute to Bernard Shaw was *You Never Can Tell*. From its opening in the dentist's operating-room, it is all a pure game of cross-purposes, a contest of ideas and sentiments. As always Shaw's dialogue crackled and gleamed, not with the fire of life but with a sort of electric current laid on from mains to which he seemed to have perpetual access. This superb comedy contains some of his finest characterization, the character of William, the waiter, being drawn with a masterly touch and Oswald Dale

Roberts carried the old man's years with ease and benignity. J. B. Priestley's first play, *Dangerous Corner* still remains one of his best with its ingenious plot showing how the past lives of a group of people at a country house might be ruthlessly revealed if a certain dangerous corner in their conversation is not successfully negotiated. It calls for team-work which came strongly from Dorothy Galbraith, Peter Rosser, Sheila Millar, Patrick Gover, Zillah Grey, Julian Clay, and Freda Jackson.

A gospel of big ideas drove Nigel Trent in quest of wealth and success in that dramatic play, *Lean Harvest*, and when Donald Gordon played the leading role, if he did not always convey the driving force of ambition consuming the man, he made a gallant attempt. Based on the poetic conception of death suspending all activities for three days, *Death Takes a Holiday*, stimulated much discussion. The delicacy of feeling and beauty of phrasing with which that novel fantasy is endowed, was given a sincere interpretation by Marjorie McEwen as Grazia, for whom death has no sting, Donald Gordon, Dorothy Galbraith, and Oswald Dale Roberts. All these productions were typical examples of Mr. Young's intelligent direction.

Sheridan made a resounding return to the repertoire with his inimitable comedy *The Rivals*. Osborne Robinson's decor captured the beauty of old Bath in an elegantly dressed presentation. Sheila Millar, looking most attractive, played Lydia Languish, with ease and charm, but Douglas Rhodes's Captain Absolute, though good-looking, was less happy. Oswald Dale Roberts's Sir Anthony Absolute, Peter Rosser's Lucius O'Trigger, and Donald Gordon's Bob Acres were expertly handled, and Dorothy Galbraith's Mrs. Malaprop scored every comic point with humorous dexterity. Five weeks later, the Company brought to the stage another but vastly different costume play, *The Barretts of Wimpole Street*, by Rudolf Besier. This idyllic love story of two poets in a house ruled by patriarchal tyranny presented the Victorian world where rigid conventionality and religious fervour were closely interwoven with affectation and hypocrisy. Elizabeth Moulton-Barrett was beautifully and movingly portrayed by Sheila Millar, and Peter Rosser gave a vital and robust performance as Robert Browning. As Edward Moulton-Barrett, the

tyrannical father, Oswald Dale Roberts played with all the restrained force and depth of passion at his command. It is doubtful if Mr. Roberts, who did many fine things with the Repertory Players, ever did anything better, and it is certain that his performance was one of the best ever seen at the Repertory Theatre in twenty-one years.

Christmas and the first week of the New Year brought three productions and a broadcast in just over a fortnight. As if the normal routine was not driving the producer and the Company strenuously enough, *Jack and the Beanstalk* occupied the stage in the afternoons, and during the first week *The Thirteenth Chair*, a thriller, originally acted by Mrs. Patrick Campbell, and during the second week Pinero's *Sweet Lavender*, were performed twice nightly in the evenings. In the midst of all this activity, Dorothy Galbraith, Sheila Millar, Zillah Grey, Oswald Dale Roberts, Donald Gordon, and Peter Rosser appeared in Stanley Houghton's *The Dear Departed* "on the air". Actually, the work accomplished on Wednesday, 3 January 1934, was in the morning a rehearsal of *Bulldog Drummond*, followed by a rehearsal of the broadcast, in the afternoon a performance of *Jack and the Beanstalk*, and in the evening two performances of *Sweet Lavender* and the broadcast of *The Dear Departed*. Surely this achievement constitutes a record for any repertory theatre in the world! Nevertheless, the Company cheerfully shouldered the busiest fortnight in the history of the Repertory Theatre. There can rarely have been such a prodigiously hard-working and valiant Company.

Jack and the Beanstalk, by Margaret Carter, the Repertory Players' first pantomime, achieved conspicuous success. Seeing the King's Palace and the Giant's Castle, meeting a real giant, a charming princess, Cuckoo the Cow, and a host of picturesque characters, and watching the beans grow, Jack climb the beanstalk and steal the hen that laid golden eggs, delighted young and old alike. Almost every property was made in the theatre's own workshops and Osborne Robinson designed suitably diverting and fanciful settings in glowing colours for the thirteen scenes. Special music was composed, and dances were arranged by Marian Wilson. Jack became a pleasing and resourceful lad in the hands of Peter Rosser. Zillah Grey was an attractive Lady Flavia, and Doris Littell (Mrs. Robert

Young) a delightful Azelle. The Peterkins of Oswald Dale Roberts, and the Rufus of Donald Gordon exploited every ounce of fun to the full and a newcomer named Errol Flynn made a dashing and handsome Prince Donzil. It was a triumph for Robert Young, plainly proving his versatility and sensitiveness of feeling. How carefully were scenes plotted and grouped and timed to appeal to youthful minds! How delightfully were appropriate twists and surprises contrived to increase the fun! The whole production gave immense satisfaction to the crowded audiences, who were unstinting in their applause and vocal praise.

In 1934, several changes occurred in the directorate within a few months. Mr. Francis Graves was forced to resign through leaving the town to become editor of a newspaper at Windsor. One who played his part in the launching of this venture in repertory, Mr. Graves had helped to shape its course as one of the original directors. His keenness, tact, and cultured mind, as well as his eloquent pen, had always been at the service of the Repertory Theatre. Everyone connected with the theatre regretted his departure. As successor to Mr. Graves, they welcomed that distinguished Northamptonian, Lieut.-General Sir John Brown, K.C.B., D.S.O., D.L., who, although a director of the New Theatre, Northampton, and one of the busiest men in the town, willingly gave of his wide experience for the furtherance of repertory in the town. Shortly afterwards, the theatre sustained a severe blow by the death of Mr. G. F. Skinner, who had acted both as expert financial adviser and as a director. His practical mind, shrewd common sense, and enthusiasm were greatly missed by his fellow directors.

Thrills marked the commencement of the eighth year with *Bulldog Drummond*, Peter Rosser playing the title role, and Sheila Millar in the part of Irma Peterson, but the next production, *A Doll's House*, provided the real milestone. It was characteristic of Mr. Young's indefatigable vitality and his love of the finest drama that not content with introducing the plays of Shakespeare to the repertoire he should also introduce those of Ibsen. No play in contemporary European drama had at once so delighted and so offended the diverse tastes of the intellectual world as this picture of a cosy household wrecked, first, by a

doting husband, and, secondly, by a devoted wife. Through an innocent subterfuge, the young wife not only finds herself but also discovers her husband's true character, and then realizes she can no longer bear to be a mere doll. Written in 1878, it was the first Ibsen play to stir the waters of theatrical London in 1889. Thenceforth, the influence of his plays revolutionized the technique of play-writing and brought Truth into the theatre. Dressed in the costumes of 1900, Sheila Millar sensitively conveyed the futility and frustration of Nora caged in her doll's house and Oswald Dale Roberts bore the burden of the self-sufficient Helmer as though at times it weighed too heavily upon him. With Dorothy Galbraith, Peter Rosser, Freda Jackson, Errol Flynn, and Zillah Grey completing the cast, this powerfully dramatic and provocative play was worthily performed. No mean achievement when you consider that an Ibsen play is not an easy medium, even with eight or ten weeks for rehearsals! In complete contrast, the following week, the Repertory Players turned their attention to Edgar Wallace's melodrama of the Chicago underworld, *On the Spot*.

The crop of comedies was not as prolific as usual that season but what it lacked in quantity was made up in quality, and included such popular successes as *The Wind and the Rain*, *Paddy the Next Best Thing*, and *Fresh Fields*. Even so, the event of the season for all lovers of lively fun was two excursions into the Garden of Eden Phillpotts. As a contriver of comedy, Mr. Phillpotts is both an honest playwright and a skilled one. First came *Yellow Sands*, a trim, wholesome, mirth-provoking comedy all about Jennifer Varwell's relatives clamouring after her money with her eightieth birthday-party marking the climax of family celebrations. Dorothy Galbraith's Jennifer was a likeable, far-sighted old lady. Errol Flynn gave a satisfying and sincere performance as Joe Varwell, her Communist nephew and easily his best piece of acting with the Company. Richard Varwell, that old rascal for whom no quantity of beer could drown his natural breeding, lacked nothing in the capable charge of Oswald Dale Roberts. The second Phillpott venture was *The Farmer's Wife*, that storm of fun in Thirza Tapper's tea-cups. Dorothy Galbraith as Thirza, and Oswald Dale Roberts as Samuel Sweetland, the farmer seeking a second

wife, again excelled. Freda Jackson's Araminta, his house-keeper, Zillah Grey's Sibley, and Elizabeth Inglis's Petronnell set these women securely in their places. Erroll Flynn and Peter Rosser made an amusing pair of Devonshire worthies, whilst Donald Gordon gave a highly creditable rendering of that superb comic creation, Churdles Ash. *The Farmer's Wife* proved such an attractive lady that she stayed at the theatre for a second week and almost broke all records.

Plays of unusual interest abounded that season. Among them were two plays of a political flavour: Miles Malleson's *Conflict*, a sincere piece of creative thought quivering with taut drama, and H. M. Harwood's witty and absorbing *The Grain of Mustard Seed*; Mordaunt Shairp's two piquant plays, *The Crime at Blossoms*, a satire on the morbid excitement aroused by crime, and *The Green Bay Tree*, depicting the battle between normal and abnormal influences for possession of a young man's soul, and Somerset Maugham's *Sheppey*, with Oswald Dale Roberts in the chief role giving an impressive performance built up with care and observation, and Dorothy Galbraith investing the street-walker with drab humour and humanity. A double helping of Shavian wit with *Pygmalion*, and *The Devil's Disciple*, offered a good spread of fine acting. In *Pygmalion*, Shaw takes a firm stand for the preservation of the English language. Wit and understanding were brought to Eliza Doolittle by Dorothy Galbraith, and Donald Gordon gave Henry Higgins, who attempts to improve Liza's speech, that right combination of assurance and humility. Doolittle as sketched by Oswald Dale Roberts was a perfect specimen of the undeserving poor. An exciting tale of the American War of Independence, *The Devil's Disciple*, concerns the wrong man who is nearly hanged and the right woman who manages to behave sensibly, and Sheila Millar, Peter Rosser, Zillah Grey, Oswald Dale Roberts, Errol Flynn, and Veronica Rose, a pretty newcomer who had starred in several films with Tom Walls, famous Northampton-born stage and film star, pro-duced first-class performances.

Giving history without tears, Clifford Bax's *The Rose Without a Thorn* was a bold and resourceful production skilfully directed by Mr. Young and richly decorated by Mr. Robinson. Although Peter Rosser had as yet neither the maturity, nor

technical equipment to give a full-length portrait of Henry VIII, he acquitted himself with credit. As Cranmer, Oswald Dale Roberts and, as Anne of Cleves, Dorothy Galbraith spoke with authority, but, as Katheryn Howard—whose beauty like a rose without a thorn, seemed to hold out to Henry a promise of returning youth—Freda Jackson gave the play unity and force. A lovely performance! During her comparatively short time with the Company, she had developed into an exceptional actress and demonstrated her versatility in parts of every size and shape. She possessed that rare quality, that fluidic thing, call it magnetism or what you will, which seemed to waft itself like a vapour across the footlights. Perhaps her finest piece of acting, apart from Katheryn Howard, was her Desdemona in the production of *Othello*. Mr. Young imposed upon himself another bold task when he chose to produce this great tragedy of a man overwhelmed by jealous suspicion, in the ordinary tick-tack of the Repertory Theatre's routine. The unqualified success of *Twelfth Night*, and *The Merchant of Venice* was not repeated with *Othello*. Nevertheless, the audience saluted the venture which was abundantly worth while. So right in appearance and stature but not in years, Peter Rosser tackled the part of the noble Moor, but could not quite bring him up to the level of a great soldier and a man of passionate tenderness as well as passionate fierceness. As Emilia, Dorothy Galbraith gave a forceful portrayal, particularly in the last scenes. But Freda Jackson's moving and poignant performance as Desdemona, and Oswald Dale Roberts's sly, suave, and malevolent Iago, stole the honours.

SUCCESSFUL YEARS

"A good production is the result of successful collaboration between the creative mind of the playwright and the interpretive mind of the producer."

NORMAN MARSHALL

HARD as the Northampton Repertory Players worked during his régime, Robert Young was opposed to all work and no play. He staunchly believed in the artistes keeping fit in body as well as mind. Under his encouragement, they played hockey in the winter and cricket in summer. The hockey team, under the captaincy of Oswald Dale Roberts, who used to play for Oxford University, had at least one and sometimes two matches a week. In their turn, Noel Howlett, Mr. H. Musk Beattie, the director-secretary of the Company, Peppino Santangelo, the business manager, and Mr. Young himself, as well as the captain, distinguished themselves on the field. The Company fielded an even stronger cricket eleven under the leadership of Robert Young, who played regularly for the Lords and Commons, and was formidable both as a batsman and bowler. Oswald Dale Roberts, a fine forceful batsman, was justly proud that when he scored 210 runs for no wicket with Clifford Mollison against an Eleven captained by Sir Nigel Playfair, of which his contribution was 110 not out, they set up a cricket record for the Stage. Both Mr. Young and Mr. Roberts were trained in the right school, that of Sir Frank Benson, one of the keenest sportsmen in the theatrical profession, who got his blue for the three miles at Oxford. His encouragement of his Company to play games led to a host of fables about sport in the Benson Company. It was said Sir Frank used to advertise: "Wanted a Laertes and centre-forward" and "Wanted a good bowler for Roderigo." However, O. B. Clarence reports how he saw a game of rugby at Cork when Benson took a pass and sped away towards the opposite goal, when a voice rang out, "Begorra, Mike! Hamlet's in."

Commencing a fresh season on 6 August 1934, *London Wall*, John van Druten's human comedy of the affairs and affaires of

the staff in a solicitor's office, displayed the strength of the Company. Peter Rosser's Eric Brewer, the philandering managing-clerk, Oswald Dale Roberts's Mr. Walker, one of the principals, and Lorraine Clews's flighty typist, were faithful and deft characterizations, and, although Freda Jackson's study of middle-aged Blanche Janus, Mr. Walker's secretary, was quietly incisive, she dominated every scene. Mr. van Druten became the most favoured playwright that season, for two more of his plays were included. They were *The Distaff Side*, a warmly human picture of a family group, notable for Mr. Robinson's beautiful sets and forceful and sympathetic acting by Dorothy Galbraith, Freda Jackson, and Zillah Grey, and *Behold We Live*, which, being slightly morbid, did not meet with general approval.

After a spate of English comedies came *The Whiteheaded Boy*, as refreshing as a gentle breeze from the Irish hills. With a firm touch and considerable technical skill, Lennox Robinson unfolds the story of the darlin' of the Geoghegan family who is expected home after making his third endeavour to pass his medical examinations and gives a penetrating analysis of Irish character. Once again, Robert Young showed he had a flair for seizing the very core of the author's meaning and interpreting it as faithfully as possible, with the help of all the arts available to the stage. Admirable aid was consistently forthcoming from Mr. Robinson, and this production proved no exception. Effective performances were given by Donald Gordon, as the Whiteheaded Boy, Dorothy Galbraith, Helen Christie, Maurice O'Brien, Peter Rosser, and Oswald Dale Roberts. The same flair of the producer was evident in the next production of *Caesar's Friend*, in which the incidents of the supreme tragic drama in the world's history, the Crucifixion, are woven into a play in the modern idiom. It was not a sermon, but a modern miracle play, if you like, beautifully conceived and full of dramatic power with Pontius Pilate as the protagonist and with the challenge to the political power of the Jewish Priests and the Roman Governor's anxiety to avoid civil disturbance truthfully emphasized, but over and above all the personality of the invisible Jesus dominated and radiated through the play. It produced an imposing Annas from Brefni O'Rorke, a strong Gamaliel from Noel Howlett, a virile

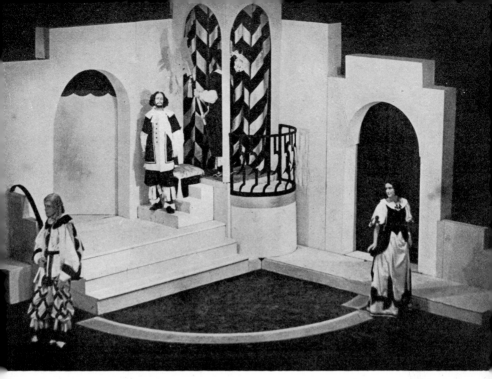

(*Above*) "MARRIAGE À LA MODE" (1936)

(*Below*) SETTING FROM "SIR MARTIN MAR-ALL" (1937)

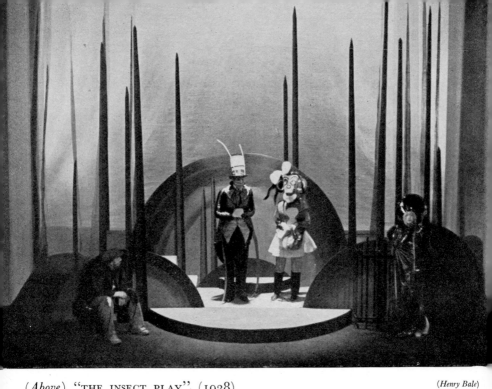

(*Above*) "THE INSECT PLAY" (1938) (*Henry Bale*)

(*Below*) "THE CIRCLE OF CHALK" (1938)
A Costume designed by Osborne Robinson (*Henry Bale*)

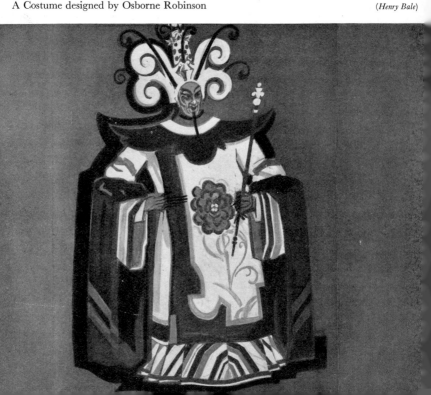

Peter from Nicholas Phipps, a quietly impressive Mary
Magdalene from Helen Christie, and a moving Zillah, the
Blind Woman (the only imaginary character) from Freda
Jackson. The laurels, however, went to Oswald Dale Roberts
for the sincerity and power he brought to the part of Pilate, a
performance of real distinction closely rivalling his Edward
Moulton-Barrett, and his Cardinal. The settings of Osborne
Robinson were as fine as anything he had designed hitherto,
the last scene in Pilate's garden glowing with simplicity and
beauty which heightened the dramatic sweep of the climax.
Two honours were accorded the production: first, a visit by
the Mayor and Corporation, followed by a cordial letter of
appreciation from the Mayor (Councillor E. Allitt, J.P.), and,
secondly, owing to public demand, its continuance for a second
week. All who witnessed *Caesar's Friend*, and quite a large
number of patrons paid it two and three visits, found it not
only "good theatre", but a cleansing and ennobling experience.

In marked contrast, there followed a flippant light comedy,
Her Shop, and what Ivor Brown called "a good, tough American
drama about a good, tough American citizen" entitled *Counsellor-
at-Law*, wherein Elmer Rice unmasks a typical American
attorney, all nerve and energy, and his adventures in law,
lawlessness, and love. Oswald Dale Roberts, and Dorothy
Galbraith, Brefni O'Rorke, Freda Jackson, and Donald Gordon
ensured that the rendering was slick, smart, and swiftly moving.
Among other important productions that season, which was
indeed an exciting one, were Beverley Nichols's "failure",
The Stag, Edgar Wallace's *Persons Unknown*, *Journey's End*, *The
Venetian*, and *The Power and the Glory*. So effective was the
presentation of R. C. Sheriff's grim and humorous "documen-
tary" play of trench warfare, *Journey's End*, that over fifty
letters of congratulation were received by the management.
The production and staging merited the highest praise as did
the acting of Peter Rosser (Captain Stanhope), Oswald Dale
Roberts (Trotter), Maurice O'Brien (Raleigh), and, in parti-
cular, Brefni O'Rorke, who revealed all the friendly humanity
and inherent integrity of Osborne, the ex-schoolmaster. An
unforgettable performance! Clifford Bax's *The Venetian*,
recounted the romance of the beautiful Bianca Capello and
Francesco Medici against a dark background of sordid intrigue

and political ambition in the sixteenth century. In an elaborate and colourful production redounding to the credit of both Mr. Young and Mr. Robinson, Freda Jackson and Brefni O'Rorke played the lovers in gallant style with flash and vigour.

Everyone was delighted with *The Power and the Glory* by Edward L. Stanway, author of *Easy Payments*, and a personal friend of Mr. Young. Here, at last, was a pleasurable new play! The visitors ,who included the Mayor and Mayoress (Councillor and Mrs. E. Allitt), the members of the Rotary Club, Mr. Cecil Chisholm, critic of the *Sunday Referee*, and several London managers, were impressed with this clever and satirical comedy somewhat in the vein of Shaw's *The Apple Cart*. His Majesty Ferdinand XIV, the King of a mid-European state, and the royal household are faced with a revolution, and an early abdication in favour of a so-called democratic leader is imminent. The manner in which the various members of the royal family determine to go out in a blaze of glory was hugely diverting. Indeed, like good lace, the texture of the play was finely drawn and developed with each thread woven the strength and satire of its cunning design. Mr. Young's production was of the same high calibre as the writing, and the performance of Noel Howlett as a suave and disarming King, Freda Jackson as a regal Queen, and Zillah Grey, Nicholas Phipps, and Donald Gordon as their less suave, less regal, ultra-modern children. Brefni O'Rorke made the General an alert and efficient member of the military caste, and Oswald Dale Roberts played the aggressive Schnitzler, the would-be dictator, with an unerring touch. Producing plays of this quality imposed a severe strain on the producer, and in December 1934, Mr. Young suffered a breakdown in health, and in order to give him a much needed rest, Mr. Dale Roberts took charge of two productions, one a revival of *The First Mrs. Fraser*, and the other, *The Maitlands*, Ronald Mackenzie's family with clashing temperaments which were realistically portrayed by Peter Rosser, Freda Jackson, Donald Gordon, and Lorraine Clews.

Pantomime, according to Mr. Willson Disher in *Clowns and Pantomimes*, can trace back its family tree over two thousand years, but in the vast assortment from the "mimes" of ancient

Rome to "Harlequinadia", the most winsome and favoured member of its honourable lineage is Cinderella. And when pantomime returned for the festive season along came *Cinderella*, by Margaret Carter, replete with the Fairy Godmother, the Ugly Sisters, the Pumpkin, the Coach, the Prince, the Ball, and the Magic Slipper. Robert Young brought the same resource and skill to the direction as he did the previous year to *Jack and the Beanstalk*. Songs, dances, topical touches, and happy surprises were introduced. Once again, it was true pantomime. May Collie's Cinderella, and Patrick Crean's Prince Amozel had the right blend of ease and charm. Dorothy Galbraith and Helen Christie made two fearsome ugly sisters. Brefni O'Rorke as the Lord High Chancellor, Freda Jackson as his daughter, Oswald Dale Roberts as Baron Slightly, Philip Dale as Choddles, Donald Gordon as Dandini, and Zillah Grey as the Fairy Godmother, entered heart and soul into all the fun and frolic. Playing twice daily for ten days, *Cinderella* drew the crowds who were unanimous in their warm appreciation of pantomime at its merriest. Unfortunately, during the run, Mr. Dale Roberts slipped and fell heavily on his right elbow. Everyone seemed to accept the incident as part of his comic capers and laughed heartily, and they were surprised when in the next scene he appeared with his right arm in a sling. He had, in fact, fractured his arm in the fall, yet despite intense pain he not only finished the scene, but sang, danced, and smiled his way through the performance. Afterwards, however, he was compelled to rest. With typical unselfishness and zeal, Mr. Young stepped into the part of the Baron, thereby saving the theatre in one of the most critical situations in its history.

The Repertory Players greeted 1935 with hilarity. They started with *The Late Christopher Bean*, Emlyn Williams's adaptation from the French, which in 1933 was hailed as "the year's most joyous comedy." It was to be produced by Mr. Dale Roberts and Mr. Young took over, but as Mr. Dale Roberts had cast himself for the leading part, he had an anxious time finding another actor without delay. He was fortunate to secure the services of the well-known West End actor, Lawrence Baskcomb, who valiantly appeared at three days' notice. Mr. Baskcomb built up a truly comic creation in Dr. Haggett, the

country doctor who becomes transformed into an art dealer, while Dorothy Galbraith brought the correct Welsh accent and cheerfulness to the part of Gwenny. Hilarity continued with that immortal farce, *Charley's Aunt*, Donald Gordon giving a sprightly performance as "the Aunt" demonstrated his undoubted ability as a comedian, and J. B. 'Priestley's well knit and ingenious comedy, *Laburnum Grove*, in which Brefni O'Rorke gave a finely etched study of the commonplace suburban householder, who did not run true to form, and Helen Christie so comfortably embodied his homely, unsuspecting wife. A baffling thriller, *Line Engaged* broke the sequence, and two of the younger artistes, Philip Dale and Zillah Grey carried off the leading parts with flying colours.

"Nothing venture, nothing win" runs the old adage. The Company continued to venture and assuredly won—won genuine and deserved success with a diverse assortment of plays, including Arnold Bennett's *The Great Adventure*, satirical portrait of a great painter whom Chance blesses with anonymity and a wife; a welcome revival of *The Cardinal*, with Oswald Dale Roberts repeating his memorable performance in the chief role; S. N. Behrman's witty American comedy, *Biography*, in which that charming actress, Betty Larke-Smith, making her debut, gave a polished and convincing portrayal as a sophisticated portrait-painter; the popular romantic costume play, *Marigold*; the perennial farce, *The Private Secretary*, which claimed a fortnight's run with Donald Gordon at the top of his form in the lead; *Double Door*, gripping melodrama in the grand Guignol tradition, and that humorous study of a moonstruck family, *Three-Cornered Moon*, in which Katherine Page, another clever newcomer, scored a well deserved success. However, the three most noteworthy productions were *The Far-Off Hills*, *The Admirable Crichton*, and *Major Barbara*.

"The far-off hills are green" is an Irish version of "Distance lends enchantment". So away went the Repertory Players to the green of the western world, and *The Far-Off Hills* which offered what Synge called "a fine bit of talk". In the same delightful vein as *The Whiteheaded Boy*, Lennox Robinson's tale of the eventful lives of a blind man and his three daughters ripples with broad humour, a free sense of fun, the dialogue

bubbling like a peaty torrent through Celtic sunlight. In
Robert Young's richly persuasive production, the Players
caught the spirit of exuberance and the Irish speech with
accuracy, but it was Brefni O'Rorke's play. He had won a
big reputation as an actor at the Abbey Theatre, and, therefore,
such a play was familiar and beloved territory to him. In the
part of the blind man, he not only did much talking but
presented to Northampton a rare sample of the lyric quality
of acting for which the Abbey Theatre is famed throughout the
world.

On the occasion of the Jubilee of H.M. King George V,
the play selected was Barrie's *The Admirable Crichton*, proclaimed
by the famous dramatic critic, A. B. Walkley "as delightful a
play as the English stage has produced in our generation",
and by Professor Phelps as "the greatest English drama of
modern times". It is a penetrating social satire showing the
fragility of caste by the simple process of shipwrecking Lord
Loam, his aristocratic relations, and his butler, Crichton, on a
desert island on which Crichton proves himself their leader,
and eventually their king. Crichton, played by Patrick Crean
with urbanity and polish, was the conservative butler, believing
in the fundamental differences in the world: "some men are
born to command, others to obey". Oswald Dale Roberts's Earl
of Loam, Betty Larke-Smith's Mary, Zillah Grey's Agatha, and
Donald Gordon's Ernest, were well-drawn character-studies.

In May 1935, Mr. Young resigned his post as producer at
the Repertory Theatre so that he could return to politics, and
chose as his last play that superb comedy, *Major Barbara*,
wherein Mr. Shaw lets fly the shafts of his satire and the darts
of his daring at the curse of poverty and other social evils.
Although written thirty years before, its topicality was as fresh
as ever, particularly the arguments of Undershaft, the munition-
maker, whose assertion that munitions are the way to achieve
economic strength and safety was being bellowed by a certain
exponent of a "new order". Oswald Dale Roberts con-
vincingly pointed Undershaft's arguments. Freda Jackson was
an imposing Lady Britomart. Nicholas Phipps placed Adolphus
securely among the poets, and Betty Larke-Smith tackled
Barbara the Salvationist with enthusiasm. Robert Young's
production kept the play fluently alive.

Few playgoers realize what is the real function of a producer. To the majority he is not a person but, at the least, a name, or, at the most, a hidden mysterious being, who is somehow concerned in bringing the play before the audience. Actually, a producer must be an artist and critic rolled into one. He must be able to control, but rarely, if ever, command. He must work without the creative satisfaction of the author or the emotional expression of the actor, and yet he must share the outlook of both. Much of his hardest work is done in the study before rehearsals commence. There he has to master the play completely in cold blood. Then, there is casting the parts, designing the settings and plotting the lighting as well as working out each movement of each character, and plotting it in the script at the appropriate line. The rehearsal period follows, when the artistes gather together and the studio plans are tested in practice. Sometimes this means quick and resourceful modifications. Think of doing that every week for forty-eight weeks in the year, and, in addition, interviewing and engaging new players, searching for and reading fresh plays and the like. Considering the strenuous work and nerve-strain which this delicate and exacting job of a producer entails, it is small wonder that both Herbert Prentice and Robert Young had breakdowns. The "everlasting" producer would need to possess the drive of a Henry Ford, the patience of Job, the constitution of Bernard Shaw, and the hide of an elephant!

Observations made by Robert Young in an article entitled "The Repertory Producer", which he contributed to a theatrical journal, are so germane and enlightening that they are deemed worthy of quotation.

"It is the absence of time which proves the greatest stumbling-block to the repertory producer," wrote Mr. Young. "Organization is the essential condition of success, for no time must be wasted. I prepare each play in detail before starting my first rehearsal. Every move is carefully marked in my producer's copy, and all grouping arranged. Of course, during rehearsals it is sometimes wise to make minor alterations, for one must remember that the artistes bring their contribution to the pooled work, and if an artiste

is experienced and has technique, he can be of much assistance by the quality of his interpretation of a given part.

"But actually rehearsing the plays is only one part of a producer's duties. There are about forty-eight plays to be chosen every year, and, of course, there are not enough really suitable good plays to fill in each week. For instance, we cannot produce every London success here. Some contain too many characters, others have a theme which may not appeal to local audiences. From London successes, one turns to the classics, and here again many problems arise.... This work of selecting plays is full of pitfalls. Not only must the plays be as good as possible: they must also be varied in their sequence, otherwise our audiences weary of similar themes. Further, we have to bear in mind the limitations of our material in flats, and also the physical limitations of the staff. They are always working at top pressure. We have to avoid two big productions following one another, for we have not enough flats, etc., to make six different full-stage scenes. (Those flats in use for one play cannot be used for the following week.) So that the plays have to be balanced one against another in plot, simplicity of setting, and size and nature of parts."

In the productions he tackled, Mr. Young showed amazing courage and enterprise. Not only did he re-introduce Shakespeare and introduce Ibsen into the repertoire, but he was responsible for the direction of a large number of ambitious productions and several new plays. Possessing a shrewd understanding of human nature combined with sound technical knowledge, Mr. Young proved himself a talented producer. Noteworthy features of his productions were a close attention to detail, skilful grouping, effective lighting, and swiftness of movement and tempo, thereby maintaining the tension from rise to fall of the curtain. Inevitably, one gained the impression that behind the curtain and the players, who had achieved splendid team-work under Mr. Young's leadership, was a flame of sincerity. Let Mr. Young add his own tribute to the Company and Staff: "During my three years at Northampton," he wrote, "I have produced about 144 plays: we have never had a serious hitch. This is a tribute to the whole company

and staff, who work together with fine co-operation and speed. I regard the mere feat of learning a new play weekly as a miracle of memory on the part of the artistes."

No one can deny that during Robert Young's régime, the Repertory Theatre enhanced its reputation and standing in the world of the theatre. Whereas it was once the Cinderella of Repertory theatres, chiefly because of the much despised twice-nightly system, it had won a place in the vanguard among the half-dozen leading English repertory theatres. A praise-worthy and notable achievement for a theatre burdened with enforced limitations.

A NEW ORDER

"In gallant trim the gilded vessel goes:
Youth on the prow, and Pleasure at the helm."

THOMAS GRAY

YOUTH left the prow and took over the helm when Bladon Peake became producer at the Northampton Repertory Theatre in June 1935. "Long experience made him sage", and yet he was still quite a young man, abounding in the vigour and burning enthusiasm of youth. "My father was a Non-conformist minister, and my mother a bareback rider in a circus," he confessed to an interviewer, "if you think that combination can be regarded as conducive to a dramatic urge." Nevertheless, the theatre was his true love from the time he became associated with Mr. Nugent Monck, who produced the Northampton Pageant in 1929, and participated in the establishment of the now famous Maddermarket Theatre, Norwich. Thereafter, he had a varied and eventful career becoming co-founder of the Crescent Theatre, Birmingham, where he was stage director, and, from 1925 to 1932, he wrote and produced numerous plays for the B.B.C.. He had also acted as the dramatic critic for the *Birmingham Weekly Post*, and the theatrical correspondent to the *Sunday Times, Manchester Guardian*, and *Daily Express*. In 1934 he became director of productions at the Abbey Theatre, Dublin, the most famous repertory in the world, thus joining a line of eminent producers among whom were Lennox Robinson, Fred O'Donovan, and St. John Ervine. Fully conscious of the exacting demands which fell upon him as successor to Robert Young, Mr. Peake began his work determined to maintain the high reputation of the Repertory Theatre.

A refreshing picture of sunny Devon painted in bright but homely hues by that unerring artist of rustic life, Eden Phill-potts, and entitled *Devonshire Cream*, served to introduce Mr. Peake as producer. The story revolved round the hatred of old Elias Widecombe, a headstrong and vindictive farmer for his

neighbours, the Blanchards, and his chagrin when his daughter, Beth, dared to fall in love with Robert Blanchard, the present representative of that family. Oswald Dale Roberts as Elias, Freda Jackson as his wife, Katherine Page as Beth, and Patrick Crean as Robert limned these Devon folk with nice gradations of light and shade, while Donald Gordon's William Blee, the herdsman, was a choice study full of rustic humour. There was richness in Mr. Peake's *Devonshire Cream*, resulting from realism of setting, effective lighting, and speedy playing, and the players' "mechanics" were cunningly worked out. Play-goers found sufficient satisfaction to feel that the direction of the Company was in experienced and able hands. This feeling was confirmed in subsequent productions, particularly by a lively production of the Quintero's sunny Spanish comedy, *The Women Have Their Way*, preceded by Chekhov's subtly humorous jest in one act, *The Proposal*; by *Payment Deferred*, a tense study in the macabre in which Oswald Dale Roberts gave a compelling performance as a bank clerk whom poverty drives into a desperate plight; by *Distinguished Villa*, Kate O'Brien's sterling first play, depicting Suburbia with remark-able veracity; and by Dryden's *Marriage à la Mode*, which will be commented on later.

The Repertory Players' broadcast of *Caesar's Friend*, with the full B.B.C. orchestra, on Sunday, 25 August 1935, thrilled everyone who was fortunate enough to hear it. This dramatiza-tion by Campbell Dixon and Dermott Morrah of the events preceding the Crucifixion proved an excellent radio play. Oswald Dale Roberts repeated the superb performance as Pilate which he gave in Robert Young's impressive production at the Repertory Theatre in September 1934, and the whole Company gave an intensely sincere and stimulating rendering, which was widely appreciated, so much so that the B.B.C. invited the Repertory Players to give a repeat performance on Good Friday, 10 April 1936. "Friday sees a revival of *Caesar's Friend*, which was first given in August last year," commented the *Sunday Pictorial*. "The Players come from the Northampton Repertory Theatre, which is always good for something out-standing." Based on those pregnant words from St. John's Gospel: "And from thenceforth Pilate sought to release Him: but the Jews cried out, saying: If thou let this man go, thou

art not Caesar's Friend", the revival was eminently suitable
for presentation on such a sacred day and proved equally as
successful as the previous performances by the Company,
evoking many complimentary notices in the Press and hosts of
congratulations from listeners.

For his fourteenth production, Mr. Peake tackled a new play,
The Wasps' Nest, by Adelaide Eden Phillpotts and Jan Stewart,
a well knit and exciting play with—as one might suspect from
its title—a sting in its tail. Although the plot conformed too
strictly to a well worn pattern, Katharine Page, Olga Murga-
troyd, Patrick Crean, Courtney Bromet, and Oswald Dale
Roberts kept it moving briskly and acquitted themselves with
credit. The authors expressed their delight with the whole
production, paying a special tribute to the contributions of Mr.
Peake and Mr. Robinson.

Quite early Bladon Peake showed his relish for cracking
hard dramatic nuts. Among those in his first season were
Reginald Berkeley's *The White Chateau*, a noble and vivid
indictment of war; *Escape Me Never*, and *The Taming of the
Shrew*. Neither *The White Chateau*, with its six episodes and
considerable cast, nor *Escape Me Never*, with eight scenes and
twenty-two characters was an easy proposition for twice-
nightly production; but Mr. Peake's alert direction matched
his courage. Margaret Kennedy's *Escape Me Never*, the
poignant tale of the wanderings of Gemma Jones, a little waif,
along the far from rose-strewn paths of love, gave Olga Murga-
troyd a finely taken opportunity to show her prowess in roles
calling for emotional treatment. Her Gemma was a lovable,
mercurial little creature. The production was artfully staged
and lighted, the semi-impressionistic effects being exceptionally
well devised. Miss Murgatroyd scored another success with
her Katherina in *The Taming of the Shrew*, Shakespeare's story
of the Paduan wooing. She gave a forthright performance as
the notorious termagant, and, as Petruchio, Alastair Mac-
Intyre carried off the wooing and the taming with a high hand.
The insipid Bianca was made as engaging by Katherine Page
as that colourless part permitted, and Oswald Dale Roberts
dealt roundly with Baptista.

A vexed question since the early days had been whether
once-nightly or twice-nightly performances were the more

preferable at the Repertory Theatre. It had often been debated by the Board, who were unanimous that once-nightly performances were preferable but impractical. They were preferred because they enabled longer plays to be performed and thus allowed a wider choice of plays, removing the necessity of cutting the scripts and reducing the arduous work of the artistes and staff. Notwithstanding, the twice-nightly system was considered more practical since it permitted prices to be lower and two houses a night suited playgoers who came from long distances, and those who dined late or supped early. As an experiment the directors decided to give once-nightly performances each Monday at 8 p.m. This interesting innovation was inaugurated when the Mayor and Mayoress of Northampton (Councillor and Mrs. Sidney Perkins), together with the Corporation and representatives of town organizations attended the opening performance of *The Taming of the Shrew*.

The departure of esteemed artistes is a regrettable part of the order of the changing scene of a repertory theatre. The end of 1935 saw three popular and versatile players leave the Company for higher realms. After delighting audiences with her forceful and intelligent acting for two-and-a-half years, Freda Jackson brought her stay to a close with a finely controlled delineation of Stella Kirby, the actress daughter, in *Eden End*. This incisive study of a clash within the family of a north country doctor proved to be one of J. B. Priestley's most thoughtful and adroit plays, and for sense of atmosphere, style, and fidelity to the author's purpose, Bladon Peake's production deserved to rank with his finest work at the Repertory Theatre. His hundreds of admirers regretted the departure of Donald Gordon, who had shown marked versatility in his stay of four years during which he had done excellent work. He delighted in humorous character parts and appropriately his final role was a rollicking one in the pantomime, *Sinbad the Sailor*, which the whole Company played with gay abandon. In response to innumerable requests, *The Barretts of Wimpole Street* was revived, thus enabling Oswald Dale Roberts to repeat his superb character-study of the tyrannical father of the gentle Elizabeth Moulton-Barrett before he bade farewell to the Company. In the history of the Repertory Theatre, few players had given of their best so conscientiously and so consistently.

He had borne the heaviest burden among the players in the course of three-and-a-half years, and had done a prodigious amount of work. Moreover, he had won a warm corner in the hearts of all frequenters of the Repertory Theatre for his many fine performances, notably as Edward Moulton-Barrett, Shylock, the Cardinal, Pontius Pilate, Lord Loam in *The Admirable Crichton*, Sir Toby Belch, Doolittle in *Pygmalion*, Iago, William the waiter in *You Never Can Tell*, and Peterkins in *Jack and the Beanstalk*. All his work was characterized by dexterity of technique, finish, and integrity. In his farewell speech, Mr. Dale Roberts said it would be a big wrench to leave Northampton, and closed with the words of Sir Henry Irving, "I go as your humble, grateful, and obedient servant."

Changes also took place in the constitution of the private Company known as Northampton Repertory Players Limited. On 21 January 1936, an Extraordinary General Meeting of the Company was held. Resolutions for winding up the Company were adopted, and Mr. H. Musk Beattie and Mr. W. H. Fox, who were appointed liquidators, were authorized to register a new Company, which was to be a non-profit-distributing Company, with the same name as the original Company. The new Company was registered on 30 January 1936, and the first Board of Directors consisted of Mrs. Helen Panther, Mr. P. B. Baskcomb, Mr. W. J. Bassett-Lowke, Sir John Brown, and Mr. H. Musk Beattie.

The versatility of the Repertory Players knew no bounds. From pantomime to comedy, from comedy to drama, from drama to expressionistic plays, they successfully rang the changes of style and tempo during the eventful year of 1936. Each Monday night saw them assuming fresh guises and taking new parts in plays of a wider range than ever before. And they did so as easily and pleasingly as a mannequin slips from one Paris model into another. Comedies, always conspicuous in any repertoire of plays in an English theatre, were a prominent feature. The ninth birthday play, *Youth at the Helm*, was a brisk farcical comedy spun round the subterfuges of an impecunious member of the upper classes, who bluffs his way into a post at a London bank. A stringent satire, its lines had a racy snap, and its extremely funny situations were admirably portrayed by Courtney Bromet as the bluffer, by George

Mudie, an experienced newcomer, as the chairman of the bank, and Betty Larke-Smith as his decorative daughter. *Duet in Floodlight* revealed J. B. Priestley in a new light waxing satirical about the queer ways of the theatre-world, and about the marriage for publicity of a popular playwright and a popular actress, played with verve by Paul Harford and Olga Murgatroyd respectively. In Noel Coward's hilarious trifle whipped up with wit and finesse, *Private Lives*, Paul Harford and Betty Larke-Smith shared honours equally in their polished playing of Elyot Chase and Amanda Prynne, those two diverting defaulters in the matrimonial stakes.

The crop of thrillers was small in quantity but large in quality. *Somebody Knows*, John van Druten's life-like crime play, which is a collector's piece in murder, was effectively staged and acted, George Mudie, Olga Murgatroyd, Patrick Crean, Margaret Gibson, Eric Micklewood, and Dorothy Evans deserving special praise for maintaining the tension. In Frank Vosper's baffling *Love from a Stranger*, telling of Bruce Lovell, a breezy colonial, who conducts a tempestuous wooing of Cecily Harrington, a wealthy young woman, Paul Harford (Bruce), and Betty Larke-Smith (Cecily) rose to heights of emotional acting, especially in the sensational third act with its terrific thrill at the climax.

Fine acting and shrewd direction made two worth-while plays, *The Roof*, Galsworthy's study of a Paris hotel fire with George Mudie giving a grand performance, and Harley Granville-Barker's Edwardian masterpiece. *The Voysey Inheritance*; and three popular successes: Keith Winter's *The Shining Hour*, in which Dorothy Evans gave a convincing performance in the difficult part of Judy Linden, the wife, Alastair MacIntyre appeared as Henry, the husband, and Betty Larke-Smith's Mariella, the other woman, afforded a vivid piece of acting; *Sweet Aloes*, with Dorothy Evans contributing a charming performance of much merit in the Diana Wynyard part, ably supported by Alastair MacIntyre and Patrick Crean; and *Nina*, with its dual role gave Dorothy Evans unlimited opportunity to indulge her really astonishing versatility.

Bladon Peake believed that if the theatre did not experiment it would die and acted upon that assumption. He welcomed the chance to experiment by producing ambitious productions,

new plays, and expressionistic plays. The new play given in 1936 was written by a finely equipped and well-known playwright, Edward Percy (who is, in fact, Edward Percy Smith, M.P.), author of *If Four Walls Told*, *Suspect*, and *The Shop at Sly Corner*. Entitled *Mary Darling*, it was a lively farcical comedy woven around an attractive woman with many admirers, who is a widow and impecunious. She is prepared for a man to change the former state if he can remedy the latter. Katharine Page endowed her with resourceful charm, and the play was admirably mounted by Osborne Robinson, and admirably directed by Bladon Peake, to both of whom gratifying tributes were paid by the author.

Although St. John Ervine declares that expressionism appeals only to neurotic minds, as an art form it has undoubtedly achieved a measure of influence on the development of the drama, and, therefore, deserves an occasional place in the theatre of ideas. Whereas the realist strives to reproduce actuality on the stage, the expressionist works in terms of allegory and metaphor, prefers the abstract to the concrete, and substitutes symbolic types for human characters in an endeavour to interpret subjectively either the happenings in a man's soul or the inner secrets of his mind. It is an analysis rather than a picture of life. Several expressionistic plays had already been given by the Repertory Players, notably *R.U.R.*, *The Rumour*, and *The White Chateau*, but it remained for Mr. Peake to produce the "tour-de-force" of this movement, Elmer Rice's *The Adding Machine*. In tracing the purgatorial progress of Mr. Zero, a humble clerk, after he has stabbed his boss with a bill-file, the author exposes the barrenness and monotony of "white-collar" slaves. Pitilessly and pityingly, with a curious conglomeration of scorn and tenderness, he unmasks the machine-forced mind of the Zero type, the slave type that never escapes from mediocrity. An exceedingly difficult play was more than reasonably well done. Mr. Peake's production was bold, well contrived, and imaginatively lighted against symbolic settings that stressed the motif of the play skilfully devised by Mr. Robinson. The brainstorm scene with its sudden flashes of light and nightmare noises left the audiences gasping—and blinking! Patrick Crean (Mr. Zero), Katharine Page (Mrs. Zero), Olga Murgatroyd, George

Mudie, Dorothy Evans, and Courtney Bromet stood out prominently in a long cast. The other example of expressionism enacted in 1936 was *The Macropulos Secret*, a later play by Karel Capek, author of *R.U.R.*, propounding the thesis of the possibility of extending the span of human life. As Emilia Marty, the daughter of Macropulos, a Greek physician, who discovered the secret by which life can be prolonged, Margaret Gibson gave a telling and beautiful performance. Mr. Peake and Mr. Robinson again combined to underline the author's purpose with appropriate symbolism in lighting and design.

Apart from these two expressionistic plays, there was no dearth of large-scale productions, the most outstanding of which were Dryden's *The Spanish Friar*, *The Constant Nymph*, *Many Waters*, *A Sleeping Clergyman*, *Richard of Bordeaux*, and *Macbeth*. Margaret Kennedy's tragi-comic story of the unconventional and undisciplined Sanger family, *The Constant Nymph*, gave Paul Harford and Katharine Page a well taken opportunity for vivid acting as Lewis Dodd and Tessa. *Many Waters*, Monckton Hoffe's "romantic chronicle" of ordinary life in ten scenes and with a cast of thirty-three, strained the Repertory Theatre's resources, but the Company and staff responded nobly. With Paul Harford, Margaret Gibson, Dorothy Evans, and Patrick Crean playing the leading roles, it was creditably performed. With its eleven scenes, James Bridie's *A Sleeping Clergyman*, depicting the struggle of genius against the blindness of its time, proved a tough proposition. Not surprisingly perhaps, the production lacked something in cohesion, but a word of praise was due to Maurice O'Brien for his portrayals of a lawless medical student with a sickly body, and of his flamboyant successor. More success came with *Richard of Bordeaux*, Gordon Daviot's historical drama in modern prose in spite of its many scenes and large cast. Against exquisite settings by Osborne Robinson, vigorous and forthright performances came from Peter Folliss as Richard II, from Olga Murgatroyd as Anne, his Queen, from Alastair MacIntyre as the Earl of Gloucester, and from Paul Harford as the Earl of Oxford.

Bladon Peake's production of *Macbeth* was a good straightforward reading. The splendour of phrase and all the high sheen and flourish of the sublime tragedy were there, and if at

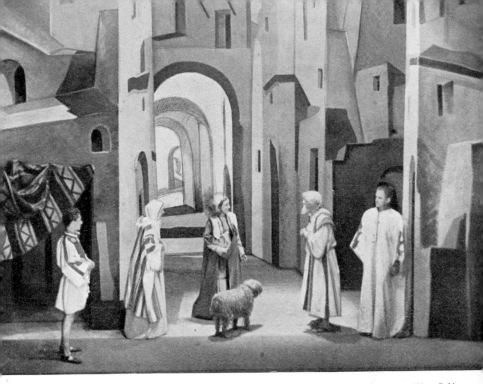

(*Above*) "TOBIAS AND THE ANGEL" (1939)

(*Below*) "ST. JOAN" (1940)
 Rosemary Johnson as "Joan of Arc"

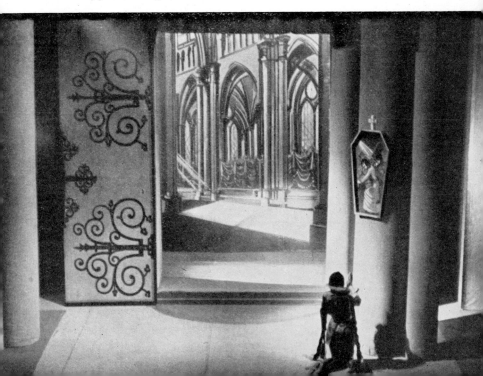

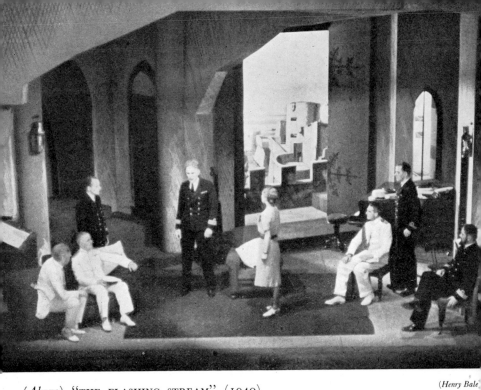

(*Above*) "THE FLASHING STREAM" (1940)

(*Henry Bale*)

(*Below*) "A HUNDRED YEARS OLD" (1942)

(*Henry Bale*)

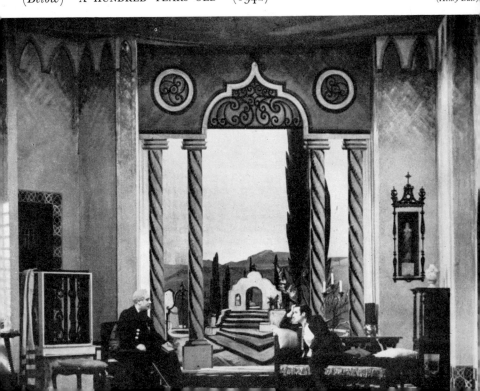

times this courageous production faltered a little, that was due to the play defying production in one week and to poor performances by one or two un-Shakespearean actors. Alastair MacIntyre wrestled with the formidable part of Macbeth. His performance had vigour and power but not depth of feeling. He was never a man betrayed by an obsession to win glory. Patrick Crean's Malcolm and Paul Harford's Banquo were satisfying performances, and Betty Larke-Smith, as Lady Macbeth, spoke with point and feeling. The utmost praise was due to Osborne Robinson who designed not only the settings, which lacked nothing in colour and atmosphere, but also the costumes, and to the staff of the theatre's workshops who made the settings, properties and costumes. The whole production was indeed a commendable achievement for a twice-nightly repertory theatre.

Enterprise was the key-note of the year 1936, during which a veritable panorama of the drama had been presented. It had been another arduous year for the Company, but an exciting and rewarding one for playgoers. The Repertory Theatre, which several years before had leapt into the front rank by virtue of vigorous production and capable acting, had not only amply maintained those attributes but had enhanced the quality of the plays performed. It stands out as a year of fine endeavour and substantial achievement, closely rivalling the momentous year of 1934. The work of both those years was a token that the Repertory Theatre had reached maturity and stood in the forefront of the Repertory Movement.

HIGH FESTIVALS

"Imagination! Imagination! I put it first years ago when I was asked what qualities I thought were necessary for success on the stage."

<div align="right">ELLEN TERRY</div>

BIRTHDAY messages were received from a number of famous people when the Northampton Repertory Theatre celebrated its tenth birthday on 10 January 1937. Among them were George Bernard Shaw, J. B. Priestley, St. John Ervine, Miss A. E. F. Horniman, Basil Dean, Geoffrey Whitworth, and Tyrone Guthrie. "Indeed I am delighted to send you my good wishes for the success and ultimate triumph of your Theatre," wrote that indefatigable pioneer, Miss Horniman, then aged seventy-six. "It is many years since I made my first attempt at interfering with the stage; it was Easter, 1894, when a certain amount of curiosity was aroused by the doings at the Avenue Theatre, and no one guessed that an obscure suburban spinster was doing secretly something which would have far-reaching effects. Let our public come in confidence that every one of you is doing his or her best, and giving the play a fair chance. Honest working together must be the foundation of any solid success."

J. B. Priestley said, "I congratulate Northampton on having the sense to keep a good Repertory Theatre going for ten years. I never see the notice of a Repertory Theatre in a town without my heart warming towards the place, not merely because the presence of such a theatre gives me the chance of picking up some royalties there, and possibly one or two promising young actors and actresses, but because I know that in that town there are some people who are enjoying the indefinable but unmistakable thrill of the theatre, the genuine performance as compared with the shadow play of the screen. I hope Northampton can look forward to another ten years of Repertory." In characteristic vein, G.B.S. wrote: "Messages do no good to anyone and are an intolerable nuisance to the people who are asked for them. My message to you is—do my plays

and send me plenty of royalties. When you celebrate your one hundredth birthday, write again."

Progress rather than enterprise marked the year 1937, and the progress was in artistic realms rather than financial. Unfortunately, public support tended to slacken and waver, and again the choice of plays had to be tempered to the winds of public favour. In consequence little new ground was broken. Current or recent West End successes received preference to the classics or plays with an intellectual appeal. Among the comparatively small number of costume plays and large-scale productions, the most noteworthy were *Sir Martin Marr-all, Carnival*, and *Late Night Final*, an outspoken exposure of American sensational journalism, with George Mudie, Anthony Pelly, and Neil Tuson outstanding in a slick impressionistic production. The crop of melodramatic plays was unusually large, the prize exhibits being Emlyn Williams's psychological study of the mind of a callous murderer, *Night Must Fall*, in which Josef Shellard placed himself arrogantly and securely in the confidence of the old Mrs. Bramson, played by Olga Murgatroyd, and her niece by Pamela Gordon, the vivacious daughter of Gertrude Lawrence; *And the Music Stopped*, a tense and ingenious thriller, acted with speed and verve by Helen Irving, Anthony Pelly, George Mudie, and Neil Tuson; *The Amazing Dr. Clitterhouse*, wherein Patrick Ross contrived to suggest the slender line between sanity and eccentricity in the title-role, and *Suspect*, in which Dorothy Fenwick, a talented newcomer, gave an excellent performance, compelling and forceful.

On the lighter side, comedy was ably represented. The delightfully satirical *Tovarich* found Paul Harford and Olga Murgatroyd displaying a perfect sense of comedy as a Russian Prince and his wife exiled in Paris and living in picturesque squalor. St. John Ervine's riotously witty *Anthony and Anna*, extolled the virtues of honest toil. The dialogue was embroidery of the most skilful and provoked constant bursts of laughter. Neil Tuson, as an American millionaire, Dorothy Evans, as his charming daughter, Eric Micklewood, as an engaging idler, and George Mudie, as a voluble head waiter, gave exhilarating performances. Strong in romantic interest and full of diverting humour, *Heart's Content* provided Dorothy

Evans with another personal success. She brought a sensitive quality, illuminating the tenderness and passion, to the part of a sophisticated young woman who unexpectedly meets the man of her dreams, a young Austrian, played with polish by Paul Harford. How a dog without a licence turned a town topsy-turvy provided great fun in *Storm in a Teacup*, a felicitious comedy freely adapted by James Bridie from the German, and every ounce of humour was extracted by Olga Murgatroyd, Paul Harford, Betty Larke-Smith, Neil Tuson, Dorothy Evans, and George Mudie, not forgetting Barry, who portrayed the mongrel dog, Patsy, with consummate ease!

A Little of Both, by Irma Russ, the only new play produced that year, dealt with the choice of a middle-aged authoress between her loyalty to a selfish husband and her desire to lead her own life—between frustration or fulfilment. In a painstaking production, the noted West End actress, Mary Byron, brought vivacity and skill to the leading part and received diligent support from the whole Company, but, though entertaining in many respects, the play failed to grip in its entirety, lacking subtlety and dramatic force.

In the realm of plays of greater depth were *Mademoiselle*, *Whiteoaks*, and *Ah, Wilderness*. In *Mademoiselle*, witty dialogue and a fine level of comedy stood out in vivid contrast to the dramatic central theme of the far-reaching effect of the intrusion of a repressed Mademoiselle into a self-centred, pleasure-seeking household. Margaret Gibson contributed a well observed performance as a frivolous wife and Pamela Gordon rarely surpassed her clever sketch of a pleasure-mad girl, whilst Olga Murgatroyd's Mademoiselle dominated the stage in a fine, controlled, and unfaltering study. After witnessing this production, Godfrey Winn wrote in the *Daily Mirror*, "A town without a proper permanent theatre is like a mind without a memory. And I cannot help feeling it is a pity that Northampton citizens do not show their appreciation in a more concrete manner. When I went to a performance of *Mademoiselle*, I found the theatre half empty. In Osborne Robinson, Northampton presents one of the most brilliant scenic designers in the country." Mazo de la Roche's *Whiteoaks*, that superb cameo of a clan and its chieftainess, was admirably enacted. Gwladys Black Roberts portrayed that wise, witty, rock-like

centenarian, "Gran" Whiteoaks, with keen perception. As her shy, sensitive grandson, Finch, Neil Tuson played with restraint and depth of feeling, and Iris Sutherland gave a sympathetic performance as her daughter-in-law, Pheasant. How real are the high hopes and sudden, overwhelming tragedies of adolescence was revealed with delicacy and understanding by Eugene O'Neill in *Ah, Wilderness*, in which Josef Shellard strove to bring out the lovable, muddle-headed qualities of the boy, competently assisted by Eric Micklewood, Margaret Gibson, George Mudie, and Betty Larke-Smith.

When the Repertory Players broadcast St. John Ervine's *The Ship*, on Sunday 4 April 1937, numerous letters of congratulation were received, including one from the author, who wrote, "I wish to thank the Company for an extremely fine performance. The play was beautifully done by all who took part in it." Clearly, the punctilious Mr. Ervine had made a considerable revision in his opinion of the Northampton Repertory Theatre since its early days!

"Rumour," it is said, "is a lying jade", and so thought the management of the Repertory Theatre when, in August, 1937, a rumour spread through the town and district that the theatre was permanently closing down. The Company's lease had several years to run, and, although from time to time audiences had been small, the directors had not the slightest intention of terminating the work of the Repertory Players. Mr. F. W. Cotter Craig, a keen student of the drama and supporter of the Repertory Movement, who had been appointed Manager in July 1937, and brought geniality and efficiency to the front of the house, dealt roundly with this fictitious story. He gave an authoritative denial to the stupid rumour, describing it as a "misleading and damaging canard". Before becoming an actor and manager of the Malvern Players, Mr. Craig had practised as a barrister-at-law, and one naturally wonders whether the fact that several plays of a legal flavour were performed during his first session was due to him or merely a coincidence. The plays in question were *The Magistrate*, Pinero's bright comedy of judicial susceptibility; Edward Wooll's *Libel*, showing human beings striving to escape entanglement in the merciless mills of the law, with Iris Sutherland and Donald Gordon standing up for struggling humanity, and Neil

Tuson, Anthony Pelly, and Leslie Sparkes representing the Law; a rollicking light comedy, *Laughter-in-Court*, and *The Ware Case*.

Few Northamptonians knew that a well-known playwright had visited the town regularly for almost a quarter of a century. He was George Pleydell Bancroft, a handsome man of striking personality, who had won distinction in the realm of the Law and the world of the Theatre. Son of those famous artistes, Sir Squire Bancroft and Lady Bancroft, who was Marie Wilton, he was a child of the Theatre and had married Sir John Hare's daughter, but it was as the Clerk of Assize of Midland Circuit that he came to Northampton three times a year. Between his appointment in 1913 and his retirement in 1946, Mr. Bancroft was connected with many "causes célèbres" and murder trials, including the Green Bicycle Case, and the Rouse Trial at Northampton. Small wonder then that he was author of *The Ware Case*, acclaimed to have the most accurate and dramatic trial scene ever written. Nothing could be more apposite than that it should be acted by the Repertory Players while the Assizes were being held in the town, and, so it was arranged. At the first performance on the 18 October 1937, the excited anticipation of the audience savoured of the first night of a new play. Seated in the Dress Circle were Sir Malcolm Macnaughton, K.B.E., His Majesty's Judge of Assize, and Lady Macnaughton, with the author and his wife. A number of counsel and solicitors were also there and enjoyed the excitement and especially the tensely dramatic conflict in the trial at the Old Bailey, and the startling disclosure on the culminating scene. That night was indeed a "busman's holiday" for lawyers! In the part of Sir Hubert Ware, originally played by Sir Gerald du Maurier, Patrick Ross gave a strong and persuasive performance. Iris Sutherland made an appealing Lady Ware, and Neil Tuson invested her brother, Eustace, with the right amount of anaemic effeminacy. Anthony Pelly and Patrick Hunt Lewis presented two leading counsel with firmness and dignity. Mr. Bancroft heartily congratulated the Company on the whole production.

John Dryden, who was born at the rectory of Aldwinckle All Saints, between Thrapston and Oundle, on 9 August 1631, is the only dramatist Northampton can claim. As poet,

satirist, and playwright, he was a living force of unusual
influence in English letters. As a dramatist, however, Dryden
was not so distinguished as the "glorious John", who became
Poet Laurate in 1668. His fourteen plays had most of the defects
of their age, and these were accentuated by his hankering after
the poetry of Shakespeare, and the stinging wit of Molière.
Nevertheless, nothing could suppress his own virility of speech
or surpass his command of fine rhetorical artifice. To Bladon
Peake must go the credit for instituting an annual Dryden
Festival which won for the Repertory Theatre high repute
among discerning critics and playgoers. He was not slow to
make the town conscious of its duty to honour John Dryden,
and planned to inaugurate an annual festival of his plays
during the second week of August 1935, which coincided with
the anniversary of Dryden's birth. Owing to requests received
from playgoers all over the country and to certain distinguished
visitors being unable to attend then, the Festival was post-
poned for five weeks.

Marriage à la Mode, chosen for the first Festival, aroused
widespread interest. A production of Dryden's best comedy,
first acted in May 1672, was hailed as an event of considerable
literary and dramatic importance to all theatre-lovers. The
theme of the principal plot is foretold in the opening lines:

> "Why should a foolish marriage vow,
> Which long ago was made,
> Oblige us to each other now
> When passion is decayed?"

Rhodophil and his wife, Doralice, having been married two
years, find that the first glamour of marriage has worn off.
They both secretly decide to go their separate ways. Each has
an amorous intrigue marked by piquant and amusing conse-
quences. This witty, satirical comedy proved a wise choice
and besides meeting with instantaneous response from the
public, received enthusiastic notices in the national newspapers
and reviews. For instance, the *New Statesman* declared:

> "High praise must be awarded to Mr. Osborne Robinson
> for his delightful black and white permanent setting and
> gay costumes. The producer, Mr. Bladon Peake, con-
> fronted with a heavy task, wisely decided to concentrate on

pace, and the comedy went with a swing throughout. The play opened and closed to music, and one could have wished for even more, especially in between the various scenes. Outstanding members of the cast were Oswald Dale Roberts (Polydamus), Donald Gordon (Palamedel), Katharine Page (Doralice), and Freda Jackson (Melantha), all of whom gave beautiful performances. The Northampton Repertory Theatre has done a fine and courageous thing, and one looks forward eagerly to the next Dryden Festival."

Sir Archibald Flower, Chairman of the Governors of the Shakespeare Memorial Theatre, Stratford-on-Avon, and Mr. B. Iden Payne, the producer, who were among the many distinguished visitors, expressed their amazement that a production of such quality could be achieved in such a short time. They voiced their admiration for the actors who so readily assumed the heroic mould and the excellent work of Mr. Peake and Mr. Robinson.

The following year Sir Archibald Flower penned an encouraging message. He wrote, "Having watched for many years the pleasure and inspiration gained by the millions who have attended the plays of Shakespeare at the Stratford-on-Avon Festival, I am greatly interested in any effort to provide fine drama for the people. Last year, I was present at the production of Dryden's *Marriage à la Mode* at the Northampton Repertory, and I wish your organization every success in the coming Festival. It is fitting that a special effort should be made to perpetuate the memory of Dryden by the presentation of his plays in the county of his birth."

The second Dryden Festival saw the Repertory Players presenting *The Spanish Friar, or the Double Discovery*, a diverting tragi-comedy full of rout and fustian in which the comic character of the accommodating friar was a lampoon on the Roman Catholic clergy. Attacking the play boldly, the Company wrested from it a lively entertainment. Bladon Peake's production was both imaginative and discriminating and Osborne Robinson's costumes and permanent setting showed style in design and good taste in use of colour. Rarely has a more exquisite picture in black and white been seen than that by the combination of the scene and costumes. Margaret Gibson

brought both confidence and comeliness to the Queen of Aragon, and spoke with a good sense of style. George Mudie cunningly assumed the load of mischief wrapped up in the person of the friar, and Patrick Crean cast Torrismond in the true romantic mould. Olga Murgatroyd, Paul Harford, and Neil Tuson also contributed lively performances. Many of the leading dramatic critics attended and T. C. Kemp of the *Birmingham Post* wrote: "The Northampton Repertory Company is to be complimented on its salute to Dryden. Gestures such as these from the repertory theatres—made as they often are under the stress involved by a weekly change of programme presented twice nightly at popular prices—are keeping the theatre alive in the provinces."

In 1667, that inimitable diarist and amorous civil servant, Samuel Pepys, witnessed the second and several subsequent performances of *Sir Martin Marr-all* the play selected for the third Dryden Festival. He was enthusiastic about it. "It is,' he says, "the most entire piece of mirth, a complete farce from one end to the other, that certainly was ever writ. I never laughed so in my life. I laughed till my head ached all the evening and night with laughing." According to the records available, the play had not been performed again until revived by the Repertory Players. A significant and praiseworthy achievement which received wide commendation including a half-column notice in both *The Times* and *Daily Telegraph*. A comedy with an air of careless abandon and spiced with hilarious wit and rollicking fun, it tells of the attempts of an egregious ass, Sir Martin, to win the hand of an heiress, Millicent. After misadventures and rebuffs, time after time, he is near his goal, thanks to the strategems of his ingenious serving-man, and every time he throws his chance away by his fatuity. Indeed, he is a descendant of Sir Andrew Aguecheek, and, as his exasperated servant says, he must have been knocked in his cradle. At last it is the servant who wins the heiress. Again, the acting was excellent. Anthony Pelly filled out the character of Sir Martin with a comic richness. Gwladys Black Roberts played Lady Dupe with assurance, and Iris Sutherland gave Mrs. Christian a generous measure of coy charm. But Helen Irving's vital Millicent and George Mudie's resourceful Warner, the servant, were the outstanding performances. In

a lengthy notice in *The Spectator*, Graham Greene, the accomplished novelist, playwright, and critic, wrote "The production at Northampton deserves high praise. They have chosen to make the whole thing a fairy story with costumes of the wildest fantasy and a charming set made up of dolls' houses and diminutive steps and streets, round which Sir Martin wanders like Gulliver in Lilliput with his gilded peruke sticking up like ass's ears. Push a house round by a handle and another scene is ready in its interior just large enough from the second floor to the ground to hold two or three characters. For this cast, one imagines, the annual Dryden play is a release of spirits after acting the grim commercial product twice nightly for a year—next week *A Girl's Best Friend!* Last week was it *Whiteoaks*? To a few of them good prose came rather stumblingly at first after the clichés, and the prologue was spoken as if it were prose—every natural pause at the couplet's end pedantically eliminated; but for Mr. George Mudie's spirited Warner, and Miss Helen Irving's Millicent, one has nothing but praise." "Mr. Peake's production is forthright, definite, and decisively in the vein of Restoration farce," remarked *The Times* critic, "Mr. Osborne Robinson, who designed the sets, is also responsible for an extraordinary gay wardrobe, not slavishly restricted in style, but always favouring the right period under a generously imaginative elaboration." The *Daily Telegraph* was even more eulogistic, it said, "Osborne Robinson's dresses are amusing and delightful enough to make the artiste's reputation in a night: if London could see them. The material, by the way, is slipper felt, and the total cost of the magnificent-looking show is said to have been £50." All three Dryden plays were indeed high festivals of artistic presentation and acting.

After working strenuously for two-and-a-half years, Bladon Peake resigned and his eventful régime as producer was brought to a close in January 1938. In the course of 116 productions, there had been no stint of diligence and sincerity in his work. Not only had he worthily maintained the high standard of mounting and production but had courageously directed many ambitious and stimulating plays of wide diversity. He could truly say with James Agate, "I love the theatre in all its manifestations, and in every width and height of brow, from tenth

rate provincial pantomime to Greek tragedy in a chalk-pit on a wet afternoon." Boundless enthusiasm, hard work, an arresting directness in attack, and, above all, a lively imagination had conspired to give his productions an essential integrity which brought honour to the Repertory Theatre.

CRITICAL YEARS

"When one thinks of the gallant Repertory movement which has to fight with all its strength merely to exist, one cannot help recalling the sad remark of Ruskin, 'I do not wonder at what men suffer, but I do wonder at what they lose.'"

J. W. MARRIOTT

WHEN, in 1938, the Northampton Repertory Theatre entered upon its twelfth year, the directors and the Company were brimful of optimism regarding the future. Everything seemed set for another year of comparatively smooth sailing. But beneath the placid surface there was a ferment which was gradually swirling up to breaking-point. Storm-clouds began to gather in Europe. Swashbuckling dictators, roaring and ranting, made exorbitant demands, and grabbed the home-lands of freedom-loving people as a starving man snatches at a crust. Every attempt to appease their ever growing greed proved abortive, and as the year waned, the shadows of war loomed on the horizon. Although the Northampton Repertory Players were not deflected from their adventurous course, the menace of such events was bound to react unfavourably upon the audiences. The days of calm seas were over and were followed by varying changes of fortune.

The impact of world events, however, was not the only problem facing the directors. *Daddy Long-Legs*, produced by William Sherwood, successor to Bladon Peake, on the Repertory Theatre's eleventh birthday, was the Repertory Players' five hundredth production. Those five hundred plays represented a large proportion of the plays available and suitable to the Company. Playgoers little realized the difficulties which confronted the directors in having to select forty-eight different plays each year. Of all the plays produced in the West End in a year, on an average not more than a dozen were suitable for performance at the Repertory Theatre and there was no certainty that they would be available. Often touring rights were held by managers who refused to allow the repertory

theatres to give the plays until the tours had finished. Even if a dozen West End successes were available, however, another thirty-six plays were required to complete a year's programme. When you also take into account the fact that the vast majority of classics were excluded because of their length or size of cast, you begin to see the dimensions of the problem. From thenceforward, revivals were inevitable. During the year there were no fewer than fourteen. However, the opportunity of witnessing such plays as *Candida*, *Mary Rose*, *Yellow Sands*, *Interference*, *Caesar's Wife*, and *Charley's Aunt* was like welcoming the return of old and trusted friends. In *Candida*, Bernard Shaw was well served by Dorothy Fenwick in the title role, Anthony Pelly as her sincere but fussy husband, and Neil Tuson as Eugene, the stray poet. *Mary Rose* found Madge Sellar as an acceptable Barrie heroine, with Courtney Bromet as Simon, her husband, and Arthur Lawrence giving a particularly delightful study as Cameron, the boatman-student.

Comedies for once in a way were far fewer than usual, A. A. Milne's *Sarah Simple*, *Square Pegs*, and *Yes and No* being the best of a rather nondescript batch. Whilst, on the other hand, no less than a round dozen of thrillers and plays of a melodramatic character were given, *To What Red Hell*, *I Killed the Count*, *Death on the Table*, *Black Limelight*, and *The Trial of Mary Dugan*, overtopping the others in their class. Percy Robinson's powerful indictment of capital punishment, *To What Red Hell*, in particular, was a fine piece of work. The efficient direction of Mr. Sherwood combined with the judiciously contrasted settings of Mr. Robinson, gave full weight to an arresting psychological study of the reactions of two groups of people, one a working-class home and the other a well-to-do family, to a murder. Strong and affecting performances were given by Rosemary Johnson, Morris Barry, Arthur Lawrence, Franklin Davies, and Oswald Dale Roberts, who made a welcome return to the Company in August.

J. B. Priestley, the year's most favoured playwright, was represented by three works, *People at Sea*, *I Have Been Here Before*, and *Time and the Conways*, each so different and yet all bearing the imprint of skilled craftsmanship. Set on S.S. *Zillah*, a ship carrying passengers and cargo to Central America, *People at Sea*, a dramatic play of ideas, introduced to repertory

audiences Sarah Churchill, daughter of the Rt. Hon. Winston Churchill, M.P., who had become a member of the Company. In *I Have Been Here Before*, Oswald Dale Roberts gave a well observed and powerful performance as the mysterious Dr. Gortler, who is obsessed with the idea of the pre-vision of events and who so drastically affects the destinies of three guests at the lonely inn on Grindle Moor. Mr. Priestley's second play dealing with the time theory, *Time and the Conways*, depicted the varying vicissitudes of an ordinary middle-class family during two decades. The warmth of human understanding and authenticity of the characterization were admirably portrayed by Rosemary Johnson, Madge Sellar, Judy Bacon, Arthur Lawrence, and Anthony Blake.

A Russian comedy, *Squaring the Circle*, by Valentin Kataev, and adapted by Ashley Dukes, exposed audiences to an amusing and ironical commentary on life in the U.S.S.R., but, despite ingenious staging and production allied with brisk acting, they did not appreciate this interesting experiment. However, another play for connoisseurs, *The Circle of Chalk*, a six-hundred-year-old Chinese drama received a slightly warmer reception. It had a delightful fairy-tale quality with its Cinderella-like theme telling of young Prince Pao's quest for Hi-Tang, a tea-garden girl. The Hi-Tang of Madge Sellar, and the Prince of Arthur Lawrence, were charming and delicately etched studies. Stout support came from Oswald Dale Roberts, Rosemary Johnson, and Richard Fisher, who all contrived to bring this quaint piece of Chinoiserie to life. Osborne Robinson, as if welcoming new worlds to conquer with design and paint, produced a symphony of line and colour. *Theatre Royal*, a play of the theatre, written by Edna Ferber and George Kaufman, who are themselves of the theatre, was both human and humorous, possessing many touches of satire, pathos, and wit. It gave Rosemary Johnson an opportunity to give one of her most effective performances in the part of Fanny Cavendish, the head of the Cavendish family who are known as the Royal Family of Broadway. Dorothy Fenwick, Madge Sellar, and Arthur Lawrence spoke decidedly and with a nice sense of character for three members of her august family. Beauty and sincerity flow through John Drinkwater's *A Man's House*, staged during Holy Week, and give it a lyrical quality reminiscent of the

heights of the author's poetry. Against a graceful setting by
Osborne Robinson, the struggle between spiritual and material
forces within the household of Salathiel, a pillar of the
established order in Jerusalem, was enacted with quiet dignity
and effect by Richard Fisher (Salathiel), Madge Sellar
(Rachel), Neil Tuson (Mathias), Arthur Lawrence (David),
Dorothy Fenwick (Esther), and Arthur Webb (Nathan).

The production of *Romeo and Juliet*, with its eighteen scenes
and cast of forty-seven, was a bold venture by William
Sherwood. Although not possessing the virility and finish
of the Company's previous Shakespearean productions, he
did a workmanlike job of work. Rosemary Johnson's Nurse,
Richard Fisher's Mercutio, and Neil Tuson's Tybalt were
satisfying performances. As Friar Lawrence, George Mudie
missed the mark and too often the audience missed Shake-
speare's lines. Arthur Lawrence and Sarah Churchill
grappled with Romeo and Juliet, the star-crossed lovers. Mr.
Lawrence's assumption of Romeo had a force and romantic
refinement. Although one lost some of the glow of imagination
and depth of feeling, Miss Churchill played with dignity and
spoke with admirable clarity. Once again, Mr. Robinson
contributed substantially to the production by designing hand-
some settings and costumes, both made in the theatre's work-
shops and representing a prodigious amount of work.

After the Munich Agreement (so-called), few countries
figured so largely in the world's news as Czecho-Slovakia, and
everyone was forced to realize that the burning question of the
hour was war or peace—which? It therefore seemed strangely
appropriate that the remarkable and thought-provoking play,
The Insect Play, which deals so vividly with the same problem,
should have been written by two brothers of Czech nationality,
Karel and Josef Capek. The Repertory Players' production
of this biting satire in which men are likened to insects was well
timed, taking place in October, 1938. Astutely marshalled by
Mr. Sherwood, the performances of the large cast were uni-
formly excellent. In the last act, the battle of the Black Ants
and Yellow Ants over the vital piece of territory lying between
two blades of grass was extraordinarily well handled and
performed. Osborne Robinson's settings and costumes were
imaginative and striking, and must rank among his best work.

William Sherwood had gained a wide knowledge of the theatre in the roles of actor, scenic designer, and author, as well as producer. Born in Dublin, as a boy he sang in the choir of the Chapel Royal. After serving throughout the Great War, 1914–18, and afterwards transferring to the Indian Army, he adopted the stage as a career and had a varied experience of work in the repertory movement, working at Sheffield, Cardiff, Southsea, and the Abbey Theatre, Dublin. Synchronizing with the advent of Mr. Sherwood, an organization known as the Repertory Circle was launched. Members met on Sunday at the Repertory Theatre for lectures, plays, and discussions. Dr. Eric Shaw was unanimously elected chairman, which role he filled in an engaging and able manner. The opening meeting was addressed by Mr. Sherwood, who, after outlining the constitution and purpose of the Circle, gave a racy and witty address. Speakers at subsequent meetings included a number of interesting personalities such as the Marquess of Donegall, William Armstrong, and Geoffrey Whitworth, and from time to time plays were given by the Northampton Drama Club. Succeeding in stimulating sociability among members besides interest in the Repertory Theatre, the Circle flourished, only closing down through the outbreak of war. In May 1938, in consequence of being given an appointment at the War Office, Sir John Brown resigned from the Board, and Dr. Shaw, a keen supporter of the Repertory Theatre, was appointed to fill the vacancy.

Another shower of birthday messages arrived from famous personages of the theatre world, such as J. B. Priestley, St. John Ervine, Dame Edith Evans, Lewis Casson, John Gielgud, Tyrone Guthrie, and Emlyn Williams, and from former members of the Company, including Herbert Prentice, Vivienne Bennett, Godfrey Kenton, Curigwen Lewis, and Noel Howlett. "I congratulate the Northampton Repertory Theatre on attaining the age of twelve years," wrote Tyrone Guthrie, renowned Old Vic producer. "This organization has behind it a fine record of service to the town; and has, besides, given to the theatre at large many artistes who owe to the Northampton Repertory Theatre early opportunities to learn their craft and try their mettle." Curigwen Lewis said, "With all my heart I wish many happy returns to Northampton Repertory.

(*Above*) "PRIVATE LIVES" (1943) (Henry Bale)

(*Below*) A SETTING FROM "ANDROCLES AND THE LION" (1943) (Henry Bale)

(*Above*) "BURNING GOLD" (1943)

(*Below*) "THE ROSE WITHOUT A THORN" (1944)
Franklin Davies as "Henry VIII"

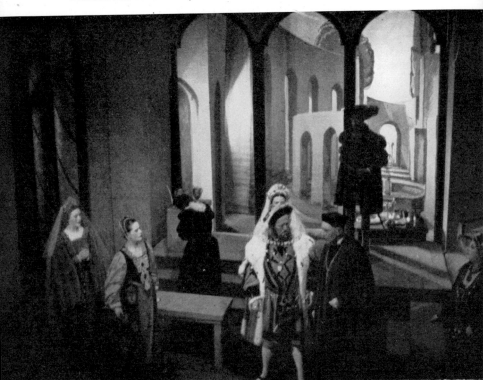

I shall always, I suppose, think of it as the toddler it was when I had something to do with it—an infant who gave me such strenuous, but such happy times—so you will understand how delighted I am that all is well with it, and how eagerly I associate myself with those who have its future welfare at heart."

A revival of *Dangerous Corner*, signalized the Birthday Week, and the programme for the following six chequered months comprised, in the main, revivals including *His House in Order*, *Pygmalion*, *Outward Bound*, and *The Farmer's Wife*, and popular London successes, such as *George and Margaret*, *Eight Bells*, and Priestley's *Bees on the Boatdeck*.

In *The Brontës*, Alfred Sangster set out to depict the amazing and talented family who lived at Haworth Parsonage in 1840. A deftly constructed plot and clear delineation of character ensured an alive and actable play. It was soundly rendered by the Company with a powerful and well controlled performance as the tyrannical father, the Rev. Patrick Brontë from Franklin Davies, finely drawn portraits of Charlotte and Emily from Rose Power and Rosemary Johnson, and a moving portrayal of the pitiable brother, Branwell, from Arthur Lawrence. Exposing the cruel and tragic effect that anonymous letters wrought upon a village, *Poison Pen*, by Richard Llewellyn, proved an exciting and enthralling piece of theatre. Margaret Greene gave a masterly performance in the best Grand Guignol manner as Phyrne Rainrider, and Leslie Sparkes as her clergyman brother was quietly effective and convincing. In an entirely different part, that of Katherine Parr in *The Queen Who Kept Her Head*, Margaret Greene gave a performance of real distinction as that grave, sweet woman of beauty and dignity, and Franklin Davies played Henry VIII, with his accustomed power and vigour, and in a make-up which was a perfect reproduction of the Holbein portrait. *Out of the Night*, a new play, written by Leslie Sparkes, the Repertory Players' stage manager, propounded in a novel and entertaining way the well-known principle of English law whereby an accused person cannot be convicted of a crime of which he is accused for a second time. Under the direction of the author, Margaret Greene, Rosemary Johnson, Franklin Davies, Arthur Lawrence, and Colin Douglas gave stalwart performances.

Three productions which shone like stars in a clear night sky were *Glorious Morning*, *Tobias and the Angel*, and *Victoria Regina*. A play of great power, Norman Macowan's *Glorious Morning* dealt with a situation of topical significance, the conflict arising in a totalitarian state between a girl visionary and the members of the Supreme Council who suppress all religious beliefs. Rosemary Johnson brought a radiant quality and dramatic force to the role of a modern St. Joan, and a finely etched and moving performance as her old grandfather came from Franklin Davies. Anthony Blake, Arthur Lawrence, Margaret Greene, Rose Power, and Richard Fisher lent strong support. In *Tobias and the Angel*, James Bridie unearthed a beautiful legend in the Apocrypha telling of the angel which appeared to Tobias in the guise of a man and acts as his companion on his strange and wonderful journey. Here was an unforgettable play infused with poetical feeling and a wealth of humour, beautifully mounted by Mr. Robinson and sensitively handled by Mr. Sherwood. The old blind Tobit of Franklin Davies, Margaret Greene's Anna, his wife, and Arthur Lawrence's Asmoday were admirable interpretations. Tobias was played by Morris Barry with telling simplicity and Rose Power made an engaging Sara. A fine performance came from Colin Douglas, who assumed the part of the angel easily and understandingly.

During the last week of June 1939, the Repertory Players brought to the stage *Victoria Regina* as the concluding play of the season. Acutely conceived and beautifully written, Laurence Housman's noble chronicle play with its cameos covering "sixty glorious years" of Queen Victoria's reign made a moving and memorable play. Rose Power portrayed the Queen with strength and benign grace, and Arthur Lawrence supplied all the charm and fidelity that the part of her consort demanded. Other notable studies were Reginald Hancock's Disraeli, Franklin Davies' Lord Conyingham, and Margaret Greene's Duchess of Sutherland. In his settings, Osborne Robinson accurately caught the elaborate detail of Victorian decoration.

Over the hills and far away travelled the Repertory Players to win renown in fresh fields. Just as in 1929 they visited the Spa of Bath, on this occasion they journeyed to the famous

Spa of Buxton, set high among the lovely dales of Derbyshire. There at the Playhouse between 3 July and 12 August 1939, they presented a season of plays comprising *Victoria Regina*, *Dangerous Corner*, *Glorious Morning*, *Poison Pen*, *I Have Been Here Before*, and *George and Margaret*. Despite the fact that the "Old Vic" Company were following with a Festival of Plays in September, the Buxton residents and visitors crowded the Playhouse and accorded the Repertory Players an enheartening reception. They spoke of all the productions in terms of the highest praise and enthusiasm, and so once again the Company enabled the citizens of another town to see the high standard repertory which Northampton had attained both artistically and dramatically.

To digress, in a speech at the end of the final performance of *Victoria Regina* at the Repertory Theatre, Franklin Davies warned the audience that if fuller and stronger support were not forthcoming when the Company returned from Buxton, the Repertory Theatre might well be compelled to close its doors. He truthfully and pointedly concluded, "It all depends on YOU." That such an admonition was necessary seemed lamentable indeed when you consider that after years of struggle and valiant endeavour, the Repertory Theatre had attained such eminence that a critic in the *Sunday Times* had declared but two months earlier, "Northampton is one of the most progressive and artistically renowned repertory theatres in the country."

A VITAL CHANGE

"Forward, forward let us range,
 Let the great world spin for ever down the ringing grooves of change."

<div align="right">TENNYSON</div>

TIME marched on towards the momentous late summer of
1939, when, after uncanny calm, the storm of war broke upon
the world. The Northampton Repertory Players had originally
intended to launch the new season with J. B. Priestley's
Johnson Over Jordan, thus giving the first provincial production
of that provocative and imaginative play, but, unfortunately,
permission was withdrawn by the author after the casting and
preliminary rehearsals had taken place. As an alternative, the
directors selected *The Millionairess*, by George Bernard Shaw
for presentation on Monday, 4 September 1939. On the day
before, however, the country became engulfed in war. Like
all other theatres, the Repertory Theatre was closed on the
declaration of war, in accordance with official instructions.
Probably it was as well. Through the sudden impact of events,
folk had neither the time nor the inclination to go to the theatre.
The speedy mobilization of the Forces, A.R.P., and other
emergency services, the fear of immediate aerial bombing, the
influx of thousands of evacuees and the black-out made the
days of theatre-going seem remote. The plans for an auspicious
opening and exciting autumn programme had to be scrapped.
The Company stood waiting and wondering what would
happen. It was anticipated that permission to re-open might
not be forthcoming for some time, but permission was received
unexpectedly on Saturday, 9 September 1939. Some members
of the Company were away from the town, and, therefore, a
hurried decision was made to give *George and Margaret*, which
the Company had recently played successfully at Buxton.
Therefore, whereas the Birmingham Repertory Theatre did
not re-open for five weeks, Northampton did so within forty-
eight hours of permission being granted. Even so, the

dislocation of people's lives and the feeling of suspense were such that the audiences were decidedly thin.

Often in the past, the thorny problem of once- or twice-nightly performances had been debated. This problem, which had defeated the management and the public, was automatically solved by the advent of the war when the Home Office issued a regulation that theatres must be closed by 10 p.m. In abandoning the restrictive and exacting twice-nightly system and adopting the policy of performing plays once nightly with two matinees, the Repertory Theatre made a significant change which was a definite stride forward. Whatever arguments may be advanced in favour of twice-nightly performances, the once-nightly system possesses three overwhelming advantages: first, it gives a wider choice of plays; secondly, it prevents the drastic cutting of so many plays; and thirdly, it makes possible a more finished presentation. Not only were the Repertory Players enabled to give such plays as *St. Joan*, *The Flashing Stream*, *The Apple Cart*, *Dear Octopus*, and *Rebecca*, but an unmistakable improvement in the acting and general presentation became evident. The alteration breathed vitality into an already virile theatre.

The first play which would have been impossible to perform twice nightly was *Geneva*, Shaw's fiftieth play, written when he was aged eighty-two. In a note on the play G.B.S. wrote: "*Geneva* is a title that speaks for itself. The critics are sure to complain that I have not solved all the burning political problems of the present and future in it, and restored peace to Europe and Asia. They always do. I am flattered by the implied attribution to me of Omniscience and Omnipotence; but I am also infuriated by the unreasonableness of the demand." Nevertheless, it was a shrewd satire on European politics, pointedly topical at that time in particular. Forceful and accurately observed portrayals of Herr Battler and Signor Bombardone were given by William Sherwood and Franklin Davies, and Rosemary Johnson made an efficient Shavian-cum-Cockney secretary in a brisk and handsomely mounted production.

Evidence of the deep interest taken in the work of the Repertory Theatre by former members of the Company was provided by the revival of *Romeo and Juliet*. Vivienne Bennett,

Godfrey Kenton, and Lawrence Baskcomb gave their services for what proved to be an excellent production. The idea came originally from Miss Bennett and Mr. Kenton as a gesture to help the theatre in critical times and as a mark of appreciation of the happy times they spent in the Company. Godfrey Kenton endowed Romeo with feeling and romantic fire, and Vivienne Bennett's Juliet was wholly enchanting, whilst Lawrence Baskcomb shed some diverting touches of individuality on Friar Lawrence. These performances took pride of place, but were well supported by Arthur Lawrence's Mercutio, Rosemary Johnson's Nurse, Colin Douglas' Tybalt, and Margaret Greene's Lady Capulet.

During the remainder of that season, the most interesting productions were *Escape Me Never*, *Without the Prince*, and *The Apple Cart*. The revival of *Escape Me Never* introduced Marjorie Sommerville, a charming young actress, who gave a finished and affecting rendering of the exacting part of the little waif, Gemma Jones. Woven around the preparations of a village's amateur dramatic society for its long-heralded production of *Hamlet*, *Without the Prince* proved a riotously amusing play. The author, Philip King, who was for some years a popular actor at the Bristol Little Theatre, depicted all the petty jealousies and quarrels among the cast, and shows how consternation seized them when they faced the problem of how to play *Hamlet* without the Prince of Denmark. Richly humorous performances were contributed by Colin Douglas, Arthur Lawrence, Neil Tuson, Franklin Davies, and Lawrence Baskcomb. In *The Apple Cart*, Bernard Shaw the Socialist, devised a perfect defence for the monarchial system. This masterpiece of humour and satire was admirably enacted, Donald Gordon's Boanerges, Margaret Greene's Lysistrata, Lawrence Baskcomb's Proteus, Franklin Davies's Balbus, and Rosemary Johnson's Orinthia being particularly satisfying. The best fruit from *The Apple Cart* falls into the part of King Magnus, a patriotic and resourceful monarch who regards himself as the protector of the common people against their oppressors—the bold, bad business barons. Besides producing efficiently, William Sherwood played the King and gave a fine piece of high comedy acting.

After a rollicking revival of *Ambrose Applejohn's Adventure* for

the Christmas season, with Franklin Davies and Marjorie Sommerville excelling in the leading roles, came *Robert's Wife* as the first play to greet the year 1940. So successfully did St. John Ervine fuse high seriousness with high comedy that this is probably his finest play, full of wit and humour, sense and sensibility. At the heart of the play lies a strong, essentially human conflict between the private and professional lives of two happily married people, Robert, a clergyman and Sanchia, a doctor. Rosemary Johnson bestowed poise and intelligence upon the part of Sanchia, created by Edith Evans, and Franklin Davies played the Owen Nares part of the Rev. Robert, with understanding and sincerity. Arthur Lawrence gave intensity to the antagonistic Anglo-Catholic priest, and the bishop was invested with a benign episcopal grace by William Sherwood.

Among many birthday greetings received by the Repertory Theatre on the occasion of its thirteenth anniversary, were messages from Dame Sybil Thorndike, J. B. Priestley, Cecil Parker, and Esmé Percy. "I would like to send my best congratulations and good wishes," wrote Sybil Thorndike. "I know the excellent work done at your theatre, and I think it is more than creditable that you have achieved so many years of success, and that without 'handing round the plate' in any way. I wish you all prosperity, and may you keep the flag flying in Northampton for many years to come." Cecil Parker said, "I know that the Repertory movement is the only sure way of discovering and fostering talent; so more power to you all who are keeping the stage cradle rocking so magnificently in Northampton."

The New Year started unfavourably owing to the black-out and to a long spell of intense cold and a heavy snowfall. During the first six weeks or so, many people were unable to attend the performances who otherwise would never have missed their weekly visit to the Repertory Theatre. Among the plays they missed were that delightful Irish comedy *Spring Meeting*, Patrick Hamilton's study in sustained terror, *Gaslight*, which was invested with the requisite touch of the macabre by Arthur Lawrence as the husband who tries to drive his wife, played by Sydney Sturgess, to madness, and by Franklin Davies as Rough, the detective; and *The Doctor's Dilemma*,

Shaw's trenchant satire on the medical profession, with William Sherwood, Arthur Lawrence, Reginald Hancock, Franklin Davies, and Neil Tuson making as stageworthy a panel of medicos as you could wish to meet, and with Colin Douglas playing the consumptive artist, Dubedat, and Sydney Sturgess as his wife.

With good reason the plays given during the year 1940 were not marked by such diversity as hitherto. There was a notable absence of classic plays and few new plays or large-scale productions. (Alas! a certain Will Shakespeare was unable to leave Stratford-on-Avon and journey to Northampton, not even as an evacuee for one week!) Even though such features are an integral part of the repertoire of a repertory theatre they had perforce to be sacrificed in war-time. As was not unnatural in such troublesome times, mirth and thrills were the prime attractions. Edgar Wallace provided the best thriller in *On the Spot*, written on his trip back from America after a fortnight's stay in that haven of gangsterdom, Chicago. Franklin Davies presented a fine character-study of Tony Perrelli, who, between his nefarious escapades, amused himself on the grand organ in a luxuriously furnished apartment with all its carnal embroidery and its machinery for misleading the police. Rarely had Mr. Davies given a more finished and convincing performance.

Mirth flowed freely with the staging of *When We Are Married*, and *Goodness, How Sad!* Forsaking his essays on the "time theory" and other bees on his boat deck, J. B. Priestley returned to the world of Jess Oakroyd, hero of *The Good Companions*, in his Yorkshire farcical comedy, *When We Are Married*. The bombshell that burst upon three highly respectable leading lights of a West Riding town and their spouses on the occasion of their joint silver weddings proved an ample helping of wholesome fun, with Franklin Davies and Rosemary Johnson, Arthur Lawrence, and Sydney Sturgess, and Arthur Webb and Margaret Greene, as the three couples scoring every comedy point, and, best of all, Colin Douglas's delightfully droll sketch of the photographer.

The outstanding feature of the programme of plays during 1940 was the number of revivals, there being no fewer than sixteen in the first seven and a half months, far exceeding any

(*Above*) "WINTERSET" (1945)

(*From a drawing by Osborne Robinson*)

(*Below*) A SETTING FROM "THE BANBURY NOSE" (1945)

(*Henry Bale*)

(*Above*) "COMMAND PERFORMANCE" (1945)
Transformation Gauze

(*Below*) "A MONTH IN THE COUNTRY" (1946)

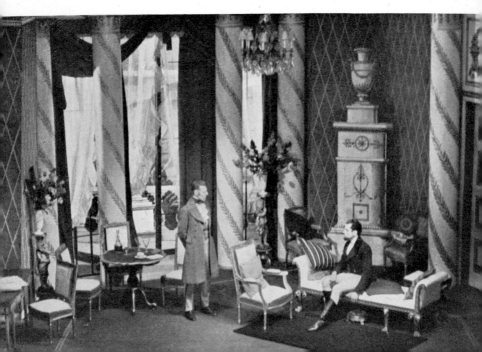

previous year. The pick of the "old friends" that playgoers were happy to welcome were *Laburnum Grove*, *Hay Fever*, *Full House*, *The High Road*, and *Murder on the Second Floor*. Mr. H. Musk Beattie, who had given diligent service as director and secretary of the Company since its formation, received a dual distinction. He became the first Northamptonian to have a play performed by the Repertory Players, and that play, *The Rest is Silence*, was the only new play produced that year. Based upon the weird happenings on an island in the Outer Hebrides, the play concerned the crew of a lighthouse who vanished without leaving any clue to the cause of their disappearance, and Rosemary Johnson, Margaret Greene, Marjorie Sommerville, Franklin Davies, Neil Tuson, and Colin Douglas acted the chief roles. During the year two one-act plays were given as "curtain-raisers", Neil Tuson's droll Chinese comedy, *The Doubtful Misfortunes of Li Sing*, which had been so successfully broadcast on several occasions, and Shaw's shrewdly witty *The Dark Lady of the Sonnets*, with Margaret Greene as Queen Elizabeth, and William Sherwood as Shakespeare rose spiritedly to the verbal sparkle.

Special interest attached to the production of *Jane Eyre*, *The Flashing Stream*, and *St. Joan*. Although suffering from the defects which invariably mark the transfer of a novel to the stage, Helen Jerome's dramatization of Charlotte Brontë's *Jane Eyre* proved an absorbing play. Jane's arrival as governess at Thornfield Hall, the gradual breaking down of Rochester's indifference leading to the thwarted wedding, her flight and ultimate return to him comprise the sequences of the stage story. In Franklin Davies's hands Rochester's harshness and strength were well matched with the charm and resourcefulness of Jane as played by Marjorie Sommerville. Distinguished dramatic critic of *The Times*, Charles Morgan joined the elect ranks of successful playwrights when he wrote *The Flashing Stream*, which possesses two outstanding qualities: the felicity and rhythm of its dialogue and its strong sense of suspense and urgency. Single-mindedness is the theme, which is developed with depth and purpose by showing how Commander Ferrers, a brilliant mathematician, encounters Karen, his late assistant's sister, and faces the conflict between work and love. The situations are as taut as a bowstring. Colin Douglas, as

Ferrers, and Rosemary Johnson as Karen, played these two exacting roles with power and perception. Margaret Greene's Lady Helston had liveliness and bite, and Lawrence Baskcomb portrayed the First Lord of the Admiralty with judicious insight. Mr. Sherwood's direction and Mr. Robinson's decor fittingly honoured the author's demands.

Quixotic as Mr. Shaw had been in the choice of subjects for his plays, a genuine surprise was felt when he wrote a play about the little peasant Maid of Orleans, who, whilst watching her father's sheep, heard voices biding her to arise and save her beloved country. Written when he was sixty-seven years of age, *St. Joan* proved that age had not withered or custom staled his infinite variety. With its seven scenes and cast of nearly fifty, the production was a stupendous task to accomplish in war-time and with only one week's rehearsal, but under Mr. Sherwood's astute supervision, the Company gallantly rose to the greatness of the occasion, and gave a performance which evoked enthusiastic praise from the large audiences. Rosemary Johnson blended naïvety and intensity in her interpretation of Joan, peasant, warrior, and saint. William Sherwood's sagacious Cauchon, Robert Doig's feckless Dauphin, Lawrence Baskcomb's dignified Archbishop, and Colin Douglas's forceful Dunois were performances of real distinction. The settings designed by Osborne Robinson were a triumph of economy and beauty. It has been truly said that *St. Joan* transcends ordinary thought and goes into a realm of imagination that Bernard Shaw had not reached before. When Anatole France introduced himself to Shaw he said, "I see, sir, you are one of us." "Yes," replied G.B.S., "I, too, am a man of genius." After seeing *St. Joan*, one could but sincerely endorse that statement for this magnificent chronicle play has honoured the English theatre and placed its author for ever in the great cathedral of literature.

The presentation of *St. Joan* took place in the last week in March 1940, and during the ensuing four months, the attendances at the Repertory Theatre steadily declined. When you remember that fateful summer, what else could you expect? What glorious weather and yet we hardly noticed it! Golden sunshine streaming from clear blue skies for weeks on end, whilst the Nazi hordes made their savage onrush across the face of

Europe, ending in the fall of France, and our "tight little island" standing alone menaced by the threat of invasion! Can you wonder that people's interest in the theatre dwindled? Folk suffered from a surfeit of drama in current events and from a surfeit of tension in day-to-day happenings. Small wonder that for the time being that box of illusions, the theatre, faded into the background of their minds. Yet another factor played an important part in reducing the size of audiences. The Forces had claimed many of the most active-minded young people who were among the keenest supporters of the Repertory Theatre. Before the war there were about 1,100 to 1,200 permanent seat-holders who visited the theatre every week. But by June, 1940, that solid column of support that had been the mainstay of the Repertory Theatre had shrunk to half that number. After fourteen far from easy years of valiant work without once calling on the public for financial help, the threat to the continuance of repertory in Northampton loomed large. The fate of the Repertory Theatre hung in the balance.

WAR YEARS

"Fierce fiery warriors fight upon the clouds,
In ranks, and squadrons, and right form of war."

SHAKESPEARE

ART is the first casualty in war. In all disturbed times, art suffers immediately and the creation of works of art almost automatically ceases. With the outbreak of war in 1939, much of the normal life of the country was suspended, as we have already seen, and a "black-out" atmosphere developed that was more than a mere switching-off of street lighting. Such was the plight of the drama in the summer of 1940 that in some forty theatres in London one straight play was being presented, which showed how, in the main, the responsibility of keeping the theatre alive rested on the provinces, and, at the time, there were few more virile outposts of the living theatre than the Northampton Repertory Theatre, which, however, through lack of support stood in jeopardy.

In July 1940, the crisis became acute, and after each performance of *Jane Eyre*, Franklin Davies made a splendid appeal from the stage. Pointing out that if the Repertory Theatre was to be a living factor in the life of Northampton after the August vacation, an increase in the size of the audiences was essential, he succeeded in impressing upon patrons the seriousness of the state of the theatre in general and of the Repertory Theatre in particular. Similar appeals were made in the Press. The response was immediate and gratifying. The audiences for *Jane Eyre* were larger than for some time, 3,914 persons paying for admission. Moreover, many interested patrons gave further proof of their intention to keep the doors of the theatre open by paying for their seats regardless of whether they occupied them or not. When you consider it, the needs of the Repertory Theatre were not very considerable for they required a regular weekly patronage of 5,000 people, which was by no means an unreasonable figure when you take into account that besides Northampton's population of about 100,000 there were a

number of towns and villages in the vicinity. Wisely the directors chose to revive five popular plays in an effort to save the situation. They were *Sheppey*, *Love from a Stranger*, *Sixteen*, *Murder on the Second Floor*, and *And So to Bed*. Happily—through the improved support which was consistently maintained through these five productions—the Repertory Players overcame the crisis, and a definite announcement was made that the Repertory Theatre would re-open for the autumn season, after a month's much needed vacation.

With few changes, the Company resumed operations in September 1940, with *Dear Octopus*. The chief change was that William E. Brookfield, as producer, replaced William Sherwood, who had taken up a similar post at York Repertory Theatre. During his stay of just over two and a half years, Mr. Sherwood directed 121 productions and earned the gratitude of the frequenters of the Repertory Theatre for his excellent and able work both as producer and actor. Mr. Brookfield brought an all-round experience of repertory and other theatres in the provinces to the position of producer and expressed his firm determination to merit increased support for the Repertory Theatre. He had run his own companies in long and successful seasons at, among other places, Manchester, Bradford, Scarborough, and Luton, until this work had been brought to an end by the war. *Dear Octopus* showed Dodie Smith on the top of her form in a delightfully human story of the reunion of three generations of the Randolph family to celebrate the golden wedding of Charles and Dora, charmingly played by Donald Gordon and Rosemary Johnson, with Dorothy Fenwick, Peggy Diamond and Hilda Malcolm, (Mrs. Brookfield) giving first-rate performances as three of their children. A smooth and satisfying production gave Mr. Brookfield a capital send-off and encouraged playgoers to look forward to witnessing more of his handiwork. The first few weeks of this season were a testing time, and on the box-office returns depended the continuance of the Repertory Theatre. The fine response of the public to *Dear Octopus*, and the six following plays, *Musical Chairs*, *Pride and Prejudice*, *The High Road*, *Romance*, and *The Bishop Misbehaves*, gave promise that the Company would ultimately win through.

Women playwrights sprang into the ascendency and provided

the two most memorable productions of the season. First
came *Pride and Prejudice*, Helen Jerome's sound dramatization
of Jane Austen's delicious novel. Those famous characters,
Mr. and Mrs. Bennet, their eldest daughter, Elizabeth, and
her four sisters and their suitors, might have stepped from the
pages of the novel to enchant us again with their humanity
and charm, their foibles and faults. Marjorie Sommerville
gave Elizabeth both a shrewd outlook and individual charm.
Franklin Davies's dryly humorous Mr. Bennet and Dorothy
Fenwick's anxious Mrs. Bennet were finely drawn studies. The
romantic Jane of Peggy Diamond, the boisterous Lydia of
Joan Button, the formidable Lady Catherine of Margaret
Greene, the unctuous Mr. Collins of Donald Gordon, and the
plausible Mr. Wickham of Neil Tuson were all admirable
performances. Mr. Brookfield's direction and Mr. Robinson's
settings caught the authentic Regency atmosphere. What a
relief it was for the war-strained audiences to find forgetfulness
in the lavender charm of a gentle and placid era! Secondly
came *Rebecca*, adapted by Daphne du Maurier from her best-
selling novel. Full of drama and suspense, it tells how a young
second wife tries to exorcize the influence of her predecessor,
which seems to brood over Manderley, the ancestral home of
the de Winters. The shy, gawky second Mrs. de Winter was
played by Marjorie Sommerville with understanding and quiet
effect. Anthony Blake brought conviction to the Owen Nares
part of Maxim de Winter. As Mrs. Danvers, the grim house-
keeper, who adored Rebecca and resents the intrusion of a
second mistress, Hilda Malcolm gave an intense performance.

As the birthday play in January 1941 the Repertory Players
presented *Secrets*, by Rudolf Besier and May Edginton, a
piquant and sentimental episodic play glorifying the ageless
virtues of love and sacrifice. Moving portrayals were con-
tributed by Anthony Blake and Peggy Diamond in the parts
of Sir John and Lady Carlton, around whom the play revolves,
and two of their children were sensitively depicted by Marjorie
Sommerville and Williams Lloyd. William Brookfield made the
bluff Dr. Arbuthnot human and likeable. Everyone associated
with the Repertory Theatre had ample grounds for satisfaction
with the attainment of its fourteenth birthday. At that time
most repertory theatres had been forced to close down through

either the exigencies of the war or lack of public support. In fact, out of the sixteen original members of the Repertory Theatres' Association, only three were functioning, Harrogate, York, and Northampton. Throughout fourteen years of struggle and vicissitudes and triumph, the sole public support received or sought had been through the box-office. That alone was a proud achievement.

Thenceforward revivals became the order of the day. There were as many as twenty-four during the year 1941. In the West End new plays were as scarce as strawberries in January. The tension and general feeling of uncertainty in beleaguered London produced a policy of safety first. Plays of proved success were favoured rather than those which were untried. Furthermore, the artificialities of many modern plays seemed out of tune with the gravity of the times, and naturally folk welcomed the opportunity of finding relief and seeking escape in the plays associated with happier days. The Northampton Repertory Theatre followed the lead of London by reviving plays with a popular appeal, such as *Marigold, Quinneys, Tons of Money, The Patsy, The Skin Game, Paddy the Next Best Thing, Berkeley Square, Fanny's First Play, The Constant Nymph*, and *Major Barbara*.

Of the plays not previously staged the best productions were *Ladies in Retirement, What Every Woman Knows, Reunion in Vienna, Thank You Mr. Pepys, Viceroy Sarah*, and *Thunder Rock*. How cunningly the atmosphere of mystery is evoked in *Ladies in Retirement*, by setting it in a dark, lonely house in the marshes of the Thames back in the 'eighties! Against this background unfolds the tale of a housekeeper who murders her employer, a retired music-hall actress, to secure sanctuary for her half-crazed sisters. As Ellen Creed the housekeeper, Dorothy Fenwick dominated the play with a truly vivid piece of acting, whilst Florence Churchill as her victim, Hilda Malcolm and Margaret Greene as the sisters, gave sterling performances. It was designated a "great play" by St. John Ervine. *What Every Woman Knows* has laughter and tears intermingled in Barrie's inimitable way and shows how the rise of John Shand from a railway porter to a Member of Parliament owes more to his wife, the homely Maggie, than he dreams is possible. Marjorie Sommerville invested Maggie with all the charm and

womanly subtlety the part demanded, and Anthony Blake as Shand achieved the transition from porter to politician with ease and understanding. In Robert Sherwood's witty and sparkling comedy, *Reunion in Vienna*, Hilda Malcolm as Elena, the wife of a psycho-analyst, played by William Brookfield, gave a lively performance, particularly in the second act where she was tempestuously wooed by Archduke Rudolf, who was piquantly portrayed by Franklin Davies. Showing how Charles II entrusted a mission of building ships without money to a patient little man at the Navy Office named Samuel Pepys, *Thank You Mr. Pepys* proved a stimulating and exciting play in which Alec Mason appeared as the King, and Edwin Morton as Mr. Pepys. Since it dealt with Sarah, the first Duchess of Marlborough who was an ancestor of Mr. Winston Churchill, the Prime Minister at that time, *Viceroy Sarah* had an appeal of special topicality and in the title role, Margaret Greene gave a finely controlled and forceful portrayal which illustrated the truth of the description of Sarah Churchill as "a torpedo in petticoats".

The hero of *Thunder Rock* was a man who had lived a full life and found it wanting. Charleston had been a journalist and, as a war correspondent, he had seen the destruction of all his hopes for humanity. To the bewilderment of his friends, he became the keeper of a lighthouse on Lake Michigan. Was it a form of escape they asked themselves, or was there some mysterious, hidden fascination lurking somewhere around Thunder Rock? In this unusual and moving play of ideas, Anthony Blake interpreted the character of Charleston with convincing fidelity, and clever studies were contributed by Donald Gordon as his aviator friend, Lawrence Baskcomb as an Austrian doctor, and Peggy Diamond as the doctor's daughter. Never descending to propaganda, *Thunder Rock* faced squarely the problem of the individual's relation to the world and had a clear, inspiring message for those turbulent times. The size of the appreciative audiences it attracted was truly enheartening.

Soon after Dr. Eric Shaw resigned from the Board of Directors owing to his heavy responsibilities in war-time, Mr. Wilfred H. Fox accepted an invitation to become a director. An enthusiastic supporter of the Repertory Players from their

inception, his wide knowledge and experience in financial matters have proved an immense help to the Board. It was with sincere regret that, also in 1941, the directors received the resignation of Mr. F. W. Cotter Craig, the popular and courteous business manager. On behalf of the directors, the Company and patrons, a presentation was made to Mr. Craig in appreciation of his five years' splendid service.

Addicts of thrillers had occasion to rejoice in 1942. They were given a goodly batch, including *Play With Fire*, *Once a Crook*, *Red for Danger*, and *Cottage to Let*, with *Suspect*, *No. 17*, *At the Villa Rose* and *Double Door* making welcome reappearances. Edward Percy repeated the success of *Suspect* and *Ladies in Retirement* with his new murder play, *Play With Fire*, which held audiences in an iron grip of suspense. It showed how an old antique-dealer with an old curiosity shop in South London is overtaken by his grim and still potent past. Franklin Davies scored a success as the old man with one of those deft character-studies for which he had a real flair. Conspicuous success attended this play on its subsequent production in the West End under the title of *The Shop at Sly Corner*, when it achieved a run of over two years.

Of the twenty-six revivals, the most worth-while were *A Hundred Years Old*, *Robert's Wife*, *The Doctor's Dilemma*, *The Man With a Load of Mischief*, *Milestones*, *The Late Christopher Bean*, *Young Woodley*, and, in May 1943, *The Ship*, William Brook-field's last production before he bade farewell to the Company. The work of producer was temporarily undertaken by George Roche, who had done useful work as an actor with the Repertory Players, particularly as Jingle in the Christmas production of *Pickwick*, as an American tipster in *Three Men on a Horse*, and Cutler Walpole in *The Doctor's Dilemma*. Mr. Roche, staunchly assisted by Mr. Robinson, did ample justice to that theatrical curiosity, *East Lynne*. With Hilda Malcolm and Franklin Davies leading the barn-stormers, it was an hilarious escapade and the audience entered into the spirit of "Mrs. Henry Wood's Victorian drama" with mirthful relish. A fortnight later came A. J. Cronin's *Jupiter Laughs*, exposing the sharp contrast between the disillusioned materialism of Dr. Venner, and the shining Christian faith of one of his assistants, Dr. Mary Murray. George Roche caught the strength and cynicism of

Venner and Marjorie Sommerville brought sensitivity and sincerity to the part of Mary.

The second season of that year opened with Dodie Smith's happy and human play, *Call it a Day*. Franklin Davies and Hilda Malcolm as the delightful Mr. and Mrs. Hilton, and Betty Fuller, John Fitzgerald and Mary Whitfield as their equally delightful children, were all in superb form. In October 1942, Arthur Leslie, who had acted in a number of productions, became producer. During a theatrical career of twenty-six years, he had spent ten years in repertory in the north of England. The most striking productions that season were *Heartbreak House*, and *Judgment Day*. George Bernard Shaw is a barometer of modern life and thought. Testimony of this was found in *Heartbreak House*, which, although written during the First Great War, proved trenchantly topical. Shaw turns the searchlight of his wit on Europe and castigates its neglect of civic duty, its philandering and its inefficiency, and through the leading character, Captain Shotover, a mystic stung by the horrors of life, delivers some of his profoundest oracles. Many playgoers found the play somewhat heavy for their mental digestions, and therefore all honour to the cast for keeping the wit and satire challengingly alive throughout three acts. Topical satire of a less abstruse kind was found in Elmer Rice's *Judgment Day*, exhibiting the trial of three people on a charge of attempted assassination of a dictator. Fine emotional performances came from Peggy Diamond as the temperamental opera singer and from Hilda Malcolm and Arthur Leslie as two of the accused, whilst Lawrence Baskcomb's Judge Slataski, upholder of the ancient tradition of law and justice to his last breath, had judicial dignity and resoluteness. On the surface, a most exciting melodrama, *Judgment Day*, with its ring of truth and underlying satire, stimulated much thought and discussion.

During 1941–2 the clouds that hung over the Repertory Theatre began to roll away. The threat to its continuance vanished like the darkness before the rising sun. Slowly but surely, the size of the audiences grew. The struggle to keep the footlights burning was gradually won, for which thanks are due to the directors for their pluck and tenacity combined with the turn of events in the war. When the bombing drove

thousands of folk out of London, legions of refugees came to Northampton. Whereas the great part of the population of the town were magnificently indifferent to the Repertory Theatre, these exiled Londoners were not slow to find it and recognize its virtues. Not only did the quality of the plays appeal to them, but the high standard of the presentation and acting astonished them. Many of them made a point of expressing their admiration of the excellent work the Company was doing, and, as a practical indication of their appreciation, they became regular patrons. Besides being an important factor in the strengthening of the support of the Repertory Theatre, that was how quite a number of these newcomers acquired the theatre-going habit for the first time in their lives. What was the over-all effect on these new playgoers won for the theatre? One critic suggested the effect would be far-reaching when he wrote: "We prophesy that when the peace comes they will return to London with a critical appreciation of what is best in the theatre, and the West End will have to look to its laurels!"

FAVOURITES OLD AND NEW

*"Repertory theatres have brought back and proved
true the maxim that 'the play's the thing.'"*

SIR BARRY JACKSON

AFTER over three years of war had passed, the Northampton
Repertory Theatre was still in good heart. Unlike Liverpool,
Birmingham, and Coventry, it had mercifully been spared the
terrible onslaught of enemy bombing which became known
as the blitz. Notwithstanding, those three years had been
strenuous and anxious years, full of doubts and difficulties,
but the troubles had perhaps served a good purpose. They had
called for many sacrifices from the Company who had responded
splendidly. By their sympathy and understanding, playgoers
had shown that the brave and tireless efforts of the Repertory
Players had not passed unrecognized, and, what is more, they
had begun to defy the "black-out". How enheartening it was
to see large audiences become a consistent feature! On the
sixteenth anniversary, therefore, everyone concerned with the
Repertory Theatre faced another year with considerably
lighter hearts than they had possessed at any time since the
outbreak of war.

Too often the English theatre had been a luxury, but for
crowds of people in time of war it became a necessity. A
blessed escape from a world fermenting with destruction and
misery, and from a daily round harassed by restrictions and
rations, queues and quotas! In common with all other theatres
fortunate enough to keep their doors open, the Repertory
Theatre did invaluable work in keeping up people's spirits
and thereby enheartening them to face life's multiplicity of
anxieties and difficulties. Appropriately, the year 1943 saw
the Repertory Players again providing an excellent feast of
entertainment. Whatever else was curtailed, good and en-
joyable plays were not rationed. Laughter was not "on points"
and thrills were "coupon free". As ever, the service was smooth,
efficient, and altogether admirable, even in face of restrictions

and scarcities such as Mrs. Beeton never knew even in a night-
mare! The producers, the scenic designer, the players and staff
mixed the ingredients skilfully and artistically. The proof of
the pudding was in the teamwork!

Varied and satisfying, the menu catered for every taste,
high-brow, low-brow and no-brow. Amidst revivals in abun-
dance, a new or special dish was slipped in just to whet the
dramatic appetites of the more aspiring playgoers. Arthur
Leslie's most memorable production during his seven month's
spell as producer was *Hedda Gabler*. It has aptly been described
as "a dramatic portrait of a neurotic shrew with time on her
hands, nobody in her arms, and a frustrated desire to pull
human beings around like puppets." Hedda, Ibsen's most
puzzling character, afforded Peggy Diamond a golden oppor-
tunity to display her talent. She stressed the swiftly changing
moods of this disturbing creature, revealing by turns her bursts
of feeling, her boredom and her nervous intensity. She was
strongly supported by Harry Geldard as Tesman, her pedantic
husband, by Franklin Davies as the wily Judge Brack, by
David Hofman as the philandering Lorborg, and by Hilda
Malcolm as serene Aunt Julia.

A third change behind the stage in twelve months occurred
in April, when Mr. Alex Reeve became producer. For a
number of years, Mr. Reeve had done fine work for the drama
at Welwyn, and as producer of the Welwyn Thalians when they
had won the Lord Howard de Walden Cup at the Old Vic in
May 1935, and also when they had won the British Drama
League Community Theatre Festival. Mr. Tyrone Guthrie
held high opinions of Mr. Reeve's undoubted abilities for stage
production. After an acceptable revival of *Hobson's Choice* as
his initial production came *The Queen's Husband*, Robert E.
Sherwood's scintillating comedy about a queen-pecked king
who outwits a blustering dictator, desperate revolutionaries,
and even his ultra-patriotic queen. David Hofman's King
Eric, Peggy Diamond's Queen, Pauline Williams's Princess
Anne, and Franklin Davies's Prime Minister were decidedly
effective performances and Mr. Reeve infused the production
with the requisite polish. Later in the season Mr. Reeve
revealed his prowess in handling plays of power and atmos-
phere when the Repertory Players staged *Thou Shalt Not*, the

adaptation into English of *Thérèse Raquin*, by Emile Zola. In the grimy, eerie, cellar-like room of Madame Raquin in Paris, unfolds the fateful love-tangle of her son, Camille, of Thérèse, his lovely wife, and of his artist friend, Laurent. Hilda Malcolm's Madame Raquin was a strong, compelling performance and Pauline Williams, as Thérèse, Eric Dowdy as Camille, and Harry Geldard as Laurent, acquitted themselves with high intelligence and grip. In complete contrast the next production was a witty, diverting comedy with an accent on craziness, *You Can't Take it With You*, by Moss Hart and George Kaufman. "You can't take your money with you," says Grandpa Vanderhof, "so why not have fun?" His household, the Sycamore family, taking the cue from him, have become individualists and are involved in innumerable "goofy" situations. In a spirited rendering, the Company kept up a fine pace and captured that brand of "hay-wire" humour in which the Americans excel.

Cecil Roberts tells how once at the R.A.C. Club, he saw a familiar face with white Santa Claus beard appear from behind some bookshelves and he cried, "You're Shaw!" To which came the prompt reply, "Young man, I am certain of nothing!" Bernard Shaw's penchant for the unexpected and unorthodox angle on life was well illustrated by *The Millionairess*, and *Androcles and the Lion*, the two Shavian dishes served that year. In *The Millionairess*, Peggy Diamond rose to the forceful personality of the millionairess, that woman like a volcano erupting, who believes that everything can be bought until she tries to apply her theories to love. The target for Shaw's caustic pen in *Androcles and the Lion* was early Christianity. This strangely fascinating fable-play received a brisk interpretation by Lawrence Baskcomb as Caesar, Franklin Davies as Ferrovius, Frederick Lane as Spintho, and Mary Whitfield as Lavinia, whilst Eric Dowdy refrained from caricature but lost none of the satire to be found in the part of Androcles, the little tailor, whose attitude towards animals is one of the most moving things in modern literature.

The first performance on any stage of *Burning Gold*, by Falkland L. Cary and A. A. Thomson provided the highlight of the year. It showed how the resolution of the younger generation of an old family to shape their own destinies brings

two worlds face to face—the old world of landed gentry, tradition, and security, and the new world of big business, social change, and shifting values. The resulting conflict, heightened by the impact of war, proved startling, moving, and apposite to the moment. Clear-cut characterization, lively dialogue and topical wit made *Burning Gold* an invigorating play which was produced with care and skill by Alex Reeve. "I am very pleased to be able to record my appreciation of the clever production of Mr. Reeve," wrote Dr. Falkland Cary afterwards. The Company performed it with obvious enjoyment and found their labours well rewarded. *Burning Gold* must rank as one of the most gratifying successes in the history of the Repertory Theatre.

Unbridled mirth greeted Reginald Arkell's version of *1066 And All That*, which packed the theatre for the Christmas season. This bluff island story of good kings and bad kings which flips a "flippant finger at English history", is indeed a cavalcade of fun. Alex Reeve made an admirable compère and Frederick Lane brought the right touch of perkiness and pathos to the Common Man. The whole Company entered whole-heartedly into the Christmas revels and carried off this prodigious venture involving twenty-five scenes and over two hundred characters with a finesse which would have amazed some of the elevated critics who speak disparagingly about the repertory movement.

No one will deny that the Repertory Theatre strove to play its part to the full throughout those dark and difficult days of war. It endeavoured to encourage the members of the three Services to keep in touch with the living theatre. Many theatre lovers in the Forces were indeed grateful for the special concessions made to them. The following note appeared in the programme: "On Mondays and Tuesdays during the Repertory Players' season, members of His Majesty's Forces in uniform are admitted to any part of the house for one shilling, and we should like this fact to be noted by the different units in the vicinity for inclusion in battalion orders." Mr. J. E. Stevenson, the courteous business manager, welcomed visitors from all parts of the world, and was naturally enheartened by the number of serving men and women, non-theatre-goers before the war, who became regular patrons whilst stationed in the district.

Furthermore, in October, 1943, half the Company went on tour as E.N.S.A. artistes to entertain the troops with Hubert Griffiths's *Nina*. Peggy Diamond, who played the lead, took charge as senior member of the Company. They had a truly adventurous time in a tour of camps of every description, playing on all kinds of make-shift stages and even once by torchlight.

Success smiled on the Repertory Players during 1944. Packed houses became the order of every night and enthusiasm ran high. Unstinted applause week by week bore unmistakable testimony to the sound team-work of the Company under the guidance of Mr. Reeve. Plays with a broad appeal were offered in the main. Carefully chosen revivals predominated, and of the thirty-two selected, the chief successes comprised, *She Stoops to Conquer, Dear Brutus, Candida, The Rose Without a Thorn, Pygmalion, Night Must Fall, Arms and the Man*, and *Eden End*. The year's most favoured playwrights were Bernard Shaw, Noel Coward, and J. B. Priestley, each of whom achieved the "hat-trick".

Robert E. Sherwood's *The Petrified Forest*, marked the seventeenth anniversary. Against the background of a remote gasoline station in the Arizona desert, it unfolded the story of a disillusioned novelist-philosopher (David Hofman), a gangster (Franklin Davies), and a young girl (Yvonne Marquand), who dreams of France and falls in love with the author. *Maria Marten, or The Murder in the Red Barn*, the renowned Barnstormer melodrama that thrilled and chilled Victorian theatregoers, and T. W. Robertson's *Caste*, an adroit comedy, proving that fond hearts are more than coronets, were added to the repertoire with signal success. However, the best productions of the year were *They Came to a City, The Anatomist, Candied Peel, The Corn is Green*, and *Ghosts*. In that clever play of ideas, *They Came to a City*, J. B. Priestley shows the vastly differing reactions of an oddly assorted group of people when they are unaccountably brought together and face the common experience of visiting a strange, unknown city. Peggy Diamond, Hilda Malcolm, Pauline Williams, John Carol, Lawrence Baskcomb, and Reginald Thorne ensured that absorbing dramatic material was endowed with humour, drama, and suspense. All of James Bridie's work is intensely individual and

not least is *The Anatomist*, a thrilling costume play based on the queer escapades of Dr. Robert Knox, and Peter Tremlett contributed a sound rendering of that famous pioneer in anatomy who also contrived to be the buccaneer of the drawing-room. The one new play to make its debut that year was Dr. Falkland L. Cary's *Candied Peel*. A well-devised plot combined with clearly drawn characters and flexible dialogue made this comedy-thriller a lively, baffling, and gripping piece of theatre and a worthy successor to his *Burning Gold*. It was woven round the mysterious happenings at a week-end party of a wealthy and eligible bachelor with a penchant for candied peel. In his book *Practical Playwriting*, Dr. Cary says:

"I saw in the Northampton production of *Candied Peel* a fine example of the producer and the player's art. The reception left me hardly daring to believe my ears, but with enough sense left to realize that if ever production and playing had made a play this was the occasion. . . . The part of Ondersley (Peter Tremlett), was played precisely and exactly, down to the smallest detail, as I had visualized it. . . . The part of Mrs. Corntonhart (Dorothy Fenwick), was recreated as something altogether better, less obvious, and more effective than what I had written. . . . The part of Miss Pethington was acted with no little skill by Margaret Pepler."

That simple and sincere play, *The Corn is Green* is recognized as Emlyn Williams's best work. With an almost uncanny sense of the theatre, he depicts the valiant battle of the middle-aged spinster, Miss Moffat, to give Morgan Evans, her pit-boy protégé, a chance to win his spurs at the university. Dorothy Fenwick's shrewd and indomitable Miss Moffat was a fine and forthright performance, and Royden Godfrey skilfully portrayed each phase of Morgan's development. Peter Tremlett's bluff squire, Yvonne Marquand's precocious Bessie, and Pauline Williams's Cockney mother were all admirably done.

The production of *Ghosts* was a landmark in Northampton's adventure in repertory for two reasons. In the first place it was the first presentation of Henrick Ibsen's masterpiece. Always

a crusader against the shame and conventions that hinder self-expression, Ibsen's message is vividly proclaimed in this flawlessly constructed tragedy of Mrs. Alving's relentless struggle and self-sacrifice to preserve the good name of her late husband and to prevent her artist son, Oswald, from knowing the shameful truth. Secondly, the part of Oswald was played by John Carol, who a few months before had scored a personal success in the same role with Beatrix Lehmann as Mrs. Alving in the London production at the Duke of York's Theatre. His highly intelligent and sensitive performance was well matched by the dramatic strength and intensity of Peggy Diamond's Mrs. Alving. They acted together with such concentrated ardour and power that the effect was almost electrifying. Yvonne Marquand, as Regina, Gerald Lennan, as Pastor Manders, and Arthur Webb as Engstrand, contributing excellent studies and Osborne Robinson providing a lovely setting, *Ghosts* was altogether a stimulating production of real integrity.

Indeed, the acting of *Ghosts* was one of the highlights of the war years. In the common round of revivals and popular successes during those years, the acting, on occasions, was not up to the high level set up in the days of peace. After all, what else could you expect with the depletion of the Company through the demands of the Forces and National Service. But—and what was all the more remarkable—the artistic standard of the decor was consistently maintained. The skill and artistry of Osborne Robinson never faltered. With ingenuity and resource, he overcame the manifold problems arising from shortages and restrictions. He continued to be a fluent speaker in the language of design. Mr. Robinson has the good fortune to work in a spacious studio at the rear of the Repertory Theatre, which would do credit to any theatre. It is, incidentally, one of the largest of its kind in the provinces and was often used by various well-known scenic-artists for painting the scenery for London productions before the advent of the Repertory Players. For many productions he has also designed the costumes, furniture, and other properties, and supervised their making in the theatre's workshop. But he is not only a designer; he is a workman. If you should visit him in the studio, you will probably find him, disguised in workman's overalls larded o'er with paint, covering a large surface of

canvas with colour-wash. He will admit to you with a disarming smile that for many sets he has no time to paint designs on paper first. Such, indeed, are the rigours of weekly repertory! What is astonishing is that his inspiration has kept up, and continues to do so, at the rate of one new play a week, and the decor of each one contains something fresh and original! If you should chance to express your surprise, he will confess diffidently that his only complaint is that the year is too short for him to put all his ideas into execution. Through his decor, Osborne Robinson has expressed his personality. For, after all, an artist is a man who, whatever his calling, does his job in such a way that you know at once that he, and he alone, has done it. Each set that Mr. Robinson has designed has borne an inimitable stamp. Nevertheless, one does not notice the set too much, for, as Alan Dent has remarked, "A good set, like a good suit, should be inconspicuously good." Whereas the producer thinks in terms of speech and action, the designer thinks in terms of pictures. Each scene for him is a canvas with the proscenium arch for a frame. The designer is an illustrator. Often it depends on him as much as on the producer to give the right interpretation to the author's words. Osborne Robinson has faithfully recognized this essential obligation. In the prodigious amount of work he has done since 1928 in designing and painting over 1,500 settings, he has acted as a sincere interpreter of the play, whether tragedy, comedy, thriller, or farce. Unfailingly, he has given the authentic atmosphere needed, bringing form, hue, colour, and unity into his decor. Whenever he has been given the scope, his designs have been exquisitely brilliant in colour and curiously beautiful in form The result has been that intelligent interest in the settings and stage decoration has increased from year to year. It is no exaggeration to say that the sum total of his artistic contribution to the development and advancement of the Repertory Theatre is beyond assessment.

Osborne Robinson, unlike the prophet, is with honour in his own country, for Northampton is his native town, but he is also honoured outside Northampton. On several occasions he has designed settings for Shakespearean productions at the Memorial Theatre, Stratford-on-Avon, and the Old Vic. In 1937, he had the distinction of being invited to design the

settings and costumes for the Old Vic production of *Hamlet*, with Sir Laurence Olivier in the title role which aroused so much interest in the Waterloo Road and in Denmark, when, at the first Hamlet Festival, it was performed in the courtyard of Kronborg Castle, Elsinore. During his twenty years' inestimable service to the Repertory Theatre, Mr. Robinson has become recognized as one of the most talented stage-designers in England. Long may he remain to lend artistry and distinction to the productions at the theatre which is justifiably proud of him!

CHAPTER XVIII

THE WORK GOES ON

"Our true intent is all for your delight."

SHAKESPEARE

CONSTRUCTIVE criticism engenders a virile theatre. After all, every art thrives on sound, informed, and honest criticism, and not least the art of the theatre. It is impossible to generalize about provincial criticism, any more than about provincial theatres or provincial audiences. It can be truly said, however, that one of the handicaps of the repertory movement in certain towns has been the lack of intelligent dramatic criticism. Such places are simply given milk-and-water notices written by reporters who are either uninformed about the drama or unashamedly disinterested in it. The discerning Mr. St. John Ervine placed his finger on one of the causes of this weakness when he said, "When a man is on a newspaper and he isn't any good, they say, 'You shall be a dramatic critic!' When he gets a bit better they send him to an inquest. And when he is very good he reports football matches—that's the height of his ambition!" Although the standard of the notices given to the Northampton Repertory Players has fluctuated from time to time, they have, by and large, received fair and competent treatment from the local Press, which, on occasion, has given invaluable help and support to the theatre. But criticism does not end with the Press. Nearly every repertory playgoer is a dramatic critic without portfolio. Time and again, one encounters unofficial critics who have no opportunity of putting their thoughts on paper, but they talk—and they do so, often surprisingly well. Often, in the foyer of the Repertory Theatre during the interval one hears two or three enthusiasts gathered together arguing about the play, the production, and the acting with understanding, shrewdness, and conviction. There are, of course, those who merely offer one of those two venerable clichés, "Good show" or "Poor show", but it is rarely one leaves the theatre without hearing some original remark in praise or constructive criticism. And what is more, folk have

149

now learned the important lesson that it is unwise to rely on the judgment of another person. The only safe way is to see the play and judge for yourself. Never was a truer word spoken by Sir Barry Jackson than when he said, "A constantly changing repertory of plays encourages a much more living and critical spirit among playgoers of all kinds."

Without doubt the play that provoked the most lively arguments among these amateur James Agates during the first season of 1945 was *Music at Night*. That original and provocative play revealed the past lives and present desires of the guests of Mrs. Amesbury whilst they listen to the first performance of David Shiel's concerto. How J. B. Priestley handles the various reactions of this contrasted group of characters, who each unveil their innermost thoughts betrays a mind keenly perceptive and alive. Reginald Thorne's David Shiel, Margaret Pepler's Katherine, his wife, Mary Russell's Mrs. Amesbury, Joan Hart's Lady Sybil, and Lawrence Baskcomb's Charles Bendrex were played with lively intelligence and dramatic intensity. Considering the originality of the treatment and Mr. Reeve's sincere production, no wonder that, during the interval and after the play, the air bristled with question-marks! Much discussion was also aroused among playgoers by *Getting Married*, and *Mr. Bolfry*. In the Shavian debate on the inconsistencies and discrepancies in our marriage system, Hotchkiss found a faithful representative in Peter Tremlett, and Joan Hart tackled the wellnigh unplayable part of Mrs. George with skill. Opinions were sharply divided about James Bridie's amusing *Mr. Bolfry*, wherein a party of young discontents by means of some ancient witchcraft conjure up the devil himself. Peter Tremlett, as a dour Scottish minister, and Mary Russell, as his imperturbable wife, gave neat studies. In a grand performance, Lawrence Baskcomb was mischievously sinister as Mr. Bolfry.

Of the forty-three plays enacted in 1945, four of our leading playwrights accounted for almost a quarter of this number. They were Noel Coward and J. B. Priestley supplying a trio and Bernard Shaw and St. John Ervine contributing two plays each. As you would expect, therefore, the year of Victory was a good vintage year for the Repertory Players. They decanted much good wine in the form of revivals of well tried favourites

such as *Hay Fever*, *The Barretts of Wimpole Street*, *Ladies in Retirement*, *Dear Octopus*, and *Robert's Wife*, as well as a number of champagne-like comedies, including George Kaufman and Moss Hart's *The Man Who Came to Dinner*, with Franklin Davies giving a robustly humorous study of the famous man who, from his wheel-chair, fires off searing sarcasm and side-splitting wisecracks and sets a whole household in confusion; *The Simpleton of the Unexpected Isles*, Shaw's loquacious but amusing allegory; Noel Coward's delicious and slightly fantastic farce, *Blithe Spirit*, about a twice-married man who receives visits from the tantalizing spirit of his first wife, in which Joan Hart, Peter Tremlett, and Margaret Pepler completed an improbable triangle; and Peter Ustinov's *The Banbury Nose*, a clever family chronicle with a backward glance, with Reginald Thorne scoring a success as a second Colonel Blimp whose god is tradition. The only fresh brew served during the year was again a play by Dr. Falkland Cary. His *Murder Out of Tune* proved baffling and deftly contrived, centreing round a notorious philanderer for whom women fall like leaves in autumn. Arthur Lawrence invested this lady-killer with a smooth, easy charm and the requisite sinister quality.

From time to time there were strong draughts with more body as for instance, *Elizabeth of England*, *An Enemy of the People*, and *Winterset*. A spectacular pageant play in twelve scenes, *Elizabeth of England*, by Ashley Dukes introducing the middle-aged Queen Elizabeth, and mirroring stirring events, like the fall of Essex, the defeat of the Armada, and the death of Philip of Spain, testified to the indomitable spirit of England. Apart from the excellence of the play, the production had a triple appeal, Alex Reeve's sound direction, Osborne Robinson's settings, handsome in line and colour, and the strong performances of Dorothy Fenwick, who endowed the Queen with regal dignity and feeling, and Lawrence Baskcomb, whose Philip of Spain had the quiet of authority. Mr. Reeve deserved praise for the urgency of the production of *An Enemy of the People*, Ibsen's searching satire on small-town politics. Dr. Stockman, the man who stood for the Truth and resolutely faced a storm of opposition alone, was forcefully played by Peter Tremlett, and Arthur Lawrence marked his return to the Company by setting the Mayor, his less scrupulous brother,

securely and suavely in his place. But one could not help feeling the dramatic values of the play would have been more finely balanced had these actors exchanged roles

Breaking new ground the Repertory Players staged Maxwell Anderson's *Winterset*, which received one of its few productions in England at the Birmingham Repertory Theatre in 1940. A grim piece on gangsterdom, it is a stimulating play imaginatively written with uncannily graphic character-drawing and having the intensity of Greek tragedy. Against Osborne Robinson's background authentically capturing the atmosphere of a riverside slum in New York, Peter Tremlett followed Mio's destiny with passionate intensity in one of his best performances with the Company. Stout and well observed studies came from Reginald Thorne and Arnold Peters as two tough gangsters, from Lawrence Baskcomb as an old Rabbi, and Margaret Pepler as the tragic heroine. *Winterset* must be counted as one of the major successes of the Repertory Players.

Throughout the year crowded houses applauded the hard work of an enthusiastic Company and stage staff and the efficiency and artistry of Alex Reeve and Osborne Robinson, who, by some miracle, found time to write and devise a topical, diverting, and highly entertaining Christmas play, *Command Performance*. The authors set out to capture the true spirit of a peace-time Christmas in a series of colourful scenes full of rollicking comedy, romance, and Christmas fantasy. Ballet, songs, and sketches were cunningly interwoven with melodrama in the best tradition of pantomime and revue. Audiences enjoyed this novel entertainment, according it a warm reception.

Infinite variety and excitement characterized the Repertory Players' journey through the year 1946. Three features stood out prominently. First, there was the high order of the productions of *Lady Windermere's Fan*, particularly notable for the richly elaborate decor of Osborne Robinson, and polished acting of Dorothy Fenwick as Mrs. Erlynne, Reginald Thorne as Lord Darlington, and June Ellis as Lady Windermere; of Turghenev's *A Month in the Country*, an enchanting high comedy in which effective acting brought sharp, authentic characters to life; and of *Alien Corn*, Sidney Howard's sincere, tense study of a musician's quest for happiness, with Joan Hart giving as

clear-cut a piece of acting as one could wish to see. Secondly, a greater number of new plays were staged. No repertory company can boast that it has fulfilled its function or achieved an important place in the world of the theatre unless it produces new plays. "Too frequently repertory theatres become mesmerized by the magical words 'Famous West End Success'," says William Armstrong. "Let them experiment with new plays occasionally, thus giving an artiste the chance of creating a part rather than a slavish imitation of a London star in a play which ran for years." Mr. Reeve was strongly in favour of new plays and surpassed all his predecessors in his enterprise in this vital sphere. In 1946 he produced four new plays, of which *Up the Garden Path* was of passing interest, and the other three, *Without Vision*, *The Bells Ring*, and *Crackling of Thorns* had a wider appeal.

Repertory audiences eagerly awaited Dr. Falkland Cary's latest play, *Without Vision*, a sequel to *Burning Gold*. Set in his ancestral home turned into worker's flats in 1950, it continued the story of Philip Woodbury, a blind ex-pilot, who becomes a revolutionary young M.P. with a policy for world recovery. Although again the plot was well constructed, the characters credible, and the dialogue pungent, the theme tended to become befogged with politics causing the play to be but a brave successor to *Burning Gold* and lacking in some of the essential dramatic values of that play. As Philip, Peter Tremlett shrewdly blended ruthlessness and idealism, and Lionel Hamilton sonorously provided the voice of the Church. *The Bells Ring*, by Joyce Dennys, a Devonshire doctor's wife, concerned the post-war problems of a doctor's family. The Company did ample justice to this engaging play, which was afterwards produced in London with John Stuart in the leading role.

Crackling of Thorns created a furore of interest since its author was Dr. C. E. M. Joad, the renowned philosopher and writer whose name has been a household word since he first figured in the Brains Trust in 1941. With scenes in a youth hostel and a national school, the play developed the theme that we can come by salvation in this country only if our population is reduced. A crowded house on the first night was agog with excitement when they saw the famous Brains Truster sitting

in the front of the dress circle. The impact of Dr. Joad's personality is instantaneous and striking. The beard gives an extra sharp edge to his approach to life and you. There is an intensity and impish twinkle in his eyes. His decision to become a playwright was surely characteristic. "I have written most things," he said, "so I thought I might as well have a shot at a play." And a shot it was, for as a play it just did not exist. Watching it one was reminded of the line in *Much Ado About Nothing*—"He doth, indeed, show some sparks that are like wit!" In short, *Crackling of Thorns* was an intellectual prank on the Shavian model but without Shaw's style and sense of theatre.

Thirdly, in November, the Repertory Theatre changed its policy and introduced fortnightly productions. Even though this was by way of being an experiment, the directors hoped a two weeks' run might become a permanent feature because they felt this system had definite advantages, including ensuring more polished and craftsmanlike production, reducing the arduous labours of the Company and widening the choice of plays. Six plays were enacted under this system, of which the most memorable was John Drinkwater's *Abraham Lincoln*, one of the most exciting chronicle plays in the modern drama. Accepting the challenge offered by the title role, Reginald Thorne etched a full-length portrait of Lincoln. His make-up and acting were both finely done and the cordial ovation he received at the end of each performance was amply deserved. A beautiful and moving cameo was provided by Lawrence Baskcomb as Frederick Douglas, an elderly negro, and must take a high place among the host of fine performances this accomplished actor has given with the Repertory Players.

Christmas saw pantomime once again reigning supreme at the Repertory Theatre. An entirely new version of *Cinderella*, the most popular of all the pantomimic stories, was written by Alex Reeve. Whilst preserving all the traditional situations, the book and lyrics were skilfully devised and abounded in hilarious fun, surprising twists, and topical witticisms. Tuneful music was specially written by the theatre's pianist, Sylvia Cohen. Beryl Robinson made a graceful and appealing Cinderella, and a newcomer, Guy Back, son of Kathleen Harrison, gave Prince Charming the right romantic approach.

Peter Tremlett and Margaret Pepler played the King and Queen, and Mary Russell and Lionel Hamilton were seen to comical advantage as the Ugly Sisters. Best of all was Ronald Radd's Buttons, a jolly performance radiating friendliness which made a big hit with the young folk. Mr. Reeve deserved hearty congratulations for devising such a delightful Christmas show. It filled the theatre for two-and-a-half weeks and proved such a resounding success that its run was extended for another week.

Fortnightly productions threw repertory playgoers into two camps of conflicting opinions, the Ayes and the Nays. Those in favour of the system adduced two strong points: (a) that it enabled the Repertory Players to attain a higher standard of work of which the production of *Abraham Lincoln* was an example, and (b) that too many playgoers, including some of the enthusiastic supporters since the early days and some of the younger generation just out of the Forces, failed to obtain seats for the once-a-week productions, and the longer run gave everyone a chance of seeing each play. On the other hand, the opponents of the two weeks' run contended (1) that it was unfair to the loyal body of permanent seat-holders who were largely responsible for the theatre's success in recent years, and (2) that once-a-week repertory had produced the players who, in the past, had become stars. The task of pronouncing judgment upon these widely divergent views did not fall on the directors because force of circumstances decided the matter. Fortnightly productions proved an expensive experiment, involving the theatre in a heavy loss in a few weeks. The directors, therefore, had no alternative but to revert to once-weekly productions in the New Year.

Premières continued to be the vogue in 1947, with two new plays produced in consecutive weeks in January. They were *The Old Man*, a gripping but not wholly satisfactory play, and *Happy Returns*, dealing humorously with the readjustments of a family when the two children return after being evacuated to America for six years of war. In Holy Week came the most memorable new play of the year, *The Man in the Market Place*, by Justin Power and Ronald Wilkinson, a clever passion play in modern guise, in which the dramatic events of the Cruci-fixion and the first Easter were depicted, taking place in an

occupied country at the present time. Lionel Hamilton as the Governor dominated the play with a powerful performance, notable for its restraint, polish, and poise. Commendable support came from the whole Company in a taut production which won wide approval from the public.

The flow of comedies was steady, broken only by such plays as Lillian Hellman's *The Little Foxes*, an intense study of a grasping American family who are likened to the little foxes that despoil the vineyards, in which the acting honours went to Joan Hart, Colin Douglas, Lionel Hamilton, and Reginald Thorne; and Robert E. Sherwood's *There Shall be No Night*, with Colin Douglas playing with verve the famous Greek scientist-pacifist who bravely faces up to the grim realities of war, and Dorothy Fenwick as his wife. Highlights among the comedies were *We Proudly Present*, one of the first repertory productions of Ivor Novello's devastating parody on theatre management, and a superbly mounted production of *An Ideal Husband*, in which Oscar Wilde with pungent wit delves into the history of a rising politician, almost ruined on the eve of his greatest success by a blackmailing woman who holds the secret of his past life.

Thus, the Repertory Theatre carries on presenting plays which otherwise would not be performed in Northampton. With a spirit undaunted by obstacles and undeterred by setbacks, it continues to honour the Drama. And so, after twenty-one adventurous years, the work goes on. . . .

PERSONALIA

"The blessing of repertory is that it creates the best type of audience— it creates a regular, sustained interest in acting for its own sake, and acting is what the theatre lives by, and will have to live by, if it's going to live at all. The live art of acting is the only thing you can find in the theatre and nowhere else."

<div align="right">SIR CEDRIC HARDWICKE</div>

THE undoubted calibre of several of the producers of the Northampton Repertory Theatre has been established beyond doubt by their subsequent achievements. After Herbert M. Prentice had set the Repertory Players on the high road to artistic success and, in so doing, had gained a national reputation, in 1932, he took charge of production at the Birmingham Repertory Theatre. In the course of eight years, he did an immense amount of distinctive work, including important productions of *Hamlet, Volpone, The Moon on the Yellow River, Lady Precious Stream, The Three Sisters, Hedda Gabler, The Boy David*, and *The Ascent of F6*. From 1934–7, he also shouldered the heavy burden of producing an impressive list of plays for the Malvern Festival, that feast of great drama instituted and inspired by Sir Barry Jackson. Among many productions of theatrical significance, he directed the first presentations of a number of new plays, among them, *A Man's House, The Simpleton of the Unexpected Isles, Jane Eyre, On the Rocks*, and *1066 and All That*. When these now well-known plays were later transferred to the West End, Mr. Prentice also acted as producer. In November 1940 when, through war conditions, the Birmingham Repertory Theatre was compelled to close, the Company was disbanded and Mr. Prentice became producer to the Sheffield Repertory Company.

Although on leaving the Repertory Theatre, Robert Young returned to politics, he did not desert the theatre. He found time to undertake engagements as an adjudicator for the British Drama League at various Drama Festivals. Later, he established the Tonbridge Repertory Theatre, which was gaining quite a considerable fame as a rendezvous of good

drama when it had to suspend its work through the exigencies of war. Mr. Young then returned to work in the West End, where he was associated as producer, stage director, or actor with a number of productions, including *A Month in the Country*, and *Uncle Harry*. On the other hand, Bladon Peake left the Repertory Theatre to enter the world of films. After working at Welwyn as a dialogue-writer, he joined Strand Films Limited as a film director, and later worked with Paul Rotha, one of the pioneers of the documentary film, with whom he founded Paul Rotha Productions Limited. For this company he directed many documentary films, several of which were for the Ministry of Health, perhaps the most notable being *Defeat Diphtheria*, which was actually filmed in Northamptonshire, where Mr. Peake has continued to live ever since his association with the theatre ceased. During the war, he became producer-director of films for the War Office, Admiralty, and Air Ministry, working through the Inter-Services Committee, and specializing in medical films. However, Bladon Peake has kept his love of the theatre as is shown by an annual visit he has made for some years past to the Rhondda Valley to produce a play for Rhondda Unity. For this society, in 1945, he produced *Ghosts*, which won first award at the South Wales Eisteddfod.

One of the original members of the Repertory Players was Clifton James, the son of a former Lord Chief Justice of Australia. When Repertory audiences first saw this slim, rather shy young actor in the opening production in January, 1927, they little thought that he was destined to figure prominently in a Second World War. Despite being gassed and losing a finger in the 1914–18 War, he joined up again in the last war and was serving as a lieutenant in the Royal Army Pay Corps. When making up for an army show at Leicester, a Pressman chanced to remark, "Good heavens, you look exactly like Monty!" So Mr. James donned a beret and a British warm, and walked on to the stage. The astonished audience responded immediately, applauding and cheering vociferously. They thought General (now Field-Marshal) Montgomery had arrived. This incident inspired Military Intelligence head-quarters to conceive an ingenious plan. If British troops could mistake Clifton James for Montgomery, why should not German agents be fooled in the same way? When approached,

Mr. James agreed to undertake a special mission, which was to deputize for General Montgomery. But careful training was necessary to make the bluff successful. He met Monty in the north of England and studied his voice, speech, gestures, walk, and even his salute, and a false finger was fitted to his right hand. A few days before D-Day, 6 June 1944, he was seen off from England by senior members of the Imperial General Staff and "General Montgomery" went by air to the Mediterranean for a tour of inspection. Field-Marshal Sir Henry Maitland-Wilson received him in Algiers, and, with an American escort, he drove through streets of cheering people. For thirty-six hours in Gibraltar and Algiers, Clifton James enjoyed all the privileges of his assumed rank and even officers at H.Q. were deceived. Information that Monty was away from the invasion base was sent by Fascist spies in Spain to Berlin, and the Germans assumed the invasion was not yet due to start. Evidence was later found in Germany that Hitler's High Command was caught napping by this first-class piece of bluff. Incidentally, perhaps it is not inappropriate to recall that one of Clifton James's best performances at the Repertory Theatre was in *The Fake*! His reward for this successful undertaking was that for every day he was "Montgomery" he received the full rate of pay of a General. Surely in that great impersonation, Clifton James played his greatest role of his twenty-five years as an actor—and to what an audience!

Another original member of the Company was John Drew Carran, who became established as a firm favourite with Repertory audiences. After leaving the theatre he retired for a short time from the stage and went to live at Guilsborough. The fascination of acting proved irresistible, however, and he returned to it, playing not only in various repertory companies but several films. When acting a leading part in *Mrs. Warren's Profession* at Cheltenham in 1944, he became ill and died suddenly. In the same year George Mudie, who proved himself a stalwart character-actor during a lengthy period of fine work with the Company, died at Peterborough. He left the Repertory Players owing to throat trouble but recovered sufficiently to return to the stage for a time, but later, after forty years on the stage, during which he had toured all over England and America, ill health forced him to retire.

It is a sad thought that T. G. Saville, Brefni O'Rorke, and
Oswald Dale Roberts, probably the three finest actors who have
brought honour to the Repertory Players, have died since
leaving the Company. Besides being a superb and versatile
actor, T. G. Saville was a rare, lovable, and compelling per-
sonality with an old-world graciousness. His imagination and
unusual mind coloured all his work as a poet, playwright, and
actor. When he was at the Repertory Theatre he contributed
a number of charming verses to the magazine programme, and,
after his death a book of his poems was published under the
title, *Beyond the Windmill*. Perhaps we may be permitted to
quote one entitled "Hullo":

> "You are lovely and compassionate. Your eyes,
> Remembering all my unremembered things:
> Forgotten stars that filled forgotten skies,
> The sunset glimmer in the sea-birds' wings,
> And many a dream I had . . . are recondite;
> And set, once more, my pilgrim dreams adrift
> Across the purple spaces of the night.
> Incomparably beautiful and swift,
> Your slim, delightful spirit sees me fawning
> Around your dawn-kissed feet. O let's be gone,
> Into the wind-swept ecstasy of morning.
> Along the rippling highways of the sun!"
> This is the sort of thing I'd LIKE to say,
> But being much in love with her, I grunt and turn away."

His ambition was to become a playwright, and, in his short
but full life, he found time to write several plays, including
Perdita Comes to Town, which he produced at the Festival
Theatre, Cambridge, and at Northampton, *Expedition*, and
The Intruder, and he adapted for the stage Noel Streatfield's
novel, *The Whicharts*, and Mary Webb's *Gone to Earth*, in which
Beatrix Lehmann played in the West End production. After
leaving Northampton, Mr. Saville played leading parts in a
number of London productions, among them, Masefield's *The
Tragedy of Man*, *The Scion*, and *Miracle at Verdun*. His last
appearance was at the Haymarket in that phenomenal success,
Ten-Minute Alibi, in which he got every ounce of subtlety and
humour out of the young varsity detective for over 550 per-
formances. During the run he became ill and was taken to St.
Bartholomew's Hospital, where he died at the age of thirty-four.

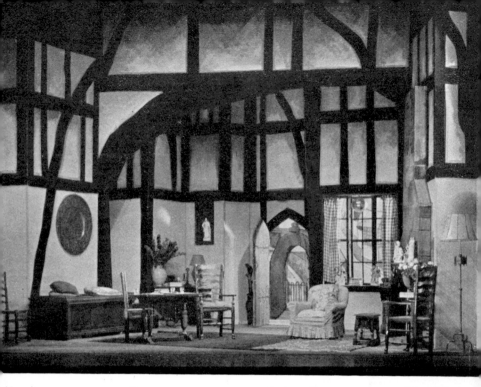

(*Above*) SETTING FROM "UP THE GARDEN PATH" (1946) (*Henry Bale*)

(*Below*) "THE MARQUISE" (1946) (*Henry Bale*)

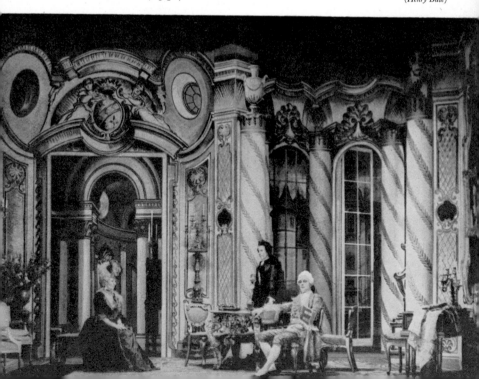

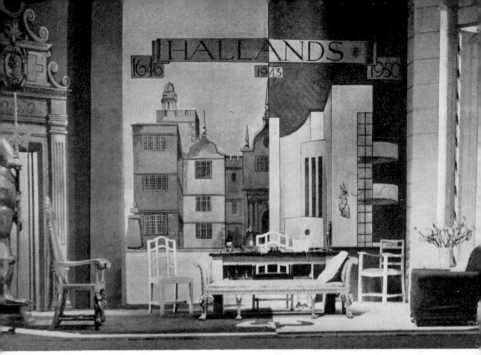

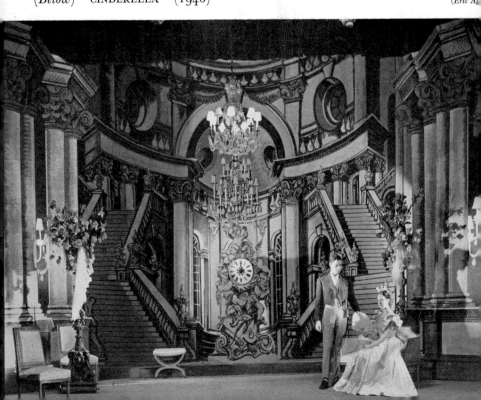

(*Above*) SETTING FROM "WITHOUT VISION" (1946)

(*Henry Be*

(*Below*) "CINDERELLA" (1946)

(*Eric Ag*

An anonymous writer wrote of T. G. Saville:

"As an actor he had most of those qualities that should lead to success if not greatness, and attributes which some of the great would give much to possess. A brilliantly alive and self-taught brain (he crammed into his thirty-four years what many men twice his age would envy) a knowledge of French, German, Italian, and Greek, a great power of expressing himself! . . . He was superlative in such roles as Richard in *Richard III*, Oedipus in *Oedipus Rex*, and many modern parts at the Embassy Theatre, London. He was for a time one of the teachers of this theatre's school of acting. 'In classical plays'—so writes a critic—'he rendered great lines with a fine appreciation of their most elusive subtleties, and to an effect which his rich, resonant voice imbued with infinite beauty and dignity.' "

Writing in *Theatre World*, yet another critic declared:

"I believe that if the late T. G. Saville had lived he would have proved himself one of the finest actors of our time. He was always proud of Northampton, and Northampton was always proud of him. If he were amongst us now he would have revelled in the success of the drama in the theatre which gave him so much encouragement."

A native of Dublin, Brefni O'Rorke made his stage debut there in Shaw's *John Bull's Other Island* in 1912, and later went to the Abbey Theatre. He ran his own repertory company in Ireland for many years and during the Civil War had some hair-raising experiences. After his departure from the Repertory Theatre in 1935 he appeared consistently in British films, in James Bridie's *What Say They?* opposite Yvonne Arnaud at the Malvern Festival in 1940, and on the subsequent tour, in *Lifeline*, at the Duchess in 1942, and in *The Rivals*, with Edith Evans at the Criterion in 1945. In each performance he displayed his exceptional talent as a character-actor. In the midst of making a film, *Jassy*, at Shepherd's Bush, he was taken ill and died suddenly at the age of 57, in November 1945. Although eleven years had elapsed since he took his final curtain at Northampton, so great was the impression he made

that repertory playgoers have never forgotten his outstanding acting.

When Oswald Dale Roberts bade farewell to the Northampton Repertory Players in December 1935, after a stay of three-and-a-half years, he was appointed producer at the Hull Repertory Theatre, but in August 1938, he returned to Northampton for a further season, making his last appearance in *The Private Secretary* in January 1939. Hosts of his admirers still recall with pleasure his noteworthy and memorable acting with the Repertory Players. Always the soul of courtesy and kindliness, Mr. Roberts exerted a fine influence in the theatre, promoting friendship among the players and goodwill among all who were associated with him. When in April 1939, his wife died, an ideally happy marriage was unexpectedly brought to a close. A charming and gifted lady, Mrs. Roberts continued to reside in Northampton with her son and daughter on each occasion after her husband left the Repertory Company, and gave much valuable help to the amateur stage in the town. After this bitter blow, Mr. Roberts returned to his post as assistant producer to the Forsyth Players, who alternated between Bexhill-on-Sea and the People's Palace, Mile End Road, London, but he had a severe breakdown in health and at one time it seemed doubtful if he would return to the stage that he had graced for nearly thirty years, playing with many of the greatest artistes of his day, including Ellen Terry, Sir Frank Benson, and Henry Baynton. Eventually he recovered sufficiently to stay with his clergyman brother at Smethwick. From there he went to stay at Clifton, Bristol, with his brother, Cyril Roberts, a master at Bristol Grammar School and also a playwright, being particularly well known as the writer of several clever one-act plays.

Two days later, on Friday, 20 October 1939, the body of Oswald Dale Roberts was found lying at the foot of the Avon Gorge, Bristol. He had fallen 250 feet from a spot near the Observatory and was found suffering from terrible injuries. He was rushed to hospital but died before he reached the Bristol Royal Infirmary. He was aged 52. At the subsequent inquest, evidence was given that when on that Friday Mr. Roberts left the house he seemed more cheerful than he had been for some time. There were several unposted letters in his

pocket and his dog was found at the top of the cliff. Unable to say whether the fall was accidental or not, the jury recorded an open verdict. Hundreds of repertory playgoers in Northampton felt an acute sense of personal loss by his sad death. Thus the life of one who had given a legion of forceful and impassioned interpretations of tragic roles, came to a close, shrouded in tragedy. Not tragedy alone, but mystery remains. And no one will ever probe it. No one will ever know how this accomplished actor, fine scholar, kindly friend came to keep this rendezvous with death. We only know—"This fell sergeant, Death is strict in his arrest." But with John Masefield, Oswald Dale Roberts, who was a devout man, firmly believed that

> "We find when ended is the page,
> Death but a tavern on our pilgrimage."

HONOURS LIST

"The Repertory Movement is sweeping like a wave over the country. It is creating a new taste in drama in the British public. It is making the actors and actresses of the future."

SYDNEY W. CARROLL

Repertory, it has been truly said, is the backbone of the stage. When you consider that the major proportion of our leading actors and actresses have graduated from the Repertory Theatres, you see the force of this assertion. The reasons are not far to seek. Whilst it is undeniable that acting in repertory is arduous and exacting, especially under the twice-nightly system, it is, nevertheless, an invaluable training school for an artiste. Arduous and exacting it may be, but it should be remembered that out of her wisdom and experience Sarah Bernhardt said, "Natural gifts have to be supplemented by laborious training." No one will deny that what the beginner on the stage needs above all else is practice, and an artiste in repertory gets that in abundance. He (or she) is given a chance of tackling a new part each week, and thereby obtaining a wide range of experience. Hard work and strain there may be, but it gives an artiste assurance, attack, and a faculty for memorizing lines. Although it provides little opportunity for etching the lights and shades and intricate subtleties of a part, a quick succession of varied roles should result in a development of technique. And what a contrast it is to the stultifying effect of the "long run" on the artiste in the commercial theatre, whether in the West End or on tour!

When one looks back across the span of twenty-one years and thinks of the players who have been members of the Northampton Repertory Players, a host of names flick past in the memory. Many have found fame in higher spheres, on the stage, the screen, and the radio, but they would all acknowledge that the Repertory Theatre proved a fine training ground. "Get me a fellowship in a cry of players," said Hamlet. Above all they learned the vital secret of that fellowship, that team

work which has always been a predominant feature of the Repertory Players' success. The Repertory Theatre has indeed done more than its fair share of moulding stars for the London stage. Although space does not permit to deal in detail with all those who have won success, we propose to mention those who have achieved the greatest prominence.

One of the original members, Arthur Hambling, has been in great demand as a character-actor in London ever since he left the Repertory Theatre. His name has appeared in the cast of innumerable plays, some of the recent ones being *A Sleeping Clergyman*, *Spring Tide*, *The Russians*, *The Wind of Heaven*, and *The Gleam*. Mr. Hambling has done equally well in films. Another original member, Margot Lister, has had successful seasons in Shaw's plays with the Macdona Players, and has appeared in a number of West End productions. Always regarded as a versatile actor, James Hayter confirmed this view when, after a period at the Birmingham Repertory Theatre, he went to London. Not only has he scored in such comedy successes as *The Composite Man*, and *French Without Tears*, but in several revues, including *And On We Go*, with Marie Lohr and C. B. Cochran's *Lights Up*. Among a score of films in which Mr. Hayter has appeared are *Murder in Soho*, *Marigold*, and *Big Fella*, with Paul Robeson.

Vivienne Bennett has amply fulfilled the predictions for her future made by discerning playgoers when she was giving such outstanding performances at the Repertory Theatre. Since she left in 1931 to play in *Lean Harvest* at the St. Martin's Theatre, London, she has steadily climbed the ladder to stardom. After a spell with the Birmingham Repertory Company in 1932–3, and at the Malvern Festivals, she played in *Late Night Final* at the Phoenix, in various plays at the Westminster under the production of Tyrone Guthrie, in *Counsellor-at-Law*, and in *Sweet Aloes*. At the Old Vic during 1935 and 1936, Miss Bennett scored triumph after triumph in leading parts including Ophelia (to Maurice Evans's Hamlet), Solveig in *Peer Gynt*, Lady Teazle, Lady Macbeth, and Desdemona. "She was a Desdemona of classic grace," declared M. Willson Disher in the *Daily Mail*. Subsequently, she was in *Night Must Fall*, *People at Sea*, and several plays under Norman Marshall. As the leading actress in the Diamond Jubilee Festival at the

Stratford-on-Avon Memorial Theatre in 1939, she played
Katherina, Beatrice, and Rosalind. In 1941, Miss Bennett
became a director of the Market Theatre with Godfrey
Kenton and Walter Hudd, which was established to take good
plays to isolated communities. The Company travelled all over
England for several years during the war playing in theatres,
schools, and halls of every description, and with the support of
C.E.M.A. was enabled to carry on most valuable work. Miss
Bennett has since played leading roles in productions at the
Arts Theatre, Cambridge, and the Arts Theatre, London,
notably in *Twelfth Night, Awake and Sing*, and *Back to Methuselah*,
and with Sir Cedric Hardwicke in *The House on the Bridge*.

Following seasons with the Birmingham Repertory Company,
at the Malvern Festivals in 1934 and 1935, and at the Old
Vic, Godfrey Kenton appeared in *The Happy Hypocrite* with
Ivor Novello, in *Good-bye Mr. Chips* with Leslie Banks, and
Family Portrait with Fay Compton, as well as acting the chief
male role in *After October*. He has also produced several plays
and done a considerable amount of broadcasting. But with his
fine presence and resonant voice, the Shakespearean drama
has always been his strong suit, and in 1937 and 1941 he was
at the Shakespeare Memorial Theatre, and in 1944-5 with
Donald Wolfit's Company playing leading roles.

When, in December 1936, Curigwen Lewis made her first
appearance in London in the title role in *Jane Eyre*, she reached
stardom with a resounding success. One critic described it as,
"A lovely play in which Curigwen Lewis makes a triumphant
debut as Jane Eyre to the life." She has followed this with many
superb performances on the stage and also "on the air". In
1938, she played leading parts in the Old Vic Company, her
Desdemona to Sir Ralph Richardson's Othello, and Sir
Laurence Olivier's Iago, receiving particularly high praise, and
the following year she was a member of the Old Vic Company
which toured Italy and Egypt with a repertoire of plays,
including *Hamlet, Henry V, The Rivals*, and *Man and Superman*.
Miss Lewis was married to Andrew Cruickshank, the well-
known actor, in 1939.

Play production claimed Noel Howlett in 1933 when he left
the Repertory Players and he was engaged as producer at the
Hull Repertory Theatre. Later, Mr. Howlett migrated to the

West End where he reached the top in *George and Margaret* at Wyndham's in 1937, receiving enthusiastic notices for his portrayal of the father in that record-breaking comedy. Having acted the same part in the film, in conjunction with Esmond Knight and Wilson Barrett, he inaugurated a repertory theatre at the King's Theatre, Hammersmith, and filled the triple role of co-director, producer, and player. During the war, Mr. Howlett was stationed in the Middle East, where he produced *George and Margaret* with Hazel Hughes, another ex-Repertory player, in the cast. He has returned to the stage since the war and did well in *The Master Builder* at the Arts Theatre in 1947. Arriving at Northampton at the same time as Mr. Howlett, Olive Milbourne made her debut with him in *The Green Goddess* in August 1929, and stayed with the Company for three years. She has, since leaving, performed at several Malvern Festivals and in the West End, achieving a noteworthy success in *Geneva*.

Max Adrian has left no ground for doubt about winning his spurs in the twin worlds of stage and screen. When he left Northampton he returned to the London stage and among many plays in which he has since acted are *The Composite Man*, *St. Joan*, *Troilus and Cressida*, *The Doctor's Dilemma*, *First Episode*, *Our Betters*, and in John Gielgud's company at the Haymarket in 1944, and in *Love for Love*, *Hamlet*, and *A Midsummer Night's Dream*. Turning his attention to the films he has been seen in, among others, *Second Best Bed*, *The Cardinal*, *Kipps*, *The Young Mr. Pitt*, and *Henry V*. In 1947, Mr. Adrian produced Ivor Novello's comedy, *We Proudly Present*, and in collaboration with Laurier Lister, he wrote *Against Our Hearts*, produced at the Savoy in 1938. Another Repertory Player who wrote a play which received a West End production was Peter Rosser with *All of You People*.

Few actresses have achieved such a sensational success in recent years as Sonia Dresdel, better known to Repertory playgoers as Lois Obee. After winning golden opinions for her consistently fine acting in repertory at Harrogate for five years, she joined the Old Vic Company for the Buxton Festival in 1939 in which she played leading parts with Robert Donat, Constance Cummings and Marie Ney in *Romeo and Juliet*, *Viceroy Sarah*, *The Devil's Disciple*, and *The Good-Natured Man*.

She swept into London during the dark days of 1942 with the most exciting Hedda Gabler since Mrs. Patrick Campbell. Sydney W. Carroll commented:

"I know of no other actress on the English stage who can make her eyes laugh, weep, and talk more eloquently, or look into vacancy so abstractedly. She is the Hedda Gabler of Ibsen's dreaming. She can wring her heart and ours . . . her artistry is of superlative merit, a talent of extraordinary quality. She is electric, sinuous, alert, and alive."

Since then she has had personal triumphs as Millament in *The Way of the World*, in *Le Parisienne*, *This Was a Woman*, *Laura*, *Green Laughter*, and as Nurse Wayland in a revival of *The Sacred Flame*. Writing in *Theatre World*, Eric Johns declared:

"In this actress the legitimate stage has discovered a remarkable artist who can easily take her place in the Royal Line of Great Ones . . . Sonia Dresdel is the first of her kind. She is not a second Sybil Thorndike, nor a replica of any other artist who has gone before her. There may be a slight suggestion of Edith Evans and a vague echo of Gertrude Lawrence's work, but in voice, looks, and gait she is totally unlike any other actress ever seen, and from the moment she makes her entrance she arrests your attention and holds you spellbound."

How interesting it is to remember that when Miss Dresdel first came to Northampton she was young and obviously inexperienced, although from her earliest performances a certain unmistakable quality was discernible!

Three actresses, Joan Kemp-Welch, Heather Boys, and Anne Allen, having proved themselves useful members of the Repertory Players, took the London plunge. Besides acting in such plays as *Nina*, with Lucie Mannheim, *Ladies in Retirement*, and *It Happened in September*, Miss Kemp-Welch has appeared in a number of films, including *They Flew Alone*, and *Talk About Jacqueline*. On the other hand, Heather Boys has made her name in the realm of musical shows, winning recognition in *The Two Bouquets*, *Big Top*, and *A Night in Venice*. Anne Allen came into prominence in *Murder With a Valentine*, and had a big role in *Three's a Family*, at the Saville in which Harry

Geldard played a principal role. Veronica Rose and Lorraine Clews have each made a hit in several British films.

Errol Flynn was an adventurous, globe-trotting young man. When he joined the Repertory Players, he had done most things from boxing to treasure-hunting in the South Seas. After taking his departure from the Repertory Theatre, it was characteristic of him to seek his fortune in Hollywood. When, soon after his arrival, he was photographed on the beach at Santa Barbara, California, with that glamorous film star, Lili Damita, tongues began to wag and the rumour of their engagement was speedily followed by their flight by plane to Yuma, Arizona, in June 1935, to be married. Not long after that, a dozen well-known actors were tested for the leading part in *Captain Blood*, from the Rafael Sabatini romance of pirate days, but Mr. Flynn, who also received a test, outshone them all and got the part of the buccaneer. "Talk about the luck of the Irish!" rhapsodized a Hollywood correspondent. "This young fellow, Errol Flynn, who plays the title role in *Captain Blood*, seems to have been born with his full share of it. Furthermore, he knows how to make use of it." He has since been starred in *The Adventures of Robin Hood*, *The Sea Hawk*, *Dawn Patrol*, *The Charge of the Light Brigade*, and with Bette Davis, in *The Sisters*, and *Elizabeth and Essex*. Errol Flynn thus swiftly climbed from repertory to stardom on the screen and became one of the most popular Hollywood stars of the late nineteen-thirties.

After two-and-a-half years with the Company, Freda Jackson decided to burn her boats and take the risk of going to London in an endeavour to secure advancement on the stage. Just over a year later the chance she sought came when she was cast for Madame Crevelli, the opera-singer in *Judgment Day*. Her acting was widely acclaimed, one critic asserting that she gave a "comedy performance that stands out vividly". From that time, Miss Jackson never looked back, and she gained further successes with the Old Vic at Buxton Festival in 1938, during that company's tour of Italy and Egypt in 1939, and at the Shakespeare Memorial Theatre in 1940, and with the Old Vic in London in 1942 and 1943, always showing her rare ability for strong, emotional acting. On the production of *No Room at the Inn* in 1945, Freda Jackson came into her own, receiving cordial praise from critics and playgoers for her

remarkable "tour-de-force" as the cruel, sensual, cunning slut of a woman who takes in child evacuees in war-time for profit. One critic declared: "No praise could be too high for Freda Jackson's powerful portrayal of the depraved creature, and her scene of maudlin drunkenness is a masterpiece of vivid realism."

Patrick Crean and Helen Christie, who first met when they played in *Cinderella* at the Repertory Theatre in 1934, were married in October 1943. Since they took their respective departures from the Company, they both earned honourable places in the theatre world. Following a season at the Shakespeare Memorial Theatre in 1937, Mr. Crean appeared in *Geneva* in New York, in Donald Wolfit's productions of *King Lear*, and *The Romance of David Garrick* at the St. James in 1943, in *Quiet Week-End*, and with John Gielgud at the Haymarket in 1944–5 in *Hamlet*, *A Midsummer Night's Dream*, and *The Circle*. Mr. Crean is also busily engaged in running a School of Fencing in London. Some of the West End productions in which Helen Christie has played important roles are *Aren't Men Beasts*, *The Frog*, *Spring 1600*, and *Anthony and Cleopatra*, with Edith Evans and Godfrey Tearle.

Yet another former Repertory Player who has become a playwright is Nicholas Phipps, whose thriller *First Stop North*, was produced at the King's Theatre, Hammersmith, in 1939, when it had a most favourable reception from the critics and the public. As well as contributing witty lyrics and sketches to several revues, including the highly successful *Sweet and Low*, Mr. Phipps has gained distinction for his acting in *Spring Meeting*, *Crisis in Heaven*, and in the part created by Cecil Parker in *Blithe Spirit* for a considerable proportion of that play's record run at the Duchess. Like Freda Jackson, Alistair MacIntyre had the courage to go straight from the Repertory Theatre to seek success in London, which came to him in such plays as *Storm in a Teacup*, *Last Train South*, and *They Walk Alone*. Eric Micklewood has also fulfilled the promise he showed when at the Repertory Theatre, coming into prominence in the West End productions of *Pink String and Sealing Wax*, and *The Glass Slipper*. Referring to his performance as the Prince in the latter, a critic remarked, "This fine young actor has a voice of singular beauty and must be regarded as one of the most promising romantic actors on the horizon." Among the

artistes who, after leaving the Repertory Players, passed on to
the Birmingham Repertory Theatre where they contributed
excellent work were Dorothy Evans, Bertram Heyhoe, Donald
Gordon, and Patrick Ross.

Radio has claimed Neil Tuson since he left the Repertory
Company. In the sphere of broadcasting, he has gained repute
as a playwright, actor, and producer. Among the plays which
established him as a radio-dramatist were *Revolt in Suburbia*,
Re-Union, an adaptation of Arnold Bennett's novel, *The Card*,
and *The Doubtful Misfortune of Li Sing*. Before the war he was
an announcer at the Midland B.B.C., Birmingham, when he
also appeared in a number of broadcast plays. After five years
in the R.A.F., Mr. Tuson returned to the radio world and
quickly came to the fore as a producer of various plays, of
Theatre Programme, and particularly of the first two hundred
episodes of that first thriller-serial, *Dick Barton—Special Agent*.
Furthermore, radio was the chief field of entertainment in
which Ian MacKenzie won fame. On leaving the Repertory
Theatre in March, 1942, he changed his name to Michael
Howard, and as a comedian made a hit in Non-Stop Revue
at the Windmill Theatre, London, and later, at the Palladium,
in *Look Who's Here*. As a nonchalant topical chatterer, he was
featured by the B.B.C. in "Music Hall", and in a series of
programmes of his own. Williams Lloyd is another one-time
Repertory Player who has done a great deal of radio work,
appearing frequently in the B.B.C. Repertory Company, as
also has William Sherwood. Not only has John Carol often
been heard in broadcast plays, but he has played in a number
of London productions, scoring a particular success in *The
Shop at Sly Corner*, at the St. Martins, and *Boys in Brown* at the
Arts Theatre. Having played leading parts at Worthing
Repertory Theatre, Peggy Diamond adopted the name of
Margaret Diamond, and went to London where she has se-
cured excellent notices for her performances in several pro-
ductions, notably in *The Rossiters*, with Diana Wynyard, and
He Who Gets Slapped, with Robert Helpman. In view of her
long spell of fine and intelligent acting at the Repertory
Theatre, few playgoers will be surprised to learn that Miss
Diamond shows promise of taking high honours in London.

Surely two facts emerge from these brief details of the

individual successes attained by former Repertory Players:
first, what an ideal preparation for stardom is repertory
training, and, secondly, what a substantial debt London and the
realms of the stage, screen, and radio owe to the Northampton
Repertory Theatre for acting as a "nursery" for stars. But
everyone cannot reach the front rank or get a chance in the
West End, and, after all, it is not the place where an artiste
acts but the acting itself that matters, and we can rest assured
that wherever they may be in other Repertory companies, on
tour or overseas, its former players are worthily upholding the
high standard of the Northampton Repertory Theatre.

THE CHALLENGE OF THE FUTURE

"The drama is not a plaything, but an institution
which should be the pride and mirror of the nation."

J. T. GREEN

WHEN asked the riddle, "When is a repertory theatre not a repertory theatre?" Sir Herbert Beerbohm Tree, the famous actor-manager replied, "When it is a success." But that was nearly forty years ago when a repertory theatre was invariably a hazardous enterprise and too often associated with failure. In those early days most people understood the term "repertory" to denote a sort of amateur theatrical concern performing in a dingy, dreary hall somewhere in the wilderness of the provinces. Since then, however, the wilderness has blossomed as the rose, and the repertory movement has become a major force in the English Theatre. "Nothing more striking has ever happened in the history of the Theatre," writes Sir Barry Jackson, "than the growth of the repertory movement, which has made the theatre a vital, creative nucleus in so many different communities."

A worthy and notable part has been played by the Northampton Repertory Theatre in the Renaissance of the Theatre in the Provinces. It has proved that intelligence and beauty and wit are not divorced from the stage, and that there is a "world apart" from the ephemeral products of the commercial theatre. It has fulfilled its function as a microcosm of the English drama during the twenty-one years it has run without interruption, and no other repertory theatre in this country has remained open throughout that same period from 1927 to 1948. Let there be no misunderstanding, Liverpool, established in 1911, and Birmingham in 1913 had their work interrupted through enemy action in the Great War of 1939–45. A number of other repertory theatres started before Northampton, as for instance, Manchester in 1907, Plymouth in 1915, and Bristol in 1923, but were unable to continue, although, after a break, most of them made a fresh start with additional financial backing.

Whereas the Northampton Repertory Theatre is justly proud that it has neither closed down in the sense of calling a break and disbanding the Company, nor received any outside financial assistance whatsoever. In many towns and cities, moreover, there have been severe setbacks, sometimes a waning of that early enthusiasm in which the theatre was founded. In other instances, there has been a deviation from the paths of rectitude and wisdom by straying along the by-paths of a falsely economical amateurism or of a profitable commercialism. But at Northampton, progress has been consistent and steady.

Since that wet Monday night on 10 January 1927, when the curtain was rung up for the first time, the Repertory Theatre has instilled new vitality into the dramatic life of the town. It has sowed and harvested in a wide field, having staged nearly one thousand productions. A truly formidable record! The enthusiasm has not waned with the passing years, and hundreds of people have become hardened theatre-goers since its inception. Quite apart from the pleasure enjoyed, they have derived other benefits. In the first place, they have become members of a Repertory audience which soon meets not merely as a collection of people witnessing the same play but as friends. For one of the special virtues of a repertory theatre is that a corporate feeling is engendered on both sides of the curtain. It is a place where our national frigidity of temperament is forgotten. Observe the charmingly decorated foyer of the Repertory Theatre during the intervals of any performance. Amidst the clinking of tea or coffee-cups and gay chatter, you will find a glow of good fellowship emanating from circles of friendship forged at the theatre itself. Nothing could be healthier provided audiences do not become smugly satisfied and assume an uncritical attitude. Secondly, through the Repertory Theatre, Northampton playgoers have seen hundreds of plays which otherwise they would have had no opportunity of seeing. That achievement alone towers above all others. And for it Northamptonians are profoundly indebted to the original crusaders—those dauntless "big five" —the directors, the producers, the scenic designer, the players, and the whole staff of the theatre for their fine conscientious work through the years.

Dozens of questions leap to one's mind regarding the future. Will there be drastic changes in the Repertory Theatre's policy? Will it remain independent? Will it change from the once-weekly system, which is fast dying out, and revert to fortnightly productions? At the Bristol Old Vic, the change of programme is three-weekly; in Liverpool, Birmingham, and Glasgow, four-weekly. Whatever happens, we earnestly hope it will never have to resort to twice-nightly performances. Will it descend to the exclusive production of commercial successes as some so-called repertory theatres have done? Will it form part of a national theatre, or will it be absorbed in a "nationalized" theatre? Are there to be more exciting phases, like those during the years 1933, 1934, and 1936? Is the "golden age" of the theatre's work in the years ahead?

Whatever the years to come may hold in store for repertory playgoers, they have no need to fear for the future whilst the reins of management remain in the hands of those who are experienced, sagacious, and fully sensible to the true function of a repertory theatre. The present directors, who are to be complimented on the enterprise and wisdom they have displayed through the years, have been constantly vigilant that the Repertory Theatre faithfully served the drama and the theatre-going public to the best of its ability. Although the writer is in no wise blind to the fact that an outsider cannot possibly know the exact dimensions of the problems with which they have to grapple, perhaps they will not object to a few suggestions regarding the future policy of the theatre. Let it be clearly understood, however, that the ensuing remarks are not made in the spirit of criticism but are offered by one who cherishes a keen and friendly interest in the Repertory Theatre and whose sole desire is for its artistic and dramatic prosperity.

Nothing at the Repertory Theatre has evoked more widespread interest than the Dryden Festivals. As we have shown, distinguished visitors came to the theatre and the productions excited a good deal of comment in the national Press and leading reviews. With the result that Northampton gained quite a reputation elsewhere for dramatic enterprise and artistry. Their significance lay in the fact that the Repertory Theatre was making a unique contribution to the theatre of the day, for, as Graham Greene remarked, "Mr. Sydney

Carroll in his enterprising Restoration revivals has not yet produced a play by Dryden. The Old Vic is less excusably inert, and one must go to Northampton, Dryden's county town, to see Dryden played." Unfortunately, at the third Festival, "Sir Martin Marr-all" played to thin houses and there were no more Dryden Festivals. To cease producing a Dryden play annually may have been wise, but why discontinue the Festival?

A criticism that has been levelled against the Repertory Theatre is that latterly it has been content to be merely of local significance. If that allegation is true, it must be faced and faced squarely and boldly, for that way ultimately lies stagnation and deterioration. A repertory theatre worth its salt must not be afraid to experiment and to carry on courageous and ambitious work. Acting on that principle, the Repertory Theatre leapt into the vanguard of the repertory movement. It acknowledged that, whilst producing the best plays of the commercial theatre in a worthy manner, it should be a wellspring of dramatic idealism. As Herbert Farjeon once wrote: "Every self-respecting city in England should have a repertory theatre on which it can depend for something a little deeper and a little more inspiring than the off-scourings of the West End."

As a gesture of the spirit of enterprise, why does not the Repertory Theatre inaugurate an annual festival at which a play of special interest or merit is produced? Let such a production be given more elaborate preparation, staging, and publicity than the normal weekly offering. It could, for instance, be designated a Midland Play Festival at which plays written by playwrights born in the Midland Counties were staged. Besides Dryden, Shakespeare, Beaumont, and Fletcher, Henry Arthur Jones, Arnold Bennet, and John Drinkwater would be eligible. Alternatively, Northampton could have its own Shakespeare Birthday Festival, thus ensuring the performance of at least one play each year by the brightest star in the world's drama. Whatever form such a festival might take, however, one does feel that the establishment of an annual festival might serve the twofold purpose of providing a play with an outstanding and possibly national appeal that would bring honour to the drama in the Provinces

and, at the same time, focus attention on the valuable work of the Repertory Theatre itself.

Inevitably, responsibilities in a repertory theatre are inter-weaved and interwoven like good lace. The Board of Directors owe a duty to the producer, artistes, and staff with regard to their working conditions, salaries, and the like, and to the audience to see that they are properly cared and catered for, which includes both liquid and dramatic entertainment, food, and food for thought. The producer bears the responsibility of directing and controlling all activities on the stage-side. Each in his own sphere, the business manager, the scenic designer, the artiste, the electrician, the stage carpenter, the stage-hand, and the attendant must play his or her part so that each week a new production may be presented for the audience's pleasure. That is not all. On the public rests the heaviest responsibility of giving regular support. The Repertory Theatre's most crucial need will always be a live and loyal audience to respond to live players. A play, a policy, and a flame of sincerity behind the curtain avail little if there is not also an appreciative audience. All too frequently the public do not realize how important is their responsibility and what a large share the audience plays in every theatre performance. A man may write a sonnet, paint a picture, or compose a sonata by himself and for himself alone. The co-operation or apprecia-tion of other people is unnecessary. But a vital part of the supreme fascination of the theatre is that a play does not come alive until it is acted before an audience. As an art, it involves the active co-operation of the author, the actors, and the audience. Each playgoer, therefore, plays a vital part in the performance of a play and an intelligently awake and emotion-ally alive audience is essential to a living theatre.

That indefatigable egoist and critic, the late James Agate, said, "The occasional playgoer regards play-going as an alter-native to dancing, tennis, motor-biking and pillion-riding, drinking, gambling, dog-racing, the pictures, and holding hands thereat, loafing at street corners and mooning about the house." Briefly, the occasional playgoer is not of the stuff of which a repertory theatre is built. But few things are more encouraging than the recent change in attitude of many people towards the theatre. They are no longer content to be occasional or

spasmodic frequenters of the Repertory Theatre. They no longer regard it as an alternative to the occupations to which Mr. Agate refers, and their mood is for drama rather than dope. At the Repertory Theatre, they find not only something to beguile their leisure but something to widen their outlook and enlarge their experience. The theatre having ceased to be an occasional diversion has become an integral part of their normal lives. In a greater appreciation of a more creative, vital, and imaginative theatre lies the sure hope of the future for, after all, audiences get the playhouse they deserve.

After varying changes of fortune, the Northampton Repertory Theatre has successfully reached the twenty-first milestone on its exciting and adventurous journey. There is no reason why it should not continue to perform an indispensable service to the town. There is no reason why it should not continue to be honourably spoken of all over the world for its worthy representation of our rich dramatic heritage. There is no reason whatever why it should not go forward with confidence towards its golden jubilee, provided it believes in the past, trusts the present, and plans for the future.

APPENDIX I

THE DIRECTORS OF
THE NORTHAMPTON REPERTORY PLAYERS LTD.

BETWEEN 1927 AND 1948

	Year of Appointment.	Year of Termination.
P. B. BASKCOMB, B.A.	1928	—
W. J. BASSETT-LOWKE, M.I.LOCO.E., F.R.S.A.,	1926	—
H. MUSK BEATTIE	1926	—
LT.-GEN. SIR JOHN BROWN, K.C.B.	1934	1938
SIR JAMES CROCKETT, J.P.	1926	1930
L. M. CROCKETT	1930	1931
W. H. FOX, F.S.A.A.	1941	—
F. GRAVES	1926	1934
W. H. HORTON	1926	1932
MRS. HELEN PANTHER, M.B.E., J.P.	1926	—
DR. ERIC H. SHAW	1938	1939
G. F. SKINNER	1931	1934

APPENDIX II

LIST OF PLAYS AND THEIR PLAYERS, PRESENTED BY THE NORTHAMPTON REPERTORY PLAYERS LTD.

BETWEEN 1927 AND 1948

* Stage Manager. ** Assistant Stage Manager. † Also produced a play or plays during the year. ‡ For the first time on any stage.

PLAYS—1927

Jan.	10	*His House in Order*—Sir Arthur Pinero.
	17	*The Truth about Blayds*—A. A. Milne.
	24	*A Bill of Divorcement*—Clemence Dane.
	31	*Jane*—Harry Nicholls and W. Lestocq.
Feb.	7	*The Eye of Siva*—Sax Rohmer.
	14	*Three Wise Fools*—Austin Strong.
	21	*The Blindness of Virtue*—Cosmo Hamilton.
	28	‡*Experiment*—Robert and Mabel Gilbert.
Mar.	7	*Sweet Lavender*—Sir Arthur Pinero.
	14	*Passers By*—Haddon Chambers.
	21	*Her Temporary Husband*—Edward Paulton.
	28	*The Builder of Bridges*—Alfred Sutro.
April	4	*Nothing But the Truth*—James Montgomery.
	11	*The Passing of the Third Floor Back*—Jerome K. Jerome.
	18	*Raffles*—E. W. Hornung and E. Presbery.
	25	*The Limpet*—Vernon Woodhouse and Victor MacClaire.
May	2	*The Thief*—Cosmo Gordon Lennox.
	9	*The School for Scandal*—Richard Brinsley Sheridan.
	16	*Cupid and the Styx*—J. Sackville Martin.
	23	*A Bunch of Violets*—Sydney Grundy.
	30	*Nobody's Daughter*—George Paston.
June	6	*The Education of Elizabeth*—Roy Horniman.
	13	*Helen with the High Hand*—Arnold Bennett.
	20	*The Case of Lady Camber*—H. A. Vachell.
	27	*Bought and Paid For*—Goerge Broadhurst.
July	4	*Belinda*—A. A. Milne.
	11	*The Purse Strings*—Bernard Parry.
	18	*French Leave*—Reginald Berkeley.
		(Vacation)
Aug.	1	*The Second Mrs. Tanqueray*—Sir Arthur Pinero.
	8	*The Unfair Sex*—Eric Hudson.
	15	*The Barton Mystery*—Water Hackett.
	22	*Windows*—John Galsworthy.
	29	*Our Boys*—J. H. Byron.
Sept.	5	*The Fake*—Frederick Lonsdale.
	12	*A Temporary Gentleman*—H. F. Maltby.
	19	*Peg O' My Heart*—Hartley Manners.
	26	*We Moderns*—Israel Zangwill.
Oct.	3	*The Witness for the Defence*—A. E. W. Mason.
	10	*The Adventure of Lady Ursula*—Anthony Hope.
	17	*Smith*—W. Somerset Maugham.
	24	*The Choice*—Alfred Sutro.
	31	*Advertising April*—Herbert Farjeon and Horace Horsnell.
Nov.	7	*The Old Lady Shows Her Medals*, and *The Will*—Sir James Barrie.
	14	*Ariadne*—A. A. Milne.
	21	*Arms and the Man*—Bernard Shaw.
	28	*On the Night of the Twenty-Second*—Noel Morris and Edward Blythe.
Dec.	5	*Magic*—G. K. Chesterton.
	12	*The Dover Road*—A. A. Milne.
	24	*A Midsummer Night's Dream*—William Shakespeare.

PLAYERS—1927

MARJORIE ALLEN
C. HARCOURT BROOKE
C. GRAHAM CAMERON
J. DREW CARRAN
C. T. DOE
MOLLY FRANCIS
BLUEBELL GLAID
AILSA GRAHAME
ENID GWYNNE
ARTHUR HAMBLING
JAMES HAYTER

CLIFTON JAMES
MARGOT LISTER
NOEL MORRIS
*MAURICE NEVILLE
†ALFRED RICHARDS
MARGARET RIDDICK
ELSIE SHELTON
**MILDRED TREVOR
STANLEY VINE
IVY WALEEN
MARGERY WESTON

Producers:
(1) MAX JEROME
(2) RUPERT HARVEY

Scenic Designer:
CHARLES MAYNARD

General Manager:
C. GRAHAM CAMERON

Assistant Manager:
CAPT. A. HOFMAN

PLAYS—1928

Jan.	9	*Milestones*—Arnold Bennett and Edward Knoblock.
	16	*Tilly of Bloomsbury*—Ian Hay.
	23	*Mary Stuart*—John Drinkwater.
	30	*Diplomacy*—Victorien Sardou.

Feb.	6	*Hindle Wakes*—Stanley Houghton.
	13	*The Old Adam*—Cicely Hamilton.
	20	*The Skin Game*—John Galsworthy.
	27	*If Four Walls Told*—Edward Percy.

Mar.	5	*The Likes of Her*—Charles McEvoy.
	12	*The Duke of Killiecrankie*—Robert Marshall.
	19	*Admiral Guinea*—R. L. Stevenson and H. J. Henley.
	26	*A Cigarette Maker's Romance*—Chas. Hannan.

April	2	*Outward Bound*—Sutton Vane.
	9	*The Sport of Kings*—Ian Hay.
	16	*Leah Kleschna*—C. N. S. McLellan.
	23	*Liberty Hall*—R. C. Carton.
	30	*The Mask and the Face*—C. B. Fernald.

May	7	*Diana of Dobsons*—Cicely Hamilton.
	14	*If Winter Comes*—B. Macdonald Hastings and A. S. M. Hutchinson.
	21	*Young Imeson*—James R. Gregson.
	28	*She Stoops to Conquer*—Oliver Goldsmith.

June	4	*Within the Law*—Baynard Vellier.
	11	*A Pair of Silk Stockings*—Cyril Harcourt.
	18	*Mrs. Dane's Defence*—Henry Arthur Jones.
	25	*This Woman Business*—Benn W. Levy.

July	2	*Magda*—Louis N. Parker.
	9	*At Mrs. Beams*—C. K. Munro.
	16	*R.U.R.*—Karel Capek.

(*Vacation*)

Aug.	6	*In the Next Room*—Eleanor Robson and Harriet Ford.
	13	*The Romantic Young Lady*—G. Martinez-Sierra.
	20	*The Marriage of Kitty*—Cosmo Gordon Lennox.
	27	*The Lie*—Henry Arthur Jones.

Sept.	3	*The Happy Ending*—Ian Hay.
	10	‡*The White Lady*—Ena Hay Howe.
	17	*Dr. Knock*—Jules Romain.
	24	*Quinneys*—Horace Annesley Vachell.

Oct.	1	*All of a Sudden Peggy*—Ernest Denny.
	8	*Anna Christie*—Eugene O'Neill.
	15	*The Lilies of the Field*—John Hastings Turner.
	22	*Caesar's Wife*—W. Somerset Maugham.
	29	*Grumpy*—Horace Hodges and T. Wigley Percyval.

Nov.	6	*David Garrick*—T. W. Robertson.
	12	*The Laughing Lady*—Alfred Sutro.
	19	*Come Out of the Kitchen*—A. E. Thomas.
	26	*All the King's Horses*—E. E. Openshaw.

Dec.	3	*The Scarlet Lady*—John Hastings Turner.
	24	*Alice in Wonderland*—Lewis Carroll. Dramatized by Herbert M. Prentice.

PLAYERS—1928

DATSIE ALEXANDER	JOAN INGRAM
VIVIENNE BENNETT	CLIFTON JAMES
C. GRAHAM CAMERON	GODFREY KENTON
PHYLLIS CARLESTON	CURIGWEN LEWIS
J. DREW CARRAN	MARGOT LISTER
ELMA CARSWELL	NOEL MORRIS
C. T. DOE	GUY NAYLOR
TERENCE DUFF	MARION PRENTICE
**MOLLY FRANCIS	THELMA RAE
BLUEBELL GLAID	*†ALFRED RICHARDS
OWEN GRIFFITH	†T. G. SAVILLE
RUPERT HARVEY	MARGERY WESTON
JAMES HAYTER	NORMAN WOOLAND

Producer:
HERBERT M. PRENTICE

Scenic Designer:
OSBORNE ROBINSON

Joint Managers:
CAPT. A. HOFMAN and HERBERT M. PRENTICE

PLAYS—1929

Jan.	7	*Ambrose Applejohn's Adventure*—Walter Hackett.
	14	*Tons of Money*—Will Evans and Valentine.
	21	*The Ship*—St. John Ervine.
	28	*Daddy-Long-Legs*—Jean Webster.
Feb.	4	*Sunday*—Thomas Raceward.
	11	*Perdita Comes to Town*—T. G. Saville.
	18	*The Pelican*—Tennyson Jesse and H. M. Harwood.
	25	*Billeted*—Tennyson Jesse and H. M. Harwood.
Mar.	4	*The Silver Box*—John Galsworthy.
	11	*Tiger's Cub*—George Potter.
	18	*On Approval*—Frederick Lonsdale.
	25	*Good Friday*—John Masefield.
April	1	*Sweeney Todd*—George Dibdin Pitt.

(Season at Bath)—*(Vacation)*

Aug.	5	*The Green Goddess*—William Archer.
	12	*The Faithful Heart*—Monckton Hoffe.
	19	*Lord Richard in the Pantry*—Sidney Blow and Douglas Hoare.
	26	*A Woman of No Importance*—Oscar Wilde.
Sept.	2	*The Queen was in the Parlour*—Noel Coward.
	9	*The Sign on the Door*—Channing Pollock.
	16	*The High Road*—Frederick Lonsdale.
	23	*Mixed Doubles*—Frank Stayton.
	30	*Number 17*—J. Jefferson Farjeon.
Oct.	7	*The New Morality*—Harold Chapin.
	14	*The Creaking Chair*—A. T. Wilkes.
	21	*What's Bred in the Bone*—Harold Brighouse.
	28	*Out of the Frying Pan*—Ralph Stock.
Nov.	4	*The Mannoch Family*—Murray McClymont.
	11	*Three Wise Fools*—Austin Strong.
	18	*Mr. Wu*—H. M. Vernon and H. Owen.
	25	*Aren't We All*—Frederick Lonsdale.
Dec.	2	*At the Villa Rose*—A. E. W. Mason.
	9	*Aren't Women Wonderful*—Harris Deans.
	16	*The Cheerful Knave*—Keble Howard.
	26	*Raffles*—E. W. Hornung and Eugene Presbrey.

PLAYERS—1929

ELIZABETH ARNOLD
VIVIENNE BENNETT
JOAN BUCKMASTER
JAMES COOMBS
C. T. DOE
**VERA DRAFFIN
**MOLLY FRANCIS
OWEN GRIFFITH
*ALEC HAMMERTON
JAMES HAYTER
BERTRAM HEYHOE
NOEL HOWLETT

VYVYEN JENKINS
GODFREY KENTON
CURIGWEN LEWIS
ST. JOHN MEDLEY
OLIVE MILBOURNE
NOEL MORRIS
BETTY NELSON
MARIAN PRENTICE
*ALFRED RICHARDS
†T. G. SAVILLE
ROWLAND SOMERSET
ESME VERNON

Producer:
HERBERT M. PRENTICE

Scenic Designer:
OSBORNE ROBINSON

General Manager:
HERBERT M. PRENTICE

Business Manager:
HAROLD W. WHITE

PLAYS—1930

Jan. 6 *The Prisoner of Zenda*—Founded on the novel by Anthony Hope.
13 *Ghost Manor*—R. J. McGregor.
20 *Betty at Bay*—Jessie Porter.
27 *Bella Donna*—Adapted from Robert Hichens's novel by James Bernard Fagan.

Feb. 3 *The Younger Generation*—Stanley Houghton.
10 †*The House of Crooks*—A. L. Bruyne.
17 *Hay Fever*—Noel Coward.
24 *It Pays to Advertise*—Walter Hackett and R. C. Megrue.

Mar. 3 *The Witch*—Adapted from the Norwegian by John Masefield.
10 *The Good Die Young*—Murray McClymout.
17 *Mary Rose*—Sir James Barrie.
24 *It's a Gamble*—Harold Brighouse.
31 *Easy Virtue*—Noel Coward.

April 7 *The Circle*—W. Somerset Maugham.
14 *Outward Bound*—Sutton Vane.
21 *Sherlock Holmes*—A. Conan Doyle and William Gillette.
28 *Passing Brompton Road*—Jevan Brandon-Thomas.

May 5 *This Woman Business*—Benn M. Levy.
12 *Dear Brutus*—Sir James Barrie.
19 *The Naughty Wife*—Frederick Jackson.
26 *Fanny's First Play*—Bernard Shaw, and Scene from *King John*—Shakespeare.

June 2 *Mrs. Moonlight*—Benn W. Levy.
9 *The Marquise*—Noel Coward.
16 *The Joan Danvers*—Frank Stayton.
23 *Her Husband's Wife*—A. E. Thomas.
30 *Mr. Pim Passes By*—A. A. Milne.

(*Vacation*)

Aug. 4 *Spring Cleaning*—Frederick Lonsdale.
11 *Diversion*—John van Druten.
18 *Skin Deep*—Ernest Enderline.
25 *The Soul of John Sylvester*—Eric Barber.

Sept. 1 *And So to Bed*—J. B. Fagan.
15 *Water*—Molly Marshall-Hole.
22 *The Last of Mrs. Cheyney*—Frederick Lonsdale.

Oct. 6 *Misalliance*—Bernard Shaw.
13 *A Hundred Years Old*—Adapted by Helen and Harley Granville-Barker.
20 *The Moving Finger*—Sir Patrick Hastings, K.C.
27 *Canaries Sometimes Sing*—Frederick Lonsdale.

Nov. 3 *The Witch*—Adapted by John Masefield.
10 *Ask Beccles*—Cyril Campion and Edward Dignon.
17 *March Hares*—H. W. Gribble.
24 *The Letter*—W. Somerset Maugham.

Dec. 1 *Murder on the Second Floor*—Frank Vosper.
8 *The Young Idea*—Noel Coward.
15 *Good Morning, Bill*—P. G. Wodehouse.
22 *The School for Scandal*—R. B. Sheridan.

PLAYERS—1930

MAX ADRIAN
WILLIAM ALDOUS
CHLORIS ALEXANDER
DOUGLAS ALLEN
ELIZABETH ARNOLD
MICHAEL BARRY
VIVIENNE BENNETT
DIANA CARROLL
JAMES COOMBS
JOAN DOUGLAS
**VERA DRAFFIN
ATHOL FULFORD

*ALEC HAMMERTON
JAMES HAYTER
BERTRAM HEYHOE
*J. LAIRD HOSSACK
*NOEL HOWLETT
GODFREY KENTON
CURIGWEN LEWIS
OLIVE MILBOURNE
BETTY NELSON
MARION PRENTICE
ANNE WARE
PHILIP YORKE

Producer:
HERBERT M. PRENTICE

Scenic Designer:
OSBORNE ROBINSON

General Managers:
HERBERT M. PRENTICE

Assistant Managers:
(1) DOUGLAS ALLEN
(2) JAMES COOMBS
(3) LT.-COL. C. J. ARIS, D.S.O.

PLAYS—1931

Jan.　5　*The Chinese Bungalow*—Marion Osmond and James Corbet.
12　*They Knew What They Wanted*—Sidney Howard.
19　*The Dance of Life*—Hermon Ould.
26　*Our Betters*—W. Somerset Maugham.

Feb.　2　*The Fourth Wall*—A. A. Milne.
9　*By Candlelight*—Adapted by Harry Graham.
23　*The Best People*—David Grey and Avery Hopwood.

Mar.　2　*Captain Banner*—George Preedy.
9　*Candida*—Bernard Shaw.
16　*The Rising Generation*—Wyn Weaver and Laura Leycester.
23　‡*Three Blind Mice*—R. J. McGregor and Ralph Hutton.
30　*The Tower*—Mary Pakington.

April 6　*The Importance of Being Earnest*—Oscar Wilde.
13　*The Sacred Flame*—W. Somerset Maugham.
20　*Body and Soul*—Arnold Bennett.
27　*Mary, Mary, Quite Contrary*—St. John Ervine.

May　4　*Rope*—Patrick Hamilton.
11　*Her Cardboard Lover*—Valerie Wyngate and P. G. Wodehouse.
18　*The Playboy of the Western World*—John M. Synge.
25　*A Murder Has Been Arranged*—Emlyn Williams.

June　1　*The First Mrs. Fraser*—St. John Ervine.
8　*The Constant Wife*—W. Somerset Maugham.
15　*Meet the Wife*—Lynn Starling.
22　*The Unfair Sex*—Eric Hudson.
29　*Love at Second Sight*—Miles Malleson.
　　(*Vacation*)

Aug.　3　*The Man with a Load of Mischief*—Ashley Dukes.
10　*The Torch-bearers*—George Kelly.
17　*Collusion*—J. E. Harold Terry.
24　*The Unattainable*—W. Somerset Maugham.
31　*The Outsider*—Dorothy Brandon.

Sept. 14　*I'll Leave it to You*—Noel Coward.
21　*Granite*—Clemence Dane.
28　*The Romantic Age*—A. A. Milne.

Oct.　5　*He Walked in Her Sleep*—Norman Cannon.
12　*Kimono*—William Pollock.
19　*The Builder of Bridges*—Alfred Sutro.
26　*Mrs. Warren's Profession*—Bernard Shaw.

Nov.　2　*The Man in Possession*—H. M. Harwood.
9　*Home Chat*—Noel Coward.
16　*Up Stream*—Clifford Bax.
23　*To See Ourselves*—E. M. Delafield.
30　*Paul Felice*—Allan Monkhouse.

Dec.　7　*Home and Beauty*—W. Somerset Maugham.
14　*A Damsel in Distress*—Ian Hay and P. G. Wodehouse.
21　*The Ghost Train*—Arnold Ridley.
28　*Nothing But the Truth*—James Montgomery.

PLAYERS—1931

MAX ADRIAN

MICHAEL BARRY

VIVIENNE BENNETT

*H. M. BRADFORD

AVIS BRUNNER

DIANA CARROLL

JOAN DOUGLAS

**VERA DRAFFIN

DONALD GORDON

JAMES HAYTER

BERTRAM HEYHOE

*J. LAIRD HOSSACK

NOEL HOWLETT

NOEL ILIFF

CURIGWEN LEWIS

MARGOT LISTER

MARY MACDONALD

OLIVE MILBOURNE

SHEILA MILLAR

MARION PRENTICE

†T. G. SAVILLE

PHILIP YORKE

Producer:
HERBERT M. PRENTICE

Scenic Designer:
OSBORNE ROBINSON

General Manager:
HERBERT M. PRENTICE

Assistant Manager:
(1) LT.-COL. C. J. ARIS, D.S.O
(2) PEPPINO SANTANGELO

PLAYS—1932

Jan. 4 *The Silent House*—John G. Brandon and George Pickett.
11 *Baa-Ba1, Black Sheep*—Ian Hay and P. G. Wodehouse.
18 *Interference*—Roland Pertwee and Harold Dearden.
25 *East of Suez*—W. Somerset Maugham.

Feb. 1 *The Middle Watch*—Ian Hay and Stephen King-Hall.
8 *Michael and Mary*—A. A. Milne.
15 *Bird in Hand*—John Drinkwater.
22 *The House of the Arrow*—A. E. W. Mason.
29 *After All*—John van Druten.

Mar. 7 *Mr. Faint Heart*—Ian Hay.
14 *The Silent Witness*—Jack de Leon and Jack Celestin.
21 *The Passing of the Third Floor Back*—Jerome K. Jerome.
28 *And So To Bed*—J. B. Fagan.

April 4 *Brown Sugar*—Lady Arthur Lever.
11 *The Man Who Changed His Name*—Edgar Wallace.
18 *Ambrose Applejohn's Adventure*—Walter Hackett.
25 *Petticoat Influence*—Neil Grant.

May 2 *The Second Mrs. Tanqueray*—Sir Arthur W. Pinero.
9 *The Church Mouse*—Adapted by Benn Levy.
16 *Lord Babs*—Keble Howard.
23 *The Lie*—Henry Arthur Jones.
30 *Rookery Nook*—Ben Travers.

June 6 *The Breadwinner*—W. Somerset Maugham.
13 *Hay Fever*—Noel Coward.
20 *Hindle Wakes*—Stanley Houghton.
27 *Her First Affaire*—Muriel Rogers and Frederick Jackson.

July 4 *Isabel, Edward, and Anne*—Gertrude Jennings.
11 *On Approval*—Frederick Lonsdale.
(Vacation)

Aug. 8 *Windows*—John Galsworthy.
15 *Blackmail*—Charles Bennett.
22 *Counsel's Opinion*—Gilbert Wakefield.
29 *The Silver Cord*—Sidney Howard.

Sept. 5 *The Cat and the Canary*—John Willard.
12 *Lavender Ladies*—Daisy Fisher.
19 *The Painted Veil*—W. Somerset Maugham.
26 *Le Malade Imaginaire*—Molière.

Oct. 3 *Alibi*—Michael Morton.
10 *Lucky Dip*—Frank Vosper.
17 *Musical Chairs*—Ronald Mackenzie.
24 *The Sport of Kings*—Ian Hay
31 *To Account Rendered*—John Hastings Turner.

Nov. 7 *Arms and the Man*—Bernard Shaw.
14 *White Cargo*—Leon Gordon
21 *The Case of the Frightened Lady*—Edgar Wallace.
28 *Easy Payments*—Edward L. Stanway.

Dec. 5 *The Supplanters*—H. M. Harwood.
12 *The Combined Maze*—May Sinclair.
19 *Grumpy*—Horace Hodges and T. Wigney Percyval.
26 *Tons of Money*—Will Evans and Valentine.

PLAYERS—1932

MAX ADRIAN	JOAN KEMP-WELCH
ELIZABETH BROUGH	LALA LLOYD
*H. M. BRADFORD	OLIVE MILBOURNE
MARGARET CARLISLE	SHEILA MILLAR
PEARL DADSWELL	DOREEN MORTON
STRINGER DAVIS	LOIS OBEE (SONIA DRESDEL)
JOAN DOUGLAS	BRIAN OULTON
**VERA DRAFFIN	ERIC PHILLIPS
DONALD GORDON	MARION PRENTICE
BERTRAM HEYHOE	OSWALD DALE ROBERTS
VERA HODSON	PETER ROSSER
NOEL HOWLETT	T. G. SAVILLE
NOEL ILIFF	**JANE TANN

Producers:
(1) HERBERT M. PRENTICE
(2) ROBERT YOUNG

Scenic Designer:
OSBORNE ROBINSON

Business Manager:
PEPPINO SANTANGELO

PLAYS—1933

Jan.	2	*A Message from Mars*—Richard Ganthoney.
	9	*The Man from Toronto*—Douglas Murray.
	16	*The Third Degree*—Charles Klein.
	23	*Hawk Island*—Howard Irving Young.
	30	*The Cardinal*—Louis N. Parker.
Feb.	6	*The Cardinal*—Louis N. Parker.
	13	*The Nelson Touch*—Neil Grant.
	20	*Black Coffee*—Agatha Christie.
	27	*Twelfth Night*—William Shakespeare.
Mar.	6	*Pleasure Cruise*—Austen Allen.
	13	*The Improper Duchess*—James B. Fagan.
	20	*Peg O' My Heart*—J. Hartley Manners.
	27	*Berkeley Square*—John L. Balderston.
April	3	*The Merchant of Venice*—William Shakespeare.
	10	*The Merchant of Venice*—William Shakespeare.
	17	*Eliza Comes to Stay*—H. V. Esmond.
	24	*The Play's the Thing*—Ferenc Molnar.
May	1	*The Melting Pot*—Israel Zangwill.
	8	*Can the Leopard . . ?*—Ronald Jeans.
	15	*To Have the Honour*—A. A. Milne.
	22	*Sacred and Profane Love*—Arnold Bennett.
	29	*Badger's Green*—R. C. Sherriff.
June	5	*Trilby*—George du Maurier.
	12	*Dr. Wake's Patient*—W. Gayer Mackay and Robert Ord.
	19	*Martine*—Jean-Jacques Bernard.
	26	*Captain Drew on Leave*—Hulbert Henry Davies.
July	3	*There's Always Juliet*—John Van Druten.
	10	*The Mollusc*—Herbert Henry Davies.
		(*Vacation*)
Aug.	7	*Are You a Mason?*—Emanuel Lederer.
	14	*S.O.S.*—Walter Ellis.
	21	*Mrs. Gorringe's Necklace*—Hulbert Henry Davies.
	28	*Other Men's Wives*—Walter Hackett.
Sept.	4	*Young Woodley*—John Van Druten.
	11	*You Never Can Tell*—Bernard Shaw.
	18	*Dangerous Corner*—J. B. Priestley.
	25	*Lean Harvest*—Ronald Jeans.
Oct.	2	*Death Takes a Holiday*—Alberto Casella.
	9	*The Rivals*—Sheridan.
	16	*See Naples and Die*—Elmer Rice.
	23	*Autumn Crocus*—C. L. Anthony.
	30	*Well Caught*—Anthony Armstrong.
Nov.	6	*The Green Pack*—Edgar Wallace.
	13	*The Barretts of Wimpole Street*—Rudolf Besier.
	20	*Two White Arms*—Harold Dearden.
	27	*Double Harness*—Edward Montgomery.
Dec.	4	*Another Language*—Rose Franken.
	11	*Art and Mrs. Bottle*—Benn W. Levy.
	18	*The Thirteenth Chair*—Bayard Veiller.
	27	*Jack and The Beanstalk*—Margaret Carter.

PLAYERS—1933

*H. M. BRADFORD
JULIAN CLAY
NELL CRAIG
PEARL DADSWELL
STRINGER DAVIS
WARWICK EVANS
ERROL FLYNN
DOROTHY GALBRAITH
DONALD GORDON
PATRICK GOVER
ZILLAH GREY
**KENNETH GRINLING
RONALD HICKMAN
NOEL HOWLETT

FREDA JACKSON
JOAN KEMP-WELCH
*DORIS LITTELL
LALA LLOYD
MARJORIE MCEWEN
OLIVE MILBOURNE
SHEILA MILLAR
DOREEN MORTON
LOIS OBEE (SONIA DRESDEL)
ERIC PHILLIPS
DOUGLAS RHODES
†OSWALD DALE ROBERTS
PETER ROSSER
JANE TANN
YOLANDE VAUGHAN

Producer:
ROBERT YOUNG

Scenic Designer:
OSBORNE ROBINSON

Manager:
(1) PEPPINO SANTANGELO
(2) RICHARD SUMMERS

7

PLAYS—1934

Jan.	1	*Sweet Lavender*—Arthur Pinero.
	8	*Bulldog Drummond*—"Sapper".
	15	*A Doll's House*—Henrik Ibsen.
	22	*On the Spot*—Edgar Wallace.
	29	*Pygmalion*—Bernard Shaw.
Feb.	5	*The Crime at Blossoms*—Mordaunt Shairp.
	12	*Yellow Sands*—Eden and Adelaide Phillpotts.
	19	*The Grain of Mustard Seed*—H. M. Harwood.
	26	*Seven Keys to Baldpate Inn*—George M. Cohan.
Mar.	5	*Othello*—William Shakespeare.
	12	*The Green Bay Tree*—Mordaunt Shairp.
	19	*The Fake*—Frederick Lonsdale.
	26	*The Farmer's Wife*—Eden Phillpotts.
April	2	*The Farmer's Wife*—Eden Phillpotts.
	9	*The Wind and the Rain*—Merton Hodge.
	16	*Sheppey*—Somerset Maugham.
	23	*The Soul of Nicholas Snyders*—Jerome K. Jerome.
	30	*The Devil's Disciple*—Bernard Shaw.
May	7	*By Candlelight*—Harry Graham.
	14	*Conflict*—Miles Malleson.
	21	*Paddy the Next Best Thing*—Gertrude Page.
	28	*Nine-Forty-five*—Owen Davis and Sewell Collins.
June	4	*Fresh Fields*—Ivor Novello.
	11	*Sixteen*—Aimee and Philip Stuart.
	18	*The Rose Without a Thorn*—Clifford Bax.
	25	*Good Morning, Bill*—P. G. Wodehouse.
July	2	*Springtime for Henry*—Benn Levy.
		(*Vacation*)
Aug.	6	*London Wall*—John Van Druten.
	13	*Clothes and the Woman*—George Paston.
	20	*The Quitter*—Guy Paxton, Ed. aud Gordon Hoile.
	27	*Loose Ends*—Dion Titheradge.
Sept.	3	*Jane's Legacy*—Eden Phillpotts.
	10	*The Distaff Side*—John Van Druten.
	17	*The Whiteheaded Boy*—Lennox Robinson.
	24	*Caesar's Friend*—Campbell Dixon and Dermot Morrah.
Oct.	1	*Caesar's Friend*—Campbell Dixon and Dermot Mórrah.
	8	*Her Shop*—Aimee and Philip Stuart.
	15	*Counsellor-at-Law*—Elmer Rice.
	22	*Britannia of Billingsgate*—Jope-Slade and S. Stokes.
	29	‡*The Power and the Glory*—Edward L. Stanway.
Nov.	5	*Journey's End*—R. C. Sheriff.
	12	*Persons Unknown*—Edgar Wallace.
	19	*The Stag*—Beverley Nichols.
	26	*The Venetian*—Clifford Bax.
Dec.	3	*Behold We Live*—John Van Druten.
	10	*The First Mrs. Fraser*—St. John Ervine.
		(*Producer*—Oswald Dale Roberts.)
	17	*The Maitlands*—Ronald Mackenzie.
		(*Producer*—Oswald Dale Roberts.)
	26	*Cinderella*—Margaret Carter.

PLAYERS—1934

*HELEN CHRISTIE
JULIAN CLAY
LORRAINE CLEWS
PATRICK CREAN
PHILIP DALE
ERROL FLYNN
DOROTHY GALBRAITH
DONALD GORDON
PATRICK GOVER
ZILLAH GREY
**KENNETH GRINLING
NOEL HOWLETT
ELIZABETH INGLIS

FREDA JACKSON
*DORIS LITTELL
MARJORIE MCEWEN
SHEILA MILLAR
MAURICE O'BRIEN
BREFNI O'RORKE
NIGEL PATRICK
NICHOLAS PHIPPS
†OSWALD DALE ROBERTS
VERONICA ROSE
PETER ROSSER
JOHN STOBART
**ANTONY VERNEY

Special Engagement:
MAY COLLIE

Producer:
ROBERT YOUNG

Scenic Designer:
OSBORNE ROBINSON

Business Manager:
RICHARD SUMMERS

PLAYS—1935

Jan. 7 *The Late Christopher Bean*—Emlyn Williams.
 14 *Charley's Aunt*—Brandon Thomas.
 21 *Laburnum Grove*—J. B. Priestley.
 28 *Heat Wave*—Roland Pertwee.

Feb. 4 *The Rotters*—H. F. Maltby.
 11 *Line Engaged*—Jack de Leon and Jack Celestin.
 18 *The Great Adventure*—Arnold Bennett.
 25 *The Far-Off Hills*—Lennox Robinson.

Mar. 4 *The Cardinal*—Louis N. Parker.
 11 *Biography*—S. N. Behrman.
 18 *For the Love of Mike*—H. F. Maltby.
 25 *The Sacred Flame*—W. Somerset Maugham.

April 1 *Living Dangerously*—Reginald Simpson and Frank Gregory.
 8 *Marigold*—L. Allen Harker and F. R. Pryor.
 15 *The Private Secretary*—Charles Hawtrey.
 22 *The Private Secretary*—Charles Hawtrey.
 29 *Touch Wood*—C. L. Anthony.

May 6 *The Admirable Crichton*—J. M. Barrie.
 13 *Double Door*—Elizabeth McFadden.
 20 *Three-Cornered Moon*—Gertrude Tonkonogy.
 27 *Private Room*—Naomi Royde-Smith.

June 3 *Major Barbara*—Bernard Shaw.
 10 *Devonshire Cream*—Eden Phillpotts.
 17 *Without Witness*—Anthony Armstrong and Harold Simpson.
 24 *The Proposal*—Anton Chekov, *and*
 The Women Have Their Way—Serafin and Joquin Alvarez Quintero.
 (*Vacation*)

Aug. 5 *Hollywood Holiday*—Benn W. Levy and John Van Druten.
 12 *Payment Deferred*—Jeffrey Dell.
 19 *Someone at the Door*—Dorothy and Campbell Christie.
 26 *Distinguished Villa*—Kate O'Brien.

Sept. 2 *Tilly of Bloomsbury*—Ian Hay.
 9 *The Second Man*—S. N. Behrman.
 16 *Marriage à la Mode*—John Dryden.
 23 *Thark*—Ben Travers.
 30 *Escape Me Never*—Margaret Kennedy.

Oct. 7 ‡*The Wasp's Nest*—Adelaide Eden Phillpotts and Jan Stewart.
 14 *Hobson's Choice*—Harold Brighouse.
 21 *Charmeuse*—E. Temple Thurston.
 28 *Mid-Channel*—Arthur Pinero.

Nov. 4 *Eden End*—J. B. Priestley.
 11 *The White Chateau*—Reginald Berkeley.
 18 *Bunty Pulls the Strings*—Graham Moffat.
 25 *The Taming of the Shrew*—William Shakespeare.

Dec. 2 *Accent on Youth*—Samson Raphaelson.
 9 *Barnet's Folly*—Jan Stewer.
 16 *The Barretts of Wimpole Street*—Rudolf Besier.
 26 *Sinbad the Sailor*—Margaret Carter.

PLAYERS—1935

COURTNEY BROMET

HELEN CHRISTIE

LORRAINE CLEWS

PATRICK CREAN

**PEARL DADSWELL

PHILIP DALE

ANTHONY FREIRE

DOROTHY GALBRAITH

DONALD GORDON

MARY GORDON

ZILLAH GREY

PAUL HARFORD

FREDA JACKSON

BETTY LARKE-SMITH

*MAURICE H. LEVERETT

*DORIS LITTELL

ALASTAIR MACINTYRE

OLGA MURGATROYD

MAURICE O'BRIEN

BREFNI O'RORKE

KATHERINE PAGE

NICHOLAS PHIPPS

MARIE PICQUART

OSWALD DALE ROBERTS

Special Engagements:

LAWRENCE BASKCOMB ALFRED RICHARDS

Producers:

(1) ROBERT YOUNG

(2) BLADON PEAKE

Scenic Designer:

OSBORNE ROBINSON

Business Manager:

RICHARD SUMMERS

PLAYS—1936

Jan. 13 *Youth at the Helm*—Hubert Griffith.
 20 *The Unguarded Hour*—Bernard Merivale.
 27 *Turkey Time*—Ben Travers.

Feb. 3 *Family Affairs*—Gertrude Jennings.
 10 *The Two Mrs. Carrolls*—Marguerite Veiller.
 17 ‡*Mary Darling*—Edward Percy.
 24 *The Roof*—John Galsworthy.

Mar. 2 *The Shining Hour*—Keith Winter.
 9 *Once a Gentleman*—Armitage Owen.
 16 *Macbeth*—William Shakespeare.
 23 *Lover's Leap*—Philip Johnson.
 30 *The Adding Machine*—Elmer Rice.

April 6 *The Wind and the Rain*—Merton Hodge.
 13 *Richard of Bordeaux*—Gordon Daviot.
 20 *The Dover Road*—A. A. Milne.
 27 *Rutherford & Son*—Githa Sowerby.

May 4 *Service*—C. L. Anthony.
 11 *Distinguished Gathering*—James Parish.
 18 *Duet in Floodlight*—J. B. Priestley.
 25 *Private Lives*—Noel Coward.

June 1 *Sweet Aloes*—Jay Mallory.
 8 *Dusty Ermine*—Neil Grant.
 15 *Symphony in Two Flats*—Ivor Novello.
 22 *The Voysey Inheritance*—H. Granville Barker.
 29 *The Constant Nymph*—Margaret Kennedy and Basil Dean.

(*Vacation*)

Aug. 3 *Just Married*—Adelaide Matthews and Anne Nichols.
 10 *Grumpy*—Horace Hodges and T. Wigney Percyval.
 17 *Somebody Knows*—John Van Druten.
 24 *Short Story*—Robert Morley.
 31 *Closing at Sunrise*—Richard Carruthers.

Sept. 7 *Many Waters*—Monckton Hoffe.
 14 *Cornelius*—J. B. Priestley.
 21 *The Spanish Friar*—John Dryden.
 28 *Love from a Stranger*—Agatha Christie and Frank Vosper.

Oct. 5 *Bird-in-Hand*—John Drinkwater.
 12 *Nina*—Hubert Griffith.
 19 *Full House*—Ivor Novello.
 26 *The Macropulos Secret*—Paul Selver.

Nov. 2 *Winter Sunshine*—G. A. Thomas.
 9 *A Sleeping Clergyman*—James Bridie.
 16 *Heroes Don't Care*—Margot Neville.
 23 *The Outsider*—Dorothy Brandon.
 30 *Too Young to Marry*—Martin Flavin.

Dec. 7 *Sally Who?*—Dion Titheradge.
 14 *The Ghost Train*—Arnold Ridley.
 26 *Dick Whittington*—Margaret Carter.

PLAYERS—1936

HEATHER BOYS
COURTNEY BROMET
DAVID BROWN
PATRICK CREAN
PHILIP DALE DALE
**PEARL DADSWELL
DOROTHY EVANS
PETER FOLLISS
ANTHONY FREIRE
MARGARET GIBSON
MARY GORDON
PAUL HARFORD
BETTY LARKE-SMITH
DOROTHY LEAKE

*MAURICE H. LEVERETT
FRANK LOVETT
ALASTAIR MACINTYRE
CLIFFORD MARLE
ERIC MICKLEWOOD
ANDRE MONTAIGNE
GEORGE MUDIE
OLGA MURGATROYD
MAURICE O'BRIEN
KATHARINE PAGE
**NANCY SEABROOKE
NEIL TUSON
JOAN WALLACE
EILEEN WINTER

Producer:
BLADON PEAKE

Scenic Designer:
OSBORNE ROBINSON

Business Manager:
RICHARD SUMMERS

PLAYS—1937

Jan. 11 *Tovarich*—Jacques Deval.
 18 *Anthony and Anna*—St. John Ervine.
 25 *Spring Tide*—George Billam and J. B. Priestley.

Feb. 1 *Miss Smith*—Henry Bernard.
 8 *The Shadow*—H. F. Maltby.
 15 *Wisdom Teeth*—Noel Streatfield.
 22 *The Composite Man*—Ronald Jeans.

Mar. 1 *Busman's Honeymoon*—Dorothy L. Sayers and M. St. Clare Byrne.
 8 *Vintage Wine*—Alexandra Engel.
 15 *Mademoiselle*—Jacques Deval.
 22 *Little Women*—Louisa M. Alcott.
 29 *Little Women*—Louisa M. Alcott.

April 5 *Till the Cows Come Home*—Geoffrey Kerr.
 12 *Carnival*—Pordes Milo.
 19 *Children to Bless You*—Sheila Donisthorpe.
 26 *Cynara*—R. Gore Browne.

May 3 *Night Must Fall*—Emlyn Williams.
 10 *The Glad Eye*—Jose G. Levy.
 17 *Heart's Content*—W. Chetham Strode.
 24 *All-in-Marriage*—Aurania Rouvenol and Emile Littler.
 31 ‡*A Little of Both*—Ima Russ.

June 7 *Ah, Wilderness!*—Eugene O'Neill.
 14 *The Barber and the Cow*—D. T. Davies.
 21 *The Way Things Happen*—Clemence Dane.
 28 *Storm in a Teacup*—Bruno Frank.
 (*Vacation*)

July 31 *The Amazing Dr. Clitterhouse*—Barre Lyndon.

Aug. 9 *And the Music Stopped*—Noel Scott.
 16 *The Magistrate*—Sir A. W. Pinero.
 23 *Bats in the Belfry*—Diana Morgan and R. McDermot.
 30 *To-Night at 8.30*—Noel Coward.

Sept. 6 *Libel*—Edward Wooll.
 13 *Whiteoaks*—Mazo de la Roche.
 20 *Sir Martin Marr-All*—John Dryden.
 27 *A Girl's Best Friend*—H. M. Harwood.

Oct. 4 *Housemaster*—Ian Hay.
 11 *The Yellow Streak*—Mabel Ellams Hope.
 18 *The Ware Case*—George Pleydell.
 25 *The Queen was in the Parlour*—Noel Coward.

Nov. 1 *Suspect*—Rex Judd.
 8 *Laughter in Court*—Hugh Mills.
 15 *To Have and to Hold*—Lionel Brown.
 22 *Beauty and the Barge*—W. W. Jacobs and Louis N. Parker.
 29 *Late Night Final*—Louis Weitzentkorn.

Dec. 6 *No Exit*—George Goodchild and Frank Witty.
 13 *East of Suez*—W. Somerset Maugham.
 20 *East of Suez*—W. Somerset Maugham.

PLAYERS—1937

ANNE ALLAN
PETER BICKERSTETH
GERALDINE BRITTON
HONOR BYRNE
ALAN CHADWICK
*CYRIL COLLINS
HENRY COLNETT
PATRICK CREAN
MOLLY CULLEN
DOROTHY EVANS
DOROTHY FENWICK
MARGARET GIBSON
DONALD GORDON
PAUL HARFORD
HAZEL HUGHES
PATRICK HUNT-LEWIS
HELEN IRVING

ROBIN KEMPSON
BETTY LARKE-SMITH
IAN MCKENZIE
ROBERT MELVIN
ERIC MICKLEWOOD
GEORGE MUDIE
OLGA MURGATROYD
ANTHONY PELLY
GWLADYS BLACK ROBERTS
BEATRICE ROWE
**NANCY SEABROOKE
JOSEF SHELLARD
**DOROTHY SMITH
*LESLIE SPARKES
IRIS SUTHERLAND
NEIL TUSON
*ARTHUR R. WEBB
PETER WILLIAMS

Special Engagement:
MARY BYRON

Producer:
BLADON PEAKE

Scenic Designer:
OSBORNE ROBINSON

Business Manager:
(1) RICHARD SUMMERS
(2) F. W. COTTER CRAIG

PLAYS—1938

Jan.	3	*Housemaster*—Ian Hay.
	10	*Daddy Long-Legs*—Jean Webster.
	17	*Candida*—G. Bernard Shaw.
	24	*Yellow Sands*—Eden and Adelaide Phillpotts.
	31	*White Cargo*—Leon Gordon.
Feb.	7	*Mary Rose*—James M. Barrie.
	14	*The Silent House*—J. C. Brandon and George Pickett.
	21	*The Celebrity*—Jerome K. Jerome.
	28	*Nell Gwyn*—Harold Raynor.
Mar.	7	*Squaring the Circle*—Valentin Kataev.
	14	*Jew Süss*—Ashley Dukes.
	21	*Queer Cargo*—Noel Langley.
	28	*Caesar's Wife*—W. Somerset Maugham.
April	4	*Yes, and No*—Kenneth Horne.
	11	*A Man's House*—John Drinkwater.
	18	*The Scarlet Pimpernel*—Baroness Orczy.
	25	*Sarah Simple*—A. A. Milne.
May	2	*Theatre Royal*—Edna Ferber and George Kaufman.
	9	*Peg O' My Heart*—J. Hartley Manners.
	16	*People at Sea*—J. B. Priestley.
	23	*Romeo and Juliet*—William Shakespeare.
	30	*The Trial of Mary Dugan*—Bayard Veiller.
June	6	*Charley's Aunt*—Brandon Thomas.
	13	*The Cat's Cradle*—Aimee and Philip Stuart.
	20	*Blondie White*—Bernard Merivale and Jeffrey Dell.
	27	*Square Pegs*—Lionel Brown.
		(*Vacation*)
Aug.	1	*Lord Richard in the Pantry*—Sidney Blow and Douglas Hoare.
	8	*Ghost for Sale*—Ronald Jeans.
	15	*Black Swans*—Geoffrey Kerr.
	22	*The Pursuit of Happiness*—Allen Child and Isabelle Lowdon.
	29	*The Little Damozel*—Monckton Hoffe.
Sept.	5	*Black Limelight*—Gordon Sherry.
	12	*A Murder Has Been Arranged*—Emlyn Williams.
	19	*The Circle of Chalk*—James Laver.
	26	*I Killed the Count*—Alec Coppel.
Oct.	3	*The Phantom Light*—Evadne Price.
	10	*People of Our Class*—St. John Ervine.
	17	*The Insect Play*—Josef and Karel Capek.
	24	*I Have Been Here Before*—J. B. Priestley.
	31	*Comedienne*—Ivor Novello.
Nov.	7	*Death on the Table*—G. Beauchamp and M. Pertwee.
	14	*The Saint's Husband*—Rosemary Casey and B. Iden Payne.
	21	*Interference*—R. Pertwee and H. Dearden.
	28	*Time and the Conways*—J. B. Priestley.
Dec.	5	*To What Red Hell*—Percy Robinson.
	12	*The Love Game*—Mrs. Cecil Chesterton and Ralph Neale.
	19	*'Twas Time She Wed*—William Sherwood.
	26	*Monsieur Beaucaire*—Booth Tarkington.

PLAYERS—1938

ANNE ALLAN
JUDY BACON
MORRIS BARRY
ANTHONY BLAKE
COURTNEY BROMET
SARAH CHURCHILL
HENRY COLNETT
FRANKLIN WM. DAVIES
DOROTHY FENWICK
RICHARD FISHER
JOHN FOTHERGILL
EVELYN FOX
MARGARET GIBSON
ELIZABETH GRIERSON
HAZEL HUGHES
PATRICK HUNT-LEWIS

HELEN IRVING
ROSEMARY JOHNSON
ARTHUR LAWRENCE
GEORGE MUDIE
ANTHONY PELLY
OSWALD DALE ROBERTS
PATRICK ROSS
BEATRICE ROWE
TAMAR SAVILLE
MADGE SELLAR
CATHERINE SMITH
*†LESLIE SPARKES
DAVID TOMLINSON
NEIL TUSON
**ARTHUR R. WEBB
PETER WILLIAMS

Producers:
(1) BLADON PEAKE
(2) WILLIAM SHERWOOD

Scenic Designer:
OSBORNE ROBINSON

Business Manager:
F. W. COTTER CRAIG

PLAYS—1939

Jan. 2 *The Private Secretary*—Charles Hawtrey.
 9 *Dangerous Corner*—J. B. Priestley.
 16 *The Widow's Cruise*—Joan Temple.
 23 *The Brontës*—Alfred Sangster.
 30 *Whistling in the Dark*—L. Gross and E. C. Carpenter.

Feb. 6 *The Farmer's Wife*—Eden Phillpotts.
 13 *Official Secret*—Jeffrey Dell.
 20 *His House in Order*—Arthur W. Pinero.
 27 *Glorious Morning*—Norman Macowan.

Mar. 6 *George and Margaret*—Gerald Savory.
 13 *Give Me Yesterday*—Edward Percy and Reginald Denham.
 20 *Poison Pen*—Richard Llewellyn.
 27 *Riddle of Life*—Miles Malleson.

April 3 *Outward Bound*—Sutton Vane.
 10 *Henry of Navarre*—William Devereux.
 17 *The Roundabout*—J. B. Priestley.
 24 *The Queen Who Kept Her Head*—Winifred Carter.

May 1 *London Wall*—John Van Druten.
 8 *Eight Bells*—Percy Mandley.
 15 *Tobias and the Angel*—James Bridie.
 22 *Pygmalion*—Bernard Shaw.
 29 *A Cuckoo in the Nest*—Ben Travers.

June 5 *Bees on the Boat Deck*—J. B. Priestley.
 12 ‡*Out of the Night*—Leslie Sparkes. (Produced by the Author.)
 19 *Windfall*—Jeffery Dell and H. I. Young.
 26 *Victoria Regina*—Laurence Housman.

July 3—Aug. 12. *Season at Playhouse, Buxton.*

 (*Vacation*)

Sept. 11 *George and Margaret*—Gerald Savory.
 18 *The Wind and the Rain*—Merton Hodge.
 25 *Geneva*—Bernard Shaw.

Oct. 2 *Romeo and Juliet*—William Shakespeare.
 9 *The Magic Cupboard*—Percy Walsh.
 16 *Tony Draws a Horse*—Lesley Storm.
 23 *By Candlelight*—Harry Graham.
 30 *The Man in Half-Moon Street*—Barre Lyndon.

Nov. 6 *Without the Prince*—Philip King.
 13 *Escape Me Never*—Margaret Kennedy.
 20 *Printer's Devil*—R. F. Delderfield.
 27 *The Apple Cart*—Bernard Shaw.

Dec. 4 *What Happened to Jones*—G. H. Broadhurst.
 11 *What Happened to Jones*—G. H. Broadhurst.
 26 *Ambrose Applejohn's Adventure*—Walter Hackett.

PLAYERS—1939

MORRIS BARRY
LAWRENCE BASKCOMB
ANTHONY BLAKE
JOAN BUTTON
FRANKLIN WM. DAVIES
COLIN DOUGLAS
RICHARD FISHER
JOHN FOTHERGILL
DONALD GORDON
MARGARET GREENE
ELIZABETH GRIERSON
REGINALD HANCOCK
PATRICK HUNT-LEWIS

ROSEMARY JOHNSON
ARTHUR LAWRENCE
**DOREEN MARKHAM
BERNICE PARKES
ROSE POWER
OSWALD DALE ROBERTS
TAMAR SAVILLE
CATHERINE SMITH
MARJORIE SOMMERVILLE
*LESLIE SPARKES
SYDNEY STURGESS
NEIL TUSON
*ARTHUR R. WEBB

Special Engagements:

LAWRENCE BASKCOMB
VIVIENNE BENNETT

MICHAEL EDEN
GODFREY KENTON

Producer:
WILLIAM SHERWOOD

Scenic Designer:
OSBORNE ROBINSON

Business Manager:
F. W. COTTER CRAIG

PLAYS—1940

Jan. 1 *Robert's Wife*—St. John Ervine.
 8 *The Last of Mrs. Cheyney*—Frederick Lonsdale.
 15 *Ga. Light*—Patrick Hamilton.
 22 *Spring Meeting*—M. J. Farrell and John Perry.
 29 *After the Dance*—Terence Rattigan.

Feb. 5 *The Doctor's Dilemma*—Bernard Shaw.
 12 *Goodness, How Sad*—Robert Morley.
 19 *When We Are Married*—J. B. Priestley.
 26 *The Lilies of the Field*—J. Hastings Turner.

Mar. 4 *Laburnum Grove*—J. B. Priestley.
 11 *They Walked Alone*—Max Catto.
 18 *Hay Fever*—Noel Coward, *and*
 The Doubtful Misfortune of Li Sing—Neil Tuson.
 25 *Saint Joan*—Bernard Shaw.

April 1 *Lover's Leap*—Philip Johnson.
 8 *Quiet Wedding*—Esther McCracken.
 15 *The Flashing Stream*—Charles Morgan.
 22 ‡*The Rest is Silence*—H. Musk Beattie.
 29 *The Marquise*—Noel Coward.

May 6 *The Dominant Sex*—Michael Egan.
 13 *On The Spot*—Edgar Wallace.
 20 *Eden End*—J. B. Priestley.
 27 *To-night at 8.30*—Noel Coward.

June 3 *Full House*—Ivor Novello.
 10 *The Naughty Wife*—Frederick Jackson.
 17 *The Price of Wisdom*—Lionel Brown.
 24 *The Man Who Stayed at Home*—L. Waller and Harold Terry.

July 1 *Britannia of Billingsgate*—J. Jope-Slade and Sewell Stokes *and*
 The Dark Lady of the Sonnets—Bernard Shaw.
 8 *Jane Eyre*—Helen Jerome.
 15 *Sheppey*—W. Somerset Maugham.
 22 *Sixteen*—Aimee and Philip Stuart.
 29 *Love from a Stranger*—Frank Vosper.

Aug. 5 *Murder on the Second Floor*—Frank Vosper.
 12 *And So To Bed*—J. B. Fagan.

 (*Vacation*)

Sept. 16 *Dear Octopus*—Dodie Smith
 23 *Musical Chairs*—Ronald Mackenzie.
 30 *Pride and Prejudice*—Helen Jerome.

Oct. 7 *The High Road*—Frederick Lonsdale.
 14 *Romance*—Edward Sheldon.
 21 *The Bishop Misbehaves*—G. Frederick Jackson.
 28 *The Best People*—David Grey and Avery Hopwood.

Nov. 4 *Indoor Fireworks*—Arthur Macrae.
 11 *Little Ladyship*—Ian Hay.
 18 *Third Party Risk*—G. Lennox and G. Ashley.
 25 *Rebecca*—Daphne du Maurier.

Dec. 2 *Rebecca*—Daphne du Maurier.
 9 *Trelawny of the Wells*—A. W. Pinero.
 16 *The Light of Heart*—Emlyn Williams.
 26 *The Middle Watch*—Ian Hay and Stephen King-Hall.

PLAYERS—1940

WILLIAM ABNEY
LAWRENCE BASKCOMB
ANTHONY BLAKE
RICHARD BLATCHLEY
JOAN BUTTON
PATRICK CREAN
FRANKLIN WM. DAVIES
PEGGY DIAMOND
ROBERT DOIG
COLIN DOUGLAS
DOROTHY FENWICK
DONALD GORDON
MARGARET GREENE
ELIZABETH GRIERSON
REGINALD HANCOCK

ALISON HORSTMANN
PATRICK HUNT-LEWIS
ROSEMARY JOHNSON
ARTHUR LAWRENCE
**PETER LETTS
WILLIAMS LLOYD
HILDA MALCOLM
**DOREEN MARKHAM
BERNICE PARKES
MICHAEL ROSE
CATHERINE SMITH
MARJORIE SOMMERVILLE
FRANK STEVENS
SYDNEY STURGESS
NEIL TUSON
*ARTHUR R. WEBB

Producers:
(1) WILLIAM SHERWOOD
(2) WILLIAM E. BROOKFIELD

Scenic Designer:
OSBORNE ROBINSON

Business Manager:
F. W. COTTER CRAIG

PLAYS—1941

Jan. 6 *Secrets*—Rudolf Besier and May Edginton.
 13 *Billeted*—F. Tennyson Jesse and H. M. Harwood.
 20 *The Skin Game*—John Galsworthy.
 27 *Who Are They?*—Cosmo Hamilton.

Feb. 3 *Jeannie*—Aimee Stuart.
 10 *Polly with a Past*—George Middleton and Guy Bolton.
 17 *What Every Woman Knows*—Sir James M. Barrie.
 24 *The Squall*—Jean Bart.

Mar. 3 *The Family Upstairs*—Harry Delf.
 10 *Thunder Rock*—Robert Ardrey.
 17 *Fanny's First Play*—Bernard Shaw.
 24 *Diversion*—John Van Druten.
 31 *Viceroy Sarah*—Norman Ginsbury.

April 7 *Marigold*—L. Allen Harker and F. R. Pryor.
 14 *Road House*—Walter Hackett.
 21 *Easy Virtue*—Noel Coward.
 28 *Tovarich*—Jacques Deval.

May 5 *The Unguarded Hour*—Bernard Merivale.
 12 *Major Barbara*—Bernard Shaw.
 19 *Fresh Fields*—Ivor Novello.
 26 *Paddy The Next Best Thing*—Gertrude Page.

 (*Vacation*)

June 30 *The Blue Goose*—Peter Blackmore.

July 7 *Berkeley Square*—John L. Balderston.
 14 *French for Love*—Marguerite Steen and Derek Patmore.
 21 *Quinneys*—Horace Annesley Vachell.
 28 *Passing Brompton Road*—Jevan Brandon Thomas.

Aug. 4 *Just Married*—Adelaide Matthews and Anne Nichols.
 11 *Carnival*—H. C. H. Hardinge and Matheson Lang.
 18 *Jane's Legacy*—Eden Phillpotts.
 25 *Too Young to Marry*—Martin Flavin.

Sept. 1 *The Constant Nymph*—Margaret Kennedy and Basil Dean.
 8 *The Sport of Kings*—Ian Hay.
 15 *Saloon Bar*—Frank Harvey.
 22 *The Fake*—Frederick Lonsdale.
 29 *Tons of Money*—Will Evans and Valentine.

Oct. 6 *Mystery at Greenfingers*—J. B. Priestley.
 13 *Reunion in Vienna*—Robert Emmet Sherwood.
 20 *Nine-Forty-five*—Owen Davis and Sewell Collins.
 27 *Where Innocence is Bliss*—M. M. Stanley and A. Matthews.

Nov. 3 *Whiteoaks*—Mazo de la Roche.
 10 *If Four Walls Told*—Edward Percy.
 17 *The Patsy*—Barry Conners.
 24 *Ladies in Retirement*—Edward Percy and R. Denham.

Dec. 1 *Heart's Content*—W. Chetham-Strode.
 8 *Thank You Mr. Pepys*—W. P. Lipscomb.
 15 *Three Men on a Horse*—J. C. Holm and G. Abbott.
 26 *Pickwick*—Charles Dickens.

PLAYERS—1941

PETER BACH
LAWRENCE BASKCOMB
ANTHONY BLAKE
JOAN BUTTON
FLORENCE CHURCHILL
FRANKLIN WM. DAVIES
PEGGY DIAMOND
DOROTHY FENWICK
BETTY FULLER
DONALD GORDON
MARGARET GREENE

PETER LETTS
GORDON LITTMAN
WILLIAMS LLOYD
HILDA MALCOLM
**DOREEN MARKHAM
ALEC MASON
IAN MCKENZIE
 (*Michael Howard*)
EDWIN MORTON
GEORGE ROCHE
CATHERINE SMITH
MARJORIE SOMMERVILLE
*ARTHUR R. WEBB
MARY WHITFIELD

Producer:
WILLIAM E. BROOKFIELD

Scenic Designer:
OSBORNE ROBINSON

Business Manager:
(1) F. W. COTTER CRAIG
(2) J. E. STEVENSON

PLAYS—1942

Jan. 5 *When We Are Married*—J. B. Priestley.
12 *Quality Street*—J. M. Barrie.
19 *Cottage to Let*—Geoffrey Kerr.
26 *Goodbye, Mr. Chips*—James Hilton and Barbara Burnham.

Feb. 2 *Autumn*—Margaret Kennedy and Gregory Ratoff.
9 *Duet in Floodlight*—J. B. Priestley.
16 *The Doctor's Dilemma*—Bernard Shaw.
23 *A·Hundred Years Old*—Helen and Harley Granville-Barker.

Mar. 2 *Home and Beauty*—W. Somerset Maugham.
9 *Robert's Wife*—St. John Ervine.
16 *Milestones*—Arnold Bennett and Edward Knoblock.
23 *Aren't We All?*—Frederick Lonsdale.
30 *Sweet Aloes*—Jay Mallory.

April 6 *The Housemaster*—Ian Hay.
13 *The Late Christopher Bean*—Rene Fauchois and E. Williams.
20 *Three Wise Fools*—Austin Strong.
27 *The Sign on the Door*—Channing Pollock.

May 4 *The Man With a Load of Mischief*—Ashley Dukes.
11 *No. 17*—J. Jefferson Farjeon.
18 *The Ship*—St. John Ervine.
25 *Quiet Wedding*—Esther McCracken.

June 1 *The Cat's Cradle*—Aimee and Philip Stuart.
8 *Young Woodley*—John Van Druten.
15 *Once a Crook*—Evadne Price and Ken Attiwill.
22 *Full House*—Ivor Novello.
29 *Suspect*—Edward Percy and Reginald Denham.

July 6 *East Lynne*—Mrs. Henry Wood.
13 *Actresses will Happen*—Walter Ellis.
20 *Jupiter Laughs*—A. J. Cronin.
27 *Boyd's Shop*—St. John Ervine.

Aug. 3 *Up in Mabel's Room*—Wilson Collison and O. Harbad.
(Vacation)

Sept. 14 *Call it a Day*—Dodie Smith.
21 *Red for Danger*—Evadne Price and Ken Attiwill.
28 *Winter Sunshine*—G. A. Thomas.

Oct. 5 *Double Door*—Elizabeth McFadden.
12 *Jam To-day*—Denis Waldock and Roger Burford.
19 *The Enchanted Cottage*—Arthur Pinero.
26 *Why Men Leave Home*—Avery Hopwood.

Nov. 2 *The Land of Promise*—W. Somerset Maugham.
9 *French Without Tears*—Terence Rattigan.
16 *Heartbreak House*—Bernard Shaw.
23 *Judgment Day*—Elmer Rice.
30 *At the Villa Rose*—A. E. W. Mason.

Dec. 7 *Accent on Youth*—Samson Raphaelson.
14 *Play with Fire*—Edward Percy.
26 *The Prisoner of Zenda*—Edward Rose.

PLAYERS—1942

PETER BACH
CHRISTOPHER BANKS
LAWRENCE BASKCOMB
BRUCE BRADFORD
LAUDERDALE BECKETT
STANLEY BURGESS
JOAN BUTTON
FLORENCE CHURCHILL
FRANKLIN WM. DAVIES
PEGGY DIAMOND
ERIC DOWDY (*Robert Ashley*)
DOROTHY FENWICK
JOHN FITZGERALD
BETTY FULLER
**MICHAEL HEATON
DAVID HOFMAN

FREDERICK LANE
ARTHUR LESLIE
HILDA MALCOLM
*DOREEN MARKHAM
ALEC MASON
IAN MCKENZIE
 (*Michael Howard*)
EDWIN MORTON
GEORGE ROCHE
DOROTHEA RUNDLE
HARRY SHACKLOCK
MICHAEL SHANNON
MARJORIE SOMMERVILLE
**JOHN TANFIELD
*ARTHUR R. WEBB
MARY WHITFIELD
PAULINE WILLIAMS

Producers:
(1) WILLIAM E. BROOKFIELD
(2) GEORGE ROCHE
(3) ARTHUR LESLIE

Scenic Designer:
OSBORNE ROBINSON

Manager and Licensee:
J. E. STEVENSON

PLAYS—1943

Jan. 4 *So This is London*—Arthur Goodrich.
11 *Loyalties*—John Galsworthy.
18 *Potash and Perlmutter*—Montague Glass.
25 *Old Acquaintance*—John Van Druten.

Feb. 1 *The Younger Generation*—Stanley Houghton.
8 *The Improper Duchess*—James Bernard Fagan.
15 *They Walk Alone*—Max Catto.
22 *The First Year*—Frank Craven.

Mar. 1 *The Circle*—W. Somerset Maugham.
8 *Anthony and Anna*—St. John G. Ervine.
15 *Ten Minute Alibi*—Anthony Armstrong.
22 *A Ship Comes Home*—Daisy Fisher.
29 *Hedda Gabler*—Henrik Ibsen.

April 5 *Other People's Houses*—Lynne Dexter.
12 *I Killed the Count*—Alec Coppel.
19 *Sweet Lavender*—Arthur W. Pinero.
26 *Hobson's Choice*—Harold Brighouse.

May 3 *The Queen's Husband*—Robert E. Sherwood.
10 *Glorious Morning*—Norman MacOwan.
17 *Youth at the Helm*—Hubert Griffith.
24 *Poison Pen*—Richard Llewellyn.
31 *The Millionairess*—Bernard Shaw.

June 7 *Dusty Ermine*—Neil Grant.
14 *The Mask and the Face*—C. B. Fernald.

(*Vacation*)

July 8 *The School for Scandal*—Richard Brinsley Sheridan.
19 *The Two Mrs. Carrolls*—Martin Vale.
26 *Counsellor-at-Law*—Elmer Rice.

Aug. 2 *The Farmer's Wife*—Eden Phillpotts.
9 *Nina*—Hubert Griffith.
16 *The Painted Veil*—B. Cormack and W. Somerset Maugham.
23 *Hindle Wakes*—Stanley Houghton.
30 *Androcles and the Lion*—Bernard Shaw.

Sept. 6 *Gas Light*—Patrick Hamilton.
13 *Bluebeard's Eighth Wife*—Arthur Wimperis.
20 ‡*Burning Gold*—Falkland L. Cary and A. A. Thomson.
27 *Devonshire Cream*—Eden Phillpotts.

Oct. 4 *Skylark*—Sampson Raphaelson.
11 *Dr. Brent's Household*—Edward Percy.
18 *Private Lives*—Noel Coward.
25 *I Have Been Here Before*—J. B. Priestley.

Nov. 1 *Canaries Sometimes Sing*—Frederick Lonsdale.
8 *The Sacred Flame*—W. Somerset Maugham.
15 *George and Margaret*—Gerald Savory.
22 *Thou Shalt Not*—Emile Zola.
29 *You Can't Take It With You*—M. Hart and G. Kaufman.

Dec. 6 *Man Proposes*—W. Chetham Strode.
13 *The Light of Heart*—Emlyn Williams.
27 *1066 and All That*—Reginald Arkell.

PLAYERS—1943

LAWRENCE BASKCOMB
FLORENCE CHURCHILL
FRANKLIN WM. DAVIES
PEGGY DIAMOND
**ERIC DOWDY (*Robert Ashley*)
JOHN FITZGERALD
BETTY FULLER
HARRY GELDARD
DIANA HARE
DAVID HOFMAN

FREDERICK LANE
ARTHUR LESLIE
HILDA MALCOLM
DOREEN MARKHAM
**YVONNE MARQUAND
*STEWART RUTTLEDGE
HARRY SHACKLOCK
JOHN TANFIELD
REGINALD THORNE
MARY WHITFIELD
PAULINE WILLIAMS

Producer:
(1) ARTHUR LESLIE
(2) ALEX REEVE

Scenic Designer:
OSBORNE ROBINSON

Manager and Licensee:
J. E. STEVENSON

PLAYS—1944

Jan. 10 *The Petrified Forest*—Robert Emmet Sherwood.
17 *Cock Robin*—Elmer Rice and Philip Barry.
24 *Busman's Honeymoon*—Dorothy L. Sayers and M. St. C. Byrne.
31 *To-Night at 6.30*—Noel Coward.

Feb. 7 *Candida*—Bernard Shaw.
14 *The Rose Without a Thorn*—Clifford Bax.
21 *Yellow Sands*—Eden and Adelaide Phillpotts.
28 *Tony Draws a Horse*—Lesley Storm.

Mar. 6 *The Queen Was in the Parlour*—Noel Coward.
13 *Fresh Fields*—Ivor Novello.
20 *Charley's Aunt*—Brandon Thomas.
27 *Night Must Fall*—Emlyn Williams.

April 3 *Dear Brutus*—J. M. Barrie.
10 *Pygmalion*—Bernard Shaw.
17 *The Shining Hour*—Keith Winter.
24 *Eden End*—J. B. Priestley.

May 1 *The Case of the Frightened Lady*—Edgar Wallace.
8 *I'll Leave it to You*—Noel Coward.
15 *Ghosts*—Henrik Ibsen.
22 *Indoor Fireworks*—Arthur Macrae.
29 *Nothing But The Truth*—James Montgomery.

June 5 *Granite*—Clemence Dane.
12 *French Without Tears*—Terence Rattigan.

 (Vacation)

July 13 *She Stoops to Conquer*—Oliver Goldsmith.
24 *Love from a Stranger*—Frank Vosper.
31 *They Came to a City*—J. B. Priestley.

Aug. 7 *Maria Marten*
21 *Nine till Six*—Aimee and Philip Stuart.
28 *Rope*—Patrick Hamilton.

Sept. 4 *Arms and the Man*—Bernard Shaw.
11 *Payment Deferred*—Jeffrey Dell.
18 *The Lilies of the Field*—John Hastings Turner.
25 *Caste*—T. W. Robertson.

Oct. 2 *Dangerous Corner*—J. B. Priestley.
9 *Living Room*—Esther McCracken.
16 *The Corn is Green*—Emlyn Williams.
23 *Lovers' Leap*—Philip Johnson.
30 *The Anatomist*—James Bridie.

Nov. 6 *Her Shop*—Aimee and Philip Stuart.
13 *The Romantic Young Lady*—Gregorio Martinez Sierra.
20 *Distinguished Villa*—Kate O'Brien.
27 *Even Money*—Lionel Brown.

Dec. 4 ‡*Candied Peel*—Falkland L. Cary.
11 *Painted Sparrows*—Guy Paxton and Edward V. Hoile.
26 *The Scarlet Pimpernel*—Baroness Orczy.

PLAYERS—1944

LAWRENCE BASKCOMB	FREDERICK LANE
JOAN BUTTON	GERALD LENNAN
JOHN CAROL	HILDA MALCOLM
PEGGIE CARROLL	*DOREEN MARKHAM
FLORENCE CHURCHILL	YVONNE MARQUAND
PAMELA CONROY	AUDREY NOBLE
FRANKLIN WM. DAVIES	MARGARET PEPLER
PEGGY DIAMOND	MARY RUSSELL
ERIC DOWDY (*Robert Ashley*)	**STEWART RUTTLEDGE
JOHN FALCONER	PETER TREMLETT
DOROTHY FENWICK	REGINALD THORNE
PETER FORBES-ROBERTSON	MARY WHITFIELD
HARRY GELDARD	PAULINE WILLIAMS
DAVID HOFMAN	ARTHUR R. WEBB

Special Engagement:
ROYDEN GODFREY

Producer:
ALEX REEVE

Scenic Designer:
OSBORNE ROBINSON

Manager and Licensee:
J. E. STEVENSON

PLAYS—1945

Jan. 8 *The Man Who Came to Dinner*—George S. Kaufman and Moss Hart.
 15 *The Druid's Rest*—Emlyn Williams.
 22 *Music at Night*—J. B. Priestley.
 29 *Mr. Bolfry*—James Bridie.

Feb. 5 *A Soldier for Christmas*—Reginald Beckwith.
 12 *Getting Married*—Bernard Shaw.
 19 *Mademoiselle*—Jacques Deval.
 26 *The Rotters*—H. F. Maltby.

Mar. 5 *The Outsider*—Dorothy Brandon.
 19 *Ladies in Retirement*—Edward Percy and Reginald Denham.
 26 *Robert's Wife*—St. John Ervine.

April 2 *This Happy Breed*—Noel Coward.
 16 *Claudia*—Rose Franken.
 23 *Interference*—Roland Pertwee and Harold Dearden.
 30 *When We Are Married*—J. B. Priestley.

May 7 *Caesar's Wife*—W. Somerset Maugham.
 14 *Wuthering Heights*—Emily Brontë, M. Pakington, and O. Walter.
 21 *Grouse in June*—N. C. Hunter.
 28 *Elizabeth of England*—Ashley Dukes.

 (*Vacation*)

July 12 *Dear Octopus*—Dodie Smith.
 23 *The Amazing Dr. Clitterhouse*—Barre Lyndon.
 30 *The Barretts of Wimpole Street*—Rudolf Besier.

Aug. 6 *The Family Upstairs*—Harry Delf.
 13 *The Wind and the Rain*—Merton Hodge.
 20 *Blithe Spirit*—Noel Coward.
 27 *Winterset*—Maxwell Anderson.

Sept. 3 *Acacia Avenue*—Mabel and Denis Constanduros.
 10 *Carnival*—H. C. M. Hardinge.
 17 *Without the Prince*—Philip King.
 24 *The Banbury Nose*—Peter Ustinov.

Oct. 1 *Hay Fever*—Noel Coward.
 8 *Jane Eyre*—Charlotte Brontë and Helen Jerome.
 15 *The Green Pack*—Edgar Wallace.
 22 *The Simpleton of the Unexpected Isles*—Bernard Shaw.
 29 ‡*Murder out of Tune*—Falkland L. Cary.

Nov. 5 *Jane Steps Out*—Kenneth Horne.
 12 *Quinneys*—Horace Annesley Vachell.
 19 *How Are They At Home*—J. B. Priestley.
 26 *An Enemy of the People*—Henrik Ibsen.

Dec. 3 *The First Mrs. Fraser*—St. John Ervine.
 10 *I Lived with You*—Ivor Novello.
 26 **Command Performance*—Alex Reeve and Osborne Robinson.

PLAYERS—1945

LAWRENCE BASKCOMB

JEAN BROWN

PEGGIE CARROLL

JUNE ELLIS

JOHN FALCONER

DOROTHY FENWICK

RONALD GELDARD

MICHAEL HAYES

IAN HARDY

JOAN HART

WILLIAM HONEY

JOHN INGRAM

FREDERICK LANE

ARTHUR LAWRENCE

*DOREEN MARKHAM

*FREDERICK NEWNHAM

**JANE OLIVER

JOAN PAINTER

MARGARET PEPLER

ARNOLD PETERS

EDMUND PURDOM

MARY RUSSELL

REGINALD THORNE

PETER TREMLETT

**SHEILA WARD

ARTHUR R. WEBB

Special Engagements:

FRANKLIN WM. DAVIES ZILLAH GREY

Producer:

ALEX REEVE

Scenic Designer:

OSBORNE ROBINSON

Manager and Licensee:

J. E. STEVENSON

PLAYS—1946

Jan. 14 *It Depends What You Mean*—James Bridie.
 21 *We Took a Cottage*—Mary Harris.
 28 *Lady Windermere's Fan*—Oscar Wilde.

Feb. 11 *Distinguished Gathering*—James Parish.
 18 *Pride and Prejudice*—Helen Jerome.

Mar. 4 ‡*Crackling of Thorns*—C. E. M. Joad.
 11 *One of the Few*—T. Alex Seed.
 18 *Tovarich*—Jacques Deval.
 25 *The Mystery of the "Marie Celeste"*.—L. du Garde Peach.

April 1 *Britannia of Billingsgate*—Christine Jope-Slade and Sewell Stokes.
 8 *A Month in the Country*—Turghenev and E. Williams.
 15 *A Man's House*—John Drinkwater.
 22 *Dandy Dick*—Arthur W. Pinero.
 29 *Ten Little Niggers*—Agatha Christie.

May 6 *My Mother Had Three Sons*—Richard Sargent.
 13 ‡*The Bells Ring*—Joyce Dennys.
 20 ‡*Up the Garden Path*—Hugh Beresford.
 27 *Quality Street*—J. M. Barrie.

June 3 *Black Limelight*—Gordon Sherry.
 10 *Flare Path*—Terence Rattigan.
 17 *Berkeley Square*—John L. Balderston.
 24 *Alien Corn*—Sidney Howard.

July 1 *Jeannie*—Aimee Stuart.

 (Vacation)

Aug. 3 *While the Sun Shines*—Terence Rattigan.
 12 *Three Men on a Horse*—J. C. Holm and George Abbott.
 19 *Bird in Hand*—John Drinkwater.
 26 *The Marquise*—Noel Coward.

Sept. 9 *London Wall*—John Van Druten.
 16 *The Wind of Heaven*—Emlyn Williams.
 23 *The Truth About Timothy Briggs*—H. Worrall-Thompson.
 30 ‡*Without Vision*—Falkland Cary.

Oct. 7 *This Land of Ours*—Lionel Brown.
 14 *Quiet Week End*—Esther McCracken.
 28 *Abraham Lincoln*—John Drinkwater.

Nov. 11 *By Candlelight*—S. Geyer and Harry Graham.
 25 *Call it a Day*—Dodie Smith.

Dec. 9 *Pink String and Sealing Wax*—Ronald Pertwee.
 26 ‡*Cinderella*—Alex Reeve.

PLAYERS—1946

GUY BACK
LAWRENCE BASKCOMB
JEAN BROWN
JUNE ELLIS
DOROTHY FENWICK
DONALD GORDON
LIONEL HAMILTON
JOAN HART
MICHAEL HAYES
*FREDERICK NEWNHAM
**JANE OLIVER

JOAN PAINTER
MARGARET PEPLER
ARNOLD PETERS
EDMOND PURDOM
RONALD RADD
BERYL ROBINSON
MARY RUSSELL
STEPHEN SYLVESTER
REGINALD THORNE
PETER TREMLETT
**SHEILA WARD
ARTHUR R. WEBB

Producer:
ALEX REEVE

Scenic Designer:
OSBORNE ROBINSON

Manager and Licensee:
J. E. STEVENSON

PLAYS—1947

Jan. 20 *The Ghost Train*—Arnold Ridley.
 27 ‡*The Old Man*—G. D. Boyd-Carpenter.

Feb. 3 ‡*Happy Returns*—Marjorie Stace.
 10 *The Little Foxes*—Lillian Hellman.
 17 *Symphony in Two Flats*—Ivor Novello.
 24 *Ma's Bit of Brass*—Ronald Gow.

Mar. 3 *Laburnum Grove*—J. B. Priestley.
 10 *Musical Chairs*—Ronald Mackenzie.
 17 *The Man in Half Moon Street*—Barre Lyndon.
 24 *There Shall be No Night*—Robert Sherwood.
 31 ‡*The Man in the Market Place*—Justin Power and Ronald Wilkinson.

April 7 *Saloon Bar*—Frank Harvey.
 14 *Easy Virtue*—Noel Coward.
 21 *Uncle Harry*—Thomas Job.
 28 *Badger's Green*—R. C. Sherriff.

May 5 *Jupiter Laughs*—A. J. Cronin.
 12 *Madame Louise*—Vernon Sylvaine.
 19 *An Ideal Husband*—Oscar Wilde.

(*Vacation*)

June 26 *We Proudly Present*—Ivor Novello.

July 7 *Frieda*—Ronald Millar.
 14 *The Gleam*—W. Chetham Strode.
 21 *Murder Without Crime*—J. Lee Thompson.
 28 *George and Margaret*—Gerald Savory.

Aug. 4 *Away From It All*—Val Gielgud.
 11 *Rookery Nook*—Ben Travers.
 18 *A Hundred Years Old*—Helen and Harley Granville-Barker.
 25 ‡*Madam Tic-Tac*—Falkland I. Cary and Philip King.

Sept. 1 *Quiet Wedding*—Esther McCracken.
 8 *The Fake*—Frederick Lonsdale.
 15 *The Hasty Heart*—John Patrick.
 22 *The Poltergeist*—Frank Harvey.
 29 *The Lass of Richmond Hill*—W. P. Lipscomb.

Oct. 6 *Murder on the Nile*—Agatha Christie.
 13 *Autumn*—Margaret Kennedy and G. Ratoff.
 20 *Martine*—Jean-Jacques Bernard.
 27 ‡*Man's Company*—Val Gielgud.

Nov. 3 *Fools Rush In*—Kenneth Horne.
 10 *Mary Stuart*—John Drinkwater.
 17 *And No Birds Sing*—Jenny Laird and John Fernald.
 24 *Power Without Glory*—Michael Hutton.

Dec. 1 *The Hasty Heart*—John Patrick.
 8 *Arsenic and Old Lace*—Joseph Kesselring.
 26 ‡*Dick Whittington*—Alex Reeve.

PLAYERS—1947

GUY BACK

PATRICK BARTON

LAWRENCE BASKCOMB

COLIN DOUGLAS

JUNE ELLIS

DOROTHY FENWICK

LIONEL HAMILTON

JOAN HART

BETH HAWKES

MICHAEL HAYES

*FREDERICK NEWNHAM

**JANE OLIVER

MARGARET PEPLER

ARNOLD PETERS

RONALD RADD

BERYL ROBINSON

MARY RUSSELL

STEPHEN SYLVESTER

REGINALD THORNE

PETER TREMLETT

SHEILA WARD

**ARTHUR R. WEBB

Producer:

ALEX REEVE

Scenic Designer:

OSBORNE ROBINSON

Manager and Licensee:

J. E. STEVENSON

INDEX

ABBEY THEATRE, DUBLIN, 13, 41, 93
Abraham Lincoln, 14, 154, 155
Adding Machine, The, 103
Admirable Crichton, The, 93
Adrian, Max, 60, 64–5, 67, 68, 69, 167
After All, 69
Agate, James, 114–15
Ah, Wilderness, 109
Alice in Wonderland, 45–6
Alice-Sit-by-the-Fire, 51
Alien Corn, 151
Amazing Dr. Clitterhouse, The, 107
Ambrose Applejohn's Adventure, 46, 126–7
Anatomist, The, 144–5
Androcles and the Lion, 142
And So To Bed, 60, 69–70
Anna Christie, 45
Anthony and Anna, 107
Apple Cart, The, 125, 126
Arms and the Man, 31–2, 74, 144
Armstrong, William, 14, 153
Audience, the, 79–80, 174, 177–8

BACK, GUY, 154
Badger's Green, 77
Banbury Nose, The, 151
Bancroft, George Pleydell, 110
Barretts of Wimpole Street, The, 81–2, 100, 151
Barrie, Sir James, 58, 93, 135
Barry, Michael, 64
Baskcomb, Lawrence, 23, 91–2, 126, 130, 136, 142, 144, 150, 151, 152, 153
Baskcomb, P. B., 7, 17, 18, 23, 101, 179
Bassett-Lowke, W. J., 7, 18, 21, 32, 59, 101, 179
Bath Season, 50–3
Beattie, H. Musk, 7, 18, 21, 87, 101, 129, 179
Bennett, Vivienne, 39, 40, 43, 44, 56, 58, 59, 60, 61, 63, 64, 65, 125–6, 165–6
Benson, Sir Frank, 71, 87
Berkeley Square, 135
Blake, Anthony, 134
Blithe Spirit, 151
Bill of Divorcement, A, 27
Biography, 92
Bird-in-Hand, 69
Birmingham Repertory Theatre, 14
Bristol Little Theatre, 17, 23, 31
British Drama League, 57
Broadcasting, 76, 82, 98–9, 109
Brontes, The, 121
Brookfield, William, 133, 134, 136
Brown, Lieut.-General Sir John, 19, 83, 179
Burning Gold, 142–3
Button, Mrs. M., 24–5
By Candle Light, 63–4
Buxton Season, 122–3

Caesar's Friend, 88, 98–9
Call It a Day, 138
Cambridge Festival Theatre, 36–7, 43
Cameron, C. Graham, 17, 21, 24, 26, 42
Candied Peel, 144–5
Candida, 64, 117, 144
Cardinal, The, 74, 92
Carol, John, 144, 146, 171
Carren, J. Drew, 21, 24, 29, 30, 32, 42, 159
Carroll, Lewis, 45–6
Cary, Dr. Falkland L., 142–3, 145, 151, 153
Caste, 144
Charley's Aunt, 92, 117
Choice of Plays, 34–6, 66–7, 79–80

Christie, Helen, 88, 91, 92, 170
Churchill, Sarah, 118, 119
Cinderella (M. Carter), 91
Cinderella (A. Reeve), 154–5
Circle of Chalk, The, 118
Civic Theatre, 20
Clews, Lorraine, 88, 90, 169
Command Performance, 152
Conflict, 85
Constant Nymph, The, 104, 135
Corn is Green, The, 144, 145
Counsellor-at-Law, 89
Coward, Noel, 56–7, 58, 102, 150
Crackling of Thorns, 153–4
Craig, F. W. Cotter, 109, 137
Crean, Patrick, 98, 99, 102, 103, 104, 105, 113, 170
Cricket, 87
Crockett, Sir James, 20, 54, 179

DANE, CLEMENCE, 27–8, 67
Dangerous Corner, 79, 81, 121, 123
Dark Lady of the Sonnets, The, 129
Darlington, W. A., 75
Davies, Franklin, 117, 121–3, 126–9, 132, 134, 136, 138, 141, 142, 151
Death Takes a Holiday, 79, 81
Dear Brutus, 59, 144
Dear Octopus, 125, 133, 151
Devil's Disciple, The, 85
Devonshire Cream, 87–8
Diamond, Peggy, 133–4, 136, 138, 141, 144, 146, 171
Diplomacy, 38
Directors, the, 20–1, 101, 175
Distaff Side, The, 88
Doctor's Dilemma, The, 127–8, 137
Doe, C. T., 21, 24–5, 28–32, 39, 40, 45–8
Doll's House, A, 83
Douglas, Colin, 121–2, 126, 128–30, 156
Dowdy, Eric, 142
Dramatic Criticism, 149–50
Dr. Knock, 45
Dryden Festivals, 110–14, 175–6
Dryden, John, 110–11
Duet in Floodlight, 102

East Lynn, 137
East of Suez, 69
Easy Payments, 74
Eden End, 100, 144
Elephant and Castle Theatre Co., 16, 21
Elizabeth of England, 151
Ellis, June, 152
Enemy of the People, An, 151
E.N.S.A., 144
Ervine, St. John, 14, 27, 28, 34, 39, 53, 79, 103, 109, 149, 150
Escape Me Never, 99, 126
Evans, Dorothy, 102, 104, 107–8, 171
Experiment, 28
Expressionism, 103–4

Faithful Heart, The, 55
Fanny's First Play, 59–60
Farmer's Wife, The, 84, 121
Far-off Hills, The, 92–3
Fenwick, Dorothy, 117–19, 133–4, 145, 151–2, 156
Flashing Stream, The, 125, 129
Flower, Sir Archibald, 112
Flynn, Errol, 83–5, 169
Fox, W. H., 101, 136–7, 179

GALBRAITH, DOROTHY, 80–2, 84–6, 88–9
Gas Light, 127
Geldard, Harry, 141–2, 168–9
Geneva, 125
Getting Married, 150
Ghosts, 145–6
Ghost Train, The, 68
Glaid, Bluebell, 21, 24–5, 28–9, 31–3, 42
Glorious Morning, 122–3
Good Friday, 48
Gordon, Donald, 69–70, 72, 76, 81–3, 85, 88–93, 98, 100, 112, 126, 134, 136, 171
Granite, 67
Graves, F., 17, 20–1, 83, 179
Gray, Terence, 36–7
Great Adventure, The, 92
Greene, Margaret, 121–2, 126, 128–9, 134, 136
Green Goddess, The, 54
Grey, Zillah, 80, 82, 84–5, 88, 90–2
Guthrie, Tyrone, 120, 141

HAMBLING, ARTHUR, 24–5, 27, 31, 42, 165
Hamilton, Lionel, 153, 155–6
Harford, Paul, 102, 104–5, 107–8, 113
Hart, Joan, 150–3, 156
Harvey, Rupert, 31–2, 38
Hay Fever, 58, 70, 129, 151
Hayter, James, 30, 32, 40, 46, 48, 52–3, 57, 59–60, 165
Heartbreak House, 138
Heart's Content, 107–8
Hedda Gabler, 141
Heyhoe, Bertram, 55, 58–60, 63, 66, 68–9, 171
His House in Order, 24–6, 121, 180, 204
Hockey, 87
Hofman, David, 141, 144
Holloway, Bernard G., 8, 17, 18
Home and Beauty, 68
Horniman, Miss A., 13, 14, 106
Horton, W. H., 20, 54, 73–4, 179
Howlett, Noel, 55–7, 59–60, 64–7, 73–4, 76, 80, 87–8, 166–7
Hundred Years Old, A, 60, 137

I Have Been Here Before, 117–18, 123
Ibsen, Henrik, 83–4, 95, 141, 145–6
Ideal Husband, An, 156
Importance of Being Earnest, The, 64
Improper Duchess, The, 76
Inaugural Meeting, 17
Ingram, Joan, 40, 43, 45
Insect Play, The, 119
Irving, Helen, 107, 113–14

Jack and the Beanstalk, 82–3
Jackson, Sir Barry, 14, 24, 150, 157
Jackson, Freda, 80–1, 84–6, 89–91, 93, 98, 100, 169–70
James, Clifton, 24–5, 30–1, 39, 158–9
Jane Eyre, 129, 132
Jerome, Jerome K., 29
Jerome, Max, 23–4, 26, 28, 30–1
Joad, Dr. C. E. M., 153–4
Johnson Over Jordan, 124
Johnson, Rosemary, 117–19, 121–2, 126–30, 133
Journey's End, 56, 89
Judgment Day, 138
Jupiter Laughs, 137

KENTON, GODFREY, 40, 43, 55–61, 126, 166
King John, 76

Laburnum Grove, 92, 129
Ladies in Retirement, 135
Lady Windermere's Fan, 152
Lane, Frederick, 142–3
Larke-Smith, Betty, 93, 102, 105, 108–9
Late Christopher Bean, The, 91–2, 137
Late Night Final, 107

Lawrence, Arthur, 117–19, 121–2, 126–8, 151–2
Lean Harvest, 81
Leslie, Arthur, 138
Lewis, Curigwen, 44, 46–7, 52–3, 55–7, 64, 166
Libel, 109–10
Lister, Margot, 24–5, 27–9, 32–3, 42, 67–8, 165
Little Foxes, The, 156
Liverpool Repertory Theatre, 13–14, 23
Lloyd, Williams, 134, 171
London Wall, 87–8
Love from a Stranger, 102

Macbeth, 104–5
MacIntyre, Alastair, 99, 102, 104–5, 170
Mackenzie, Ian (Michael Howard), 171
Macropulos Secret, The, 104
Mademoiselle, 108
Magic, 32
Magistrate, The, 109
Mais, S. P. B., 73
Maitlands, The, 90
Major Barbara, 93, 135
Malade Imaginaire, La, 72–3
Malcolm, Hilda, 133–6, 138, 141–2, 144
Manchester Repertory Theatre, 13
Man in the Market Place, The, 155
Man's House, A, 118–19
Man Who Came to Dinner, The, 151
Man With a Load of Mischief, The, 65–6, 137
Many Waters, 104
Maria Marten, 144
Marquise, The, 57
Marriage a la Mode, 111–12
Martine, 77
Mary Rose, 58, 117
Mary Stuart, 38
Mask and the Face, The, 40
Maynard, Charles, 30, 32
Merchant of Venice, The, 76
Micklewood, Eric, 102, 107, 109, 170
Midsummer Night's Dream, A, 32
Milbourne, Olive, 55–6, 58–60, 66, 68, 167
Milestones, 32, 137
Millar, Sheila, 68, 72–4, 76, 80–3
Millionairess, The, 124, 142
Month in the Country, A, 152
Morris, Noel, 30, 32–3, 38–40, 45–6, 48
Mrs. Dane's Defence, 43
Mrs. Warren's Profession, 67
Mudie, George, 101–4, 107–9, 113–14, 119, 159
Murder Out of Tune, 151
Murgatroyd, Olga, 99, 102–4, 107–8, 113
Musical Chairs, 73, 133
Music at Night, 150

Night Must Fall, 107, 144
Nina, 102, 144
Northampton Repertory Players Limited, 20, 101
Northampton and the Drama, 15–16
Nothing But the Truth, 68

OBEE, LOIS (Sonia Dresdel), 69, 72–4, 76–7, 80, 167–8
On Approval, 47, 70
Once-nightly system, 99–100, 125, 154–5
On the Spot, 84, 128
Opening Night, 24–6
Opera House, Northampton, 19–20
O'Rorke, Brefni, 88–93, 161–2
Othello, 86
Outsider, The, 66
Outward Bound, 40, 121

PAGE, KATHARINE, 92, 98–9, 103–4
Painted Veil, The, 72
Panther, Mrs. H., 21, 73–4, 101, 179
Parker, Cecil, 127
Passing of the Third Floor Back, The, 28–9, 70
Peake, Bladon, 97–100, 102–5, 111–12, 114–16, 158

Pelly, Anthony, 107, 110, 113
People at Sea, 117
Pepler, Margaret, 145, 150-2, 155
Percy, Edward, 103
Perdita Comes to Town, 47
Petrified Forest, The, 144
Phipps, Nicholas, 89-90, 93, 170
Pickwick, 137
Pioneers, 17
Playboy of the Western World, The, 64-5
Playgoers' Association, 17, 21, 23-4, 38, 59
Play With Fire, 137
Poison Pen, 121, 123
Power and the Glory, The, 90
Prentice, Herbert M., 36-8, 40, 44-5, 48, 50-3, 57, 61, 68-71, 157
Prentice, Marion, 47, 53, 61
Pride and Prejudice, 133-4
Priestley, J. B., 81, 92, 100, 106, 117, 124, 128, 144, 150
Prisoner of Zenda, The, 57
Private Lives, 102
Producer's work, a, 94-5
Pygmalion, 144

Queen's Husband, The, 141
Queen Was in the Parlour, The, 56-7
Queen Who Kept Her Head, The, 121

Raffles, 57
Rebecca, 125
Reeve, Alex, 141, 143, 150-2, 154-5
Repertory, 164, 173
Repertory Circle, 120
Repertory Movement, 13-14, 173
Repertory routine, 42-3
Richard of Bordeaux, 104
Rivals, The, 79, 81
Roberts, Oswald Dale, 72-7, 80-93, 98-101, 112, 117-18, 162-3
Robert's Wife, 127, 137, 151
Robinson, Beryl, 154
Robinson, Osborne, 38, 40, 44-6, 50, 52, 55, 57, 59, 61, 63-4, 69, 72, 74-6, 81-2, 85, 88-90, 99, 103-5, 108, 111-14, 118-19, 122, 130, 134, 146-8, 151-2
Roche, George, 137-8
Romantic Young Lady, The, 44
Romeo and Juliet, 119, 125-6
Rope, 64
Rose Without a Thorn, The, 85-6, 144
Rosser, Peter, 73-4, 77, 81-5, 88-90, 167
R.U.R., 43-4, 103
Russell, Mary, 150, 155

Sacred and Profane Love, 77
Saint Joan, 125, 129-30
Santangelo, Peppino, 80, 87
Saville, T. G., 43, 45-8, 55-6, 65-70, 159-61
School for Scandal, The, 29-30, 60
Second Mrs. Tanqueray, The, 30, 69
Secrets, 134
Sellar, Madge, 117-18
Shakespeare, William, 31-2, 60, 75-6, 86, 95, 99-100, 104-5, 119, 125-6, 176
Shaw, Dr. Eric, 120, 136
Shaw, G. Bernard, 31-2, 59, 67, 74, 106-7, 124-5, 129-30, 138, 142, 150-1
Sheppey, 85
Sherwood, William, 116-17, 119-20, 122, 126, 128, 130, 171
She Stoops to Conquer, 40, 144
Shining Hour, The, 102

Ship, The, 46-7, 109, 137
Silent House, The, 69
Silver Box, The, 47
Silver Cord, The, 52-3, 72
Simpleton of the Unexpected Isles, The, 151
Sir Martin Marr-all, 113-14
Sleeping Clergyman, A, 104
Somebody Knows, 102
Sommerville, Marjorie, 126, 129, 134-5, 138
Spanish Friar, The, 112-13
Spring Cleaning, 60
Squaring the Circle, 118
Stevenson, J. E., 143
Storm in a Teacup, 108
Summers, Richard, 80
Suspect, 107, 137
Sweet Aloes, 102
Synge, J. M., 64-5

Taming of the Shrew, The, 99-100
1066 and All That, 143
Thank You, Mr. Pepys, 136
Theatre Royal, 118
Therese Raquin, 141-2
There Shall Be No Night, 156
They Came to a City, 144
They Knew What They Wanted, 63
Thorndike, Dame Sybil, 127
Thorne, Reginald, 144, 150, 152, 154, 156
Thunder Rock, 135-6
Time and the Conways, 117-18
Tobias and the Angel, 122
Tons of Money, 46, 74, 135
To See Ourselves, 67-8
Tovarich, 107
To What Red Hell, 117
Training school for acting, 164-5
Tremlett, Peter, 145, 150-3, 155
Tributes, 47, 49, 57, 62, 75, 77-8, 111-14, 123
Trilby, 76
Truth About Blayds, The, 27
Tuson, Neil, 107-10, 113, 119, 126, 128-9, 134, 171
Twelfth Night, 75-6
Twice-nightly system, 99-100, 125

Venetian, The, 89-90
Viceroy Sarah, 136
Victoria Regina, 122-3
Voysey Inheritance, The, 102

WAR, 124-5, 130-2, 140-1
Ware Case, The, 110
Webb, Arthur R., 146
We Moderns, 31
We Proudly Present, 156
What Every Woman Knows, 135
When We Are Married, 128
Whiteheaded Boy, The, 88
Whiteoaks, 108-9
Whitfield, Mary, 138, 142
Williams, Pauline, 141-2, 144-5
Winterset, 151-2
Witch, The, 60-1
Without the Prince, 126
Without Vision, 153
Woman of No Importance, A, 55

Yellow Sands, 84, 117
You Can't Take It With You, 142
You Never Can Tell, 79-80
Young, Robert, 71-2, 75-7, 81-7, 90-1, 93-7, 157-8
Young Woodley, 79-80, 137
Youth at the Helm, 101-2